BODIES *of* SUBVERSION

A Secret History of Women and Tattoo

by Margot Mifflin

NEW YORK CITY

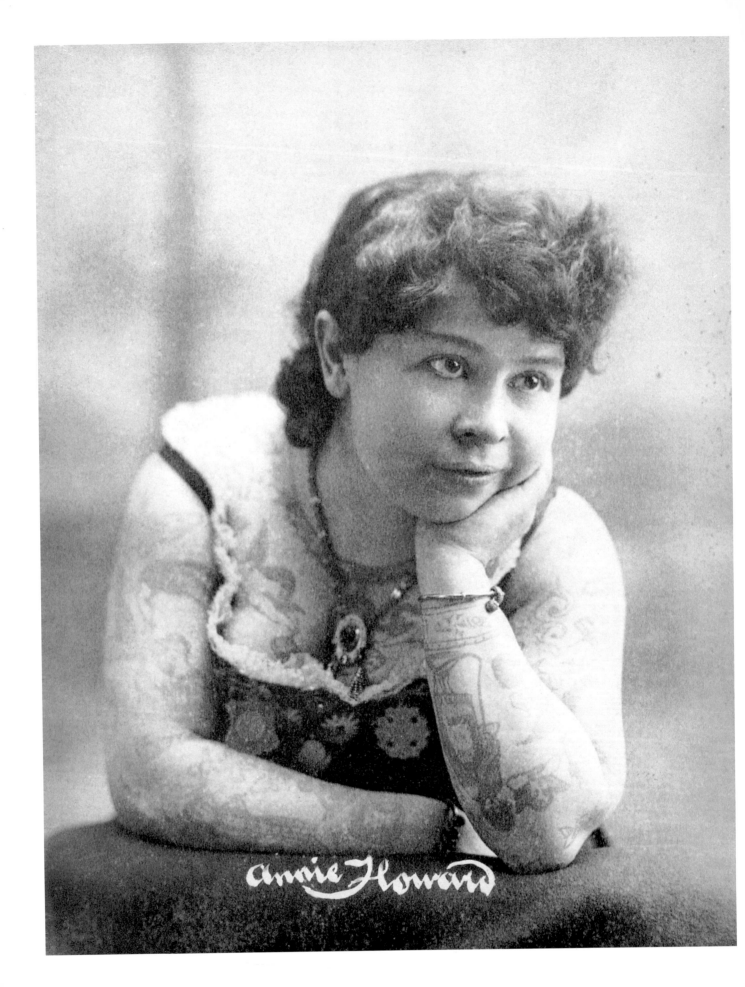
Annie Howard

CONTENTS

Annie Howard, circus attraction, circa 1885.
(The Ron Becker Collection, Syracuse University
Library, Department of Special Collections)

Katzen—see p. 126
(Photo by Emily Tucker)

Introduction:
Skin

In a culture where surfaces matter, skin, the largest organ, is the scrim on which we project our greatest fantasies and deepest fears about our bodies. Expose too much of it, and Christian fundamentalists or anti-porn feminists will come after you. Pierce or brand it, and you assume the uniform of the counterculture. Nip and tuck it through surgery, and you drink from the fountain of youth or buy into the beauty myth.

Skin houses the network of nerve endings that connects us to pain and pleasure, and it's the casing that protects us from bacteria and disease. Our sense of touch resides in its top layer, the epidermis, and a second layer, the dermis, holds the ink and ash that tattooed people have used to decorate themselves for more than 5,000 years. Skin is expressive: it bears our unique pore patterns and fingerprints, and registers temperature (through chills, hot flashes and goose bumps) and emotion (through blushing and blanching).

Throughout the world, skin color affects one's social status, if not one's fate. In the Western world, gradations of white skin have class associations: a tan was the mark of the manual laborer in agrarian times, but during the machine age, it became a hallmark of the sunbathing, surf-loving leisure class.

For women, skin is a work in progress through which we celebrate—and denigrate—ourselves: we shave our legs to achieve a childlike smoothness and smear make-up on our faces to enhance our adult sexuality; we bleach and pluck our facial hair and buy expensive creams that promise to "repair" the skin and "reverse" the effects of aging.

No form of skin modification is as layered with meaning as tattooing—especially for women. Tattoos tell stories about female experience and trigger reactions that underscore cultural assumptions about women. The Riot Grrrls of their day, tattooed women of the 19th and early 20th centuries flouted the Victorian ideals of feminine purity that have

been gradually peeled away, like so many starched undergarments, throughout this century. Even after decades of feminist progress, however, women who mark themselves with tattoos commit a transgressive act whose shock value lingers on in some quarters: as recently as 1979, a woman was discharged from the Marines, of all places, after a small tattoo was discovered on her wrist.

Tattoos appeal to contemporary women both as emblems of empowerment in an era of feminist gains and as badges of self-determination at a time when controversies about abortion rights, date rape, and sexual harassment have many women thinking hard about who controls their bodies—and why. Their significance can lie in the mere act of getting tattooed (as a form of rebellion or a way of reclaiming one's body after rape or sexual abuse) or in their timing (to commemorate milestones such as marriage or divorce, or in remembrance of dead friends or relatives). Written on the body, these private insignia are keys to women's self-images during a period when traditional gender roles are being challenged, and often rejected.

"I want a mark on my body that my husband has never seen," says one woman who set out to shed her wifely identity after a divorce. "I did it as a way to express my differences," explains a young lesbian who got her first tattoo after coming out in high school. "I tattooed a family—grandmother, mother, aunt, and two granddaughters," says artist SuzAnne Fauser. "They all got the same little violet and heart tattoo—to show family allegiance." As Diane Ackerman put it in A Natural History of the Senses, "Tattoos make unique the surface of one's self, embody one's secret dreams, adorn with magic emblems the Altamira of the flesh."

A fifty-something Californian, Marcia Rasner has a tattoo collection that reads like an owner's manual to her dramatic life story. When she got her first tattoo in 1973, she had no idea that the symbolism of her tattoos would change during her life, then change the course of her life itself. Matching bands of delicate green leaves and red berries made perfect hippie wedding rings for a Vietnam vet and a divorced refugee from suburbia, and—to Rasner's satisfaction—outraged her Midwestern family. Her second tattoo, a Black-eyed Susan designed around a small birthmark on her leg, commemorated her son's birth and reaffirmed her non-conformist spirit. "I was married and had a baby and was living in the Midwest," she says, "and I had to be scandalous once more."

Rasner's tattooed wedding ring took on added meaning 15 years after her marriage, when her husband died suddenly of brain cancer. In the mid '80s, she was diagnosed with breast cancer and underwent a double mastectomy; her subsequent struggle with her scarred body and wounded self-image ended when she traded old skin for new by having her scars

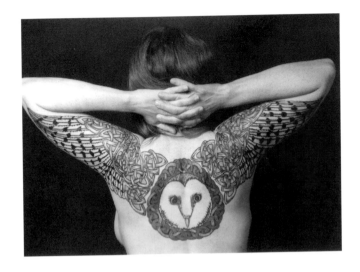

This tattoo by Pat Fish was custom-designed for a client rebounding from a painful divorce. Fish and her client visited a natural history museum to study the skins and wings of many species of owls before choosing this pattern, which Fish combined with her trademark knotwork. The client considers the owl both a symbol of freedom and a guardian for her new life.
(Photo by Copáge, Model: Sylvia Owl)

tattooed. Now, her chest is rich in color and symbolism, and her scars are submerged in life-affirming, organic imagery: flowers, fish, a shining heart and a series of eight phases of the moon float across her sternum. Where her earlier tattoos were gestures of self-expression, this one was an act of self-transformation.

"I have a picture of me taken before and after," says Rasner, "and I can see the change in my eyes in those pictures. It's a feeling of having taken something essentially negative and turned it into something beautiful."

Poignant as they are, Rasner's motivations for getting tattooed aren't unusual. Since the '70s, thousands of women have seized the symbolic and decorative possibilities of this once quintessentially male medium. Don Ed Hardy, one of the best-known tattooists in the country, watched women grow from 5% to 60% of his clientele from the 1960s to the '90s. The ranks of women tatooists have also swelled: when pioneering artist Vyvyn Lazonga started out in Seattle in 1972, she was one of a handful of female artists. Now, artists estimate that at least 20% of American tattooists are women.

Despite their unconventional profession, women tattooists struggle with many of the same issues their professional peers face in the corporate arena, in the art world, and on the playing field: issues of separatism, competition, and the sort of biological determinism that says women naturally run or throw or draw (as one male tattooist described his female apprentice's early style) "like a girl." Interestingly enough, the one battle they've never had to fight is for equal pay. They've struggled for respect and exposure at conventions and in trade magazines, but they don't settle, as so many other working women do, for 71 cents to a man's dollar.

As recently as the early '90s, when I began researching this book, tattooed women trailed a cloud of scandal; now they merely enjoy of whiff of intrigue. Tattoos are staples of liquor and cigarette ads, and tattooed celebrities are so common that they're no longer newsworthy (except, perhaps, when the news is Cher's tattoo removal). For irrefutable proof of the mainstreaming of tattoo art, consider Butterfly Art Barbie, who debuted in 1999, the year of the original material girl's 40th birthday—and what some construed as a midlife crisis: Who but a belated trend-hopper like Barbie would regard a butterfly tattoo as newly fashionable in 1999? It was tantamount to a balding boomer growing a stringy ponytail in a desperate last grab at youth. (The Australians have done Mattel one better with Feral

Cheryl, a "wild child" doll from the rainforest region of New South Wales, who, "goes barefoot, has tattoos, dreadlocks, simple clothes and a handmade rainbow bag.")

Although there's no comprehensive way to track them, one study suggests that 20 million Americans (that's 13%) are tattooed. Even the social stigma of tattoos is in measurable decline: a mid-'90s study conducted by Texas Tech University Health Sciences Center revealed that while younger and younger kids are getting tattooed (the mind-boggling limit case being an eight year-old), 60% of tattooed adolescents surveyed were getting grades of A's and B's. We've come a long way since the 1880s, when the Italian criminologist Cesare Lombroso identified tattoos as the sign of a "born criminal," charging it was just a matter of time before a tattooed person without a criminal record would earn one.

Tattooed women are no longer seen as freaks, except, like men, when the quantity or content of their tattoos is extreme. A recent ad in Winston's "No Additives, No Bull" campaign shows a haughty woman remarking, "Yeah, I got a tattoo. And no, you can't see it." Her tattoo signifies self-determination—not sexual availability, as it would have just two decades ago, or victimization, as it would have a century ago. And although the ad titillates by concealing (just where is her tattoo?), it also features a conventional-looking twenty-something whose skin art is clearly not a rebellious gesture, but rather a middle-class fashion choice.

"Hula Kali" tattoo by Pat Fish.
(Photo by Aaron Serafino)

Traveling the college lecture circuit in the three years since Bodies of Subversion *was published, I've collected more tattoo stories than I could ever have imagined, ranging from the tragic (a mother and daughter who share a tiny Madeline tattoo in honor of their daughter/granddaughter who died of cancer at age four) to the moronic (a woman who, at her boyfriend's prompting, tattooed his name onto her labia). Even religious tattoos are on the rise: one woman wears a Star of David wrapped in barbed wire as a Holocaust memorial, and a West Coast subculture of tattooed born-again Christians includes a devotee who's put a new spin on the word made flesh: she wears the citation "II Tim. 2:15" on her back.*

As women's interest in tattoo art thrives, so does a cottage industry of scholarship devoted to it. Artist Mary Jane Haake may have caused a furor by proposing tattoo art for her senior thesis at Pacific Northwest College of Art in the early '80s (her story appears in "The Seventies Revival"), but now the subject is a thriving academic subgenre in art, English, sociology and anthropology departments. One such investigation provides a riveting missing piece of tattooed women's history.

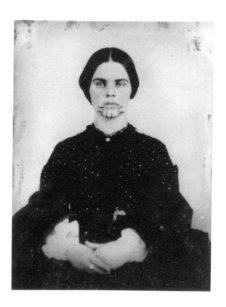 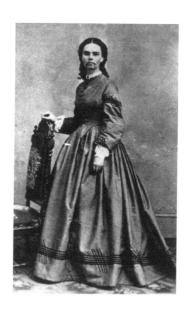

Above, Left and Right
Olive Oatman was abducted by
Yavapais Indians in 1851, when she was
13, and later traded to the Mojave, who
tattooed her chin and arms. The saga of
her five-year ordeal, *Life Among the
Indians: Being an Interesting Narrative of
the Captivity of the Oatman Girls*, was
written by a Methodist clergyman
named Royal B. Stratton, and was
tremendously popular when it was
published in 1857. From 1858-1865,
Oatman toured and lectured to promote
it, becoming the first American woman
to display her tatooed body commer-
cially. Though the book emphasized her
victimization and depicted the Indians
as "filthy, lazy and ignorant [sic],"
Oatman was reputed to have had a
Mojave husband and children, and may
have been fully integrated into the
tribe. A close friend claimed Oatman
tried to return to the Mojave, and
described her as "a grieving, unsatisfied
woman who somehow shook ones" [sic]
belief in civilization."
(Photos courtesy:
Arizona Historical Society/Tuscon,
AH 1927 and SCS-17 N-4776)

*In "Identifying Marks: The Marked Body in Nineteenth-Century American Literature,"
Jennifer Putzi recounts the saga of Olive Oatman, an American who was abducted and
tattooed by Indians in Arizona in 1851—a full three decades before the debut of the
circus attractions who open this book.*

*Oatman's story was darker and stranger than the tall tales she later inspired tattooed
circus ladies to concoct. In 1850, her family was attacked by Yavapais Indians on a
journey from Missouri to Arizona. Thirteen year-old Oatman was captured, sold for
blankets to the Mohave, tattooed on the chin and arm, and spent five years with the tribe
before she was rescued. Ever after, she wore five parallel lines stretching from her lower lip
to her jawline, framed on each side by two cone-shaped horizontal lines.*

*Oatman was permanently marked in more ways than one: a tattooed savage, she became, in
essence, a de-civilized freak, and could never fully rejoin society as a "natural" woman
(her husband even tried—unsuccessfully—to have her tattoos removed). She spent years
traveling the country, describing her experience. Decades later, her ordeal became a script for
pioneering circus women who voluntarily tattooed and exhibited themselves on the pretense that
they too had been kidnapped by Indians and forcibly marked.*

*While Oatman's bizarre story dramatized the consequences of straddling primitive and
civilized worlds, tattooed circus ladies were significant for different reasons: like Oatman,
they exploited the colonialist fascination with Native Americans—they too bore the mark*

of the savage (albeit, fashioned in a conspicuously non-tribal style), but they also trampled, without precedent, convetional standards of feminine beauty, and the aesthetic transgressions they initiated live on in millennial modern primitives. More than ever, women are expressing their artistic, social, and political selves through their tattoos, and their imagery is evolving: Whereas 19th-century circus women redeemed themselves as non-conformists by becoming sandwich boards for shared national sentiments from piety to patriotism, contemporary women wear more personal designs.

For some, tattoos are purely and delightfully decorative. For many, they're heavily symbolic. And for women like Marcia Rasner, they are transformative—or at least they feel like it. In "Totem and Tattoo," I discuss the risks of mistaking control over one's body art for control over one's body, a concern that's perfectly distilled in a recent ad for The Pro-Choice Public Education Project. Countering the assumption that body modification serves as a kind of armor against external threats to the self, the ad shows a pierced and tattooed twenty-something slapped with the words, "Think you can do whatever you want with your body? Think again." Body art, it implies, may symbolize self-empowerment, but unless your political involvement matches your body consciousness, you'll be thoroughly disempowered when, say, George W. stacks the Supreme Court with pro-lifers.

Tattoos, of course, are not innately positive, and it would be silly to suggest that wearing them makes women de facto feminists. As an extrovert's art form, however, tattooing appeals to the iconoclast in many women. It's no coincidence that women's initial interest in tattoo art came in the wake of feminism's first wave in the late 19th century, that a second craze crested in the suffragist '20s, and that women tattooists broke the gender barrier in the feminist '70s—all periods when women's public profile was ebbing. How strange to consider that P.T. Barnum, circus and freak show impresario, also hatched the idea for the first beauty pageant, and that one daring woman, Betty Broadbent, dauntlessly fused the two forms of spectacle in 1939 by appearing, heavily tattooed, in the first televised beauty contest. Though she didn't stand a chance of winning, she didn't believe her full body suit diminished her starlet good looks for a minute, and displayed it proudly. As scholar Christine Braunberger notes in "Revolting Bodies: The Monster Beauty of Tattooed Women," Broadbent was the ultimate subversive: she accepted the appraising eye of the contest judges while she challenged it.

Examined against the shifting social backdrop of Western culture in the last two centuries, tattoos serve as touchstones for women's changing roles and evolving concerns during the most progressive era in women's history, and as passkeys to the psyches of women who are rewriting accepted notions of feminine beauty and self-expression. Bodies of Subversion is a journey through the art, history, and folkways of these renegades of the flesh.

An ad for the Pro-Choice Public Education Project challenges the idea that body art is synonymous with self determination.
(Photo courtesy: Planned Parenthood)

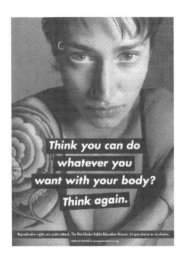

vi

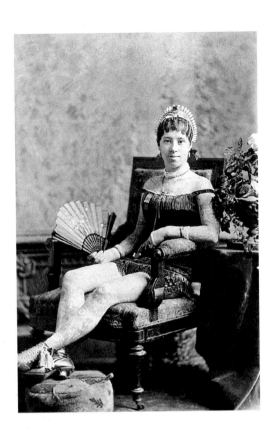

Circus Ladies and Society Women

The mother of all tattooed circus women, 22-year-old Nora Hildebrandt arrived at Bunnell's Museum in New York in March of 1882 boasting 365 designs and claiming to have been forcibly tattooed by her father after being captured by "red skin devils" in the Wild West. Hildebrandt was indeed tattooed by her father, but not, as she alleged, under threat of death from Sitting Bull. A German immigrant who opened the first professional street shop in New York in the 1840s, Martin Hildebrandt tattooed sailors, circus people, and—during the Civil War—both Yankee and Confederate soldiers.

Displaying mostly ornamental birds and flowers, Hildebrandt beat her closest competition, Irene Woodward, the self-proclaimed "only tattooed lady" to the stage by mere weeks, but Woodward enjoyed a longer, more celebrated career. Woodward's debut made *The New York Times*, where her first public sitting was described in loving and surprisingly open-minded detail, from her "pleasing appearance" to her "artistic" (and remarkably narrative) tattoos, which included a hive of worker bees, a sailor leaving home, a floral necklace that disappeared into her cleavage, the goddesses

10

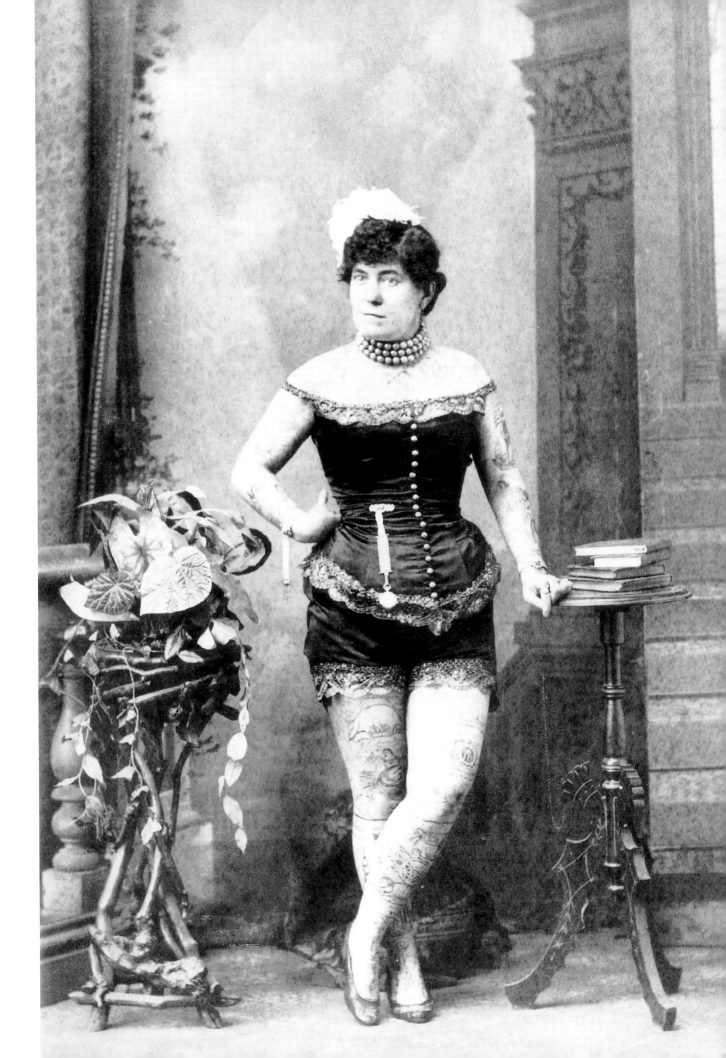

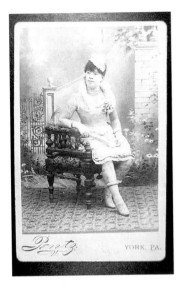

Above
La Belle Irene, circus attraction.
Date unknown.
(Tattoo Archive, Berkeley, Ca.)

Opposite
La Belle Irene, "Genuine Tattooed
Woman" (French circus poster).
Date unknown.
(Tattoo Archive, Berkeley, Ca.)

of Hope and Liberty, and the watchwords "Never despair," "Nothing without labor," and "I live and die for those I love." The *Times* reported,

> During a reception of three hours at The Sinclair House yesterday afternoon she was attired in a scant costume of black velvet and gold. A close-fitting bodice or jacket, trimmed with gold bullion and fringe, surmounted a pair of trunks whose long golden fringe stopped an inch or more above the knee....The visitors were permitted to look upon the quaintly decorated skin of the upper portions of the chest and back, the arms and the exposed portions of the lower limbs. Miss Woodward remarked that she felt a little bashful about being looked at that way, never having worn the costume in the presence of men before.

The day after her Sinclair House appearance, 19-year-old Woodward began working at Bunnell's Museum and quickly became an international sensation: she was paraded before European royalty and studied by curious scientists. By the time she died in 1915, there were allegedly 38 wax figures of her in European museums.

History offers only sketchy first-hand accounts of what prompted women to become tattooed attractions more than half a century after tattooed sailors first presented themselves as sidewalk oddities in port cities. Woodward told the *Times* she'd decided to exhibit herself after seeing Constantine, the famous Greek tattooed man who P.T. Barnum had begun touring in the early 1870s. More likely, news of Constantine's $1,000 a week salary inspired her—and other like-minded would-be exhibitionists—to go under the needle. As the popularity of freak shows grew throughout the century, a combination of economic need and the growing post-war influx of women into jobs outside the home emboldened them to pursue this tantalizingly lucrative livelihood.

Nonetheless, the circumstances of Woodward and Hildebrandt's unveiling was radical, considering that nearly 30 years earlier, Amelia Bloomer and other prominent first wave feminists had abandoned their effort to promote bloomers (named after Amelia herself) as part of their dress reform campaign, having churned up so much negativity that they feared it

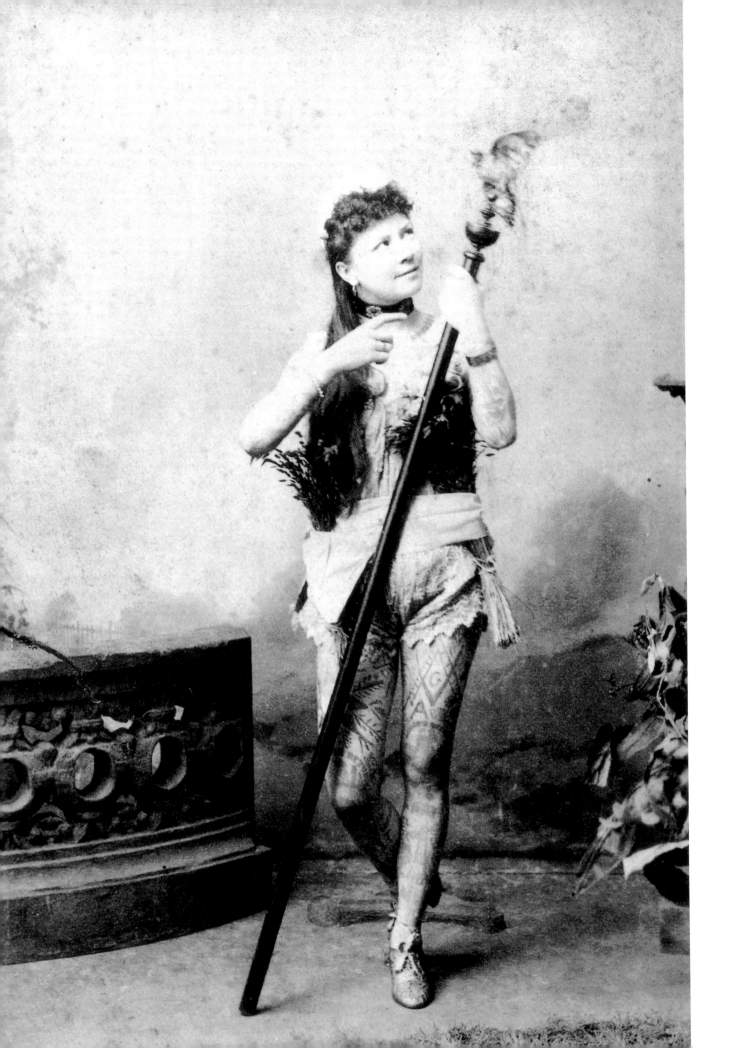

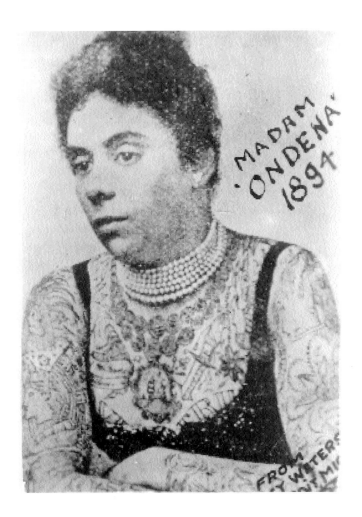

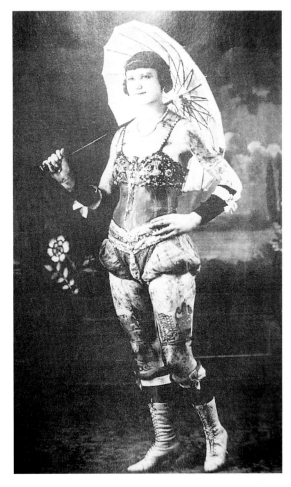

would detract from more important causes, like voting. The issue resurfaced in 1870, when two sisters who ran their own brokerage firm, Victoria Woodhull and Tennessee Claflin, launched *Woodhull and Claflin's Weekly*, a feminist paper in which short skirts were championed along with suffrage, free love, and legalized prostitution.

Tattooed women leapfrogged beyond bloomers and short skirts to unheard of thigh-hugging trunks, donned not for freedom of movement, like pants, but for public display. Lest Woodward's exposed skin give anyone the wrong idea, the autobiographical pamphlet she distributed at shows assured audiences, "The lady...is not offensive to anyone, no matter how sensitive they may be. Her tattooing is of itself a beautiful dress."

Above, left
Madam Ondena, circus attraction, 1894.
(Photo courtesy Chris Pfouts)

Right
Trixie, circus attraction. Date unknown.
(Tattoo Archive, Berkeley, Ca.)

Opposite
Miss Lulu, circus attraction.
Date unknown. (The Ron Becker
Collection, Syracuse University Library,
Department of Special Collections)

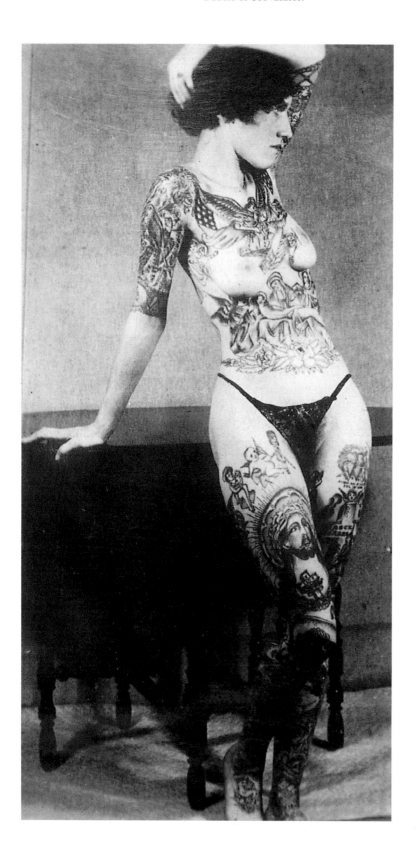

Left

Jean Furella Carson, circus attraction, date unknown.

Furella began her career as a bearded lady, but her livelihood came between her and her husband-to-be, carny John Carson. "I loved her all right...but I couldn't kiss her," said Carson, who fell for Furella when she was 14 and married her 18 years later. "It always seemed to me it would be like kissing my uncle."

When a friend suggested Furella remove the beard and become a tattooed lady, she did, smoothing the way for her happy marriage and her career as a "Tattoo Queen" at Chicago's Riverview Park, which lasted until the mid-1960s. "I was one of the few real, honest-to-goodness bearded ladies in the business," she said. "Most of the bearded ladies you see around are fakers." (Tattoo Archive, Berkeley, Ca.)

Opposite

Jean Furella, 1967
Tattoo by Debbie Lenz
(Photo by Kent Noble)

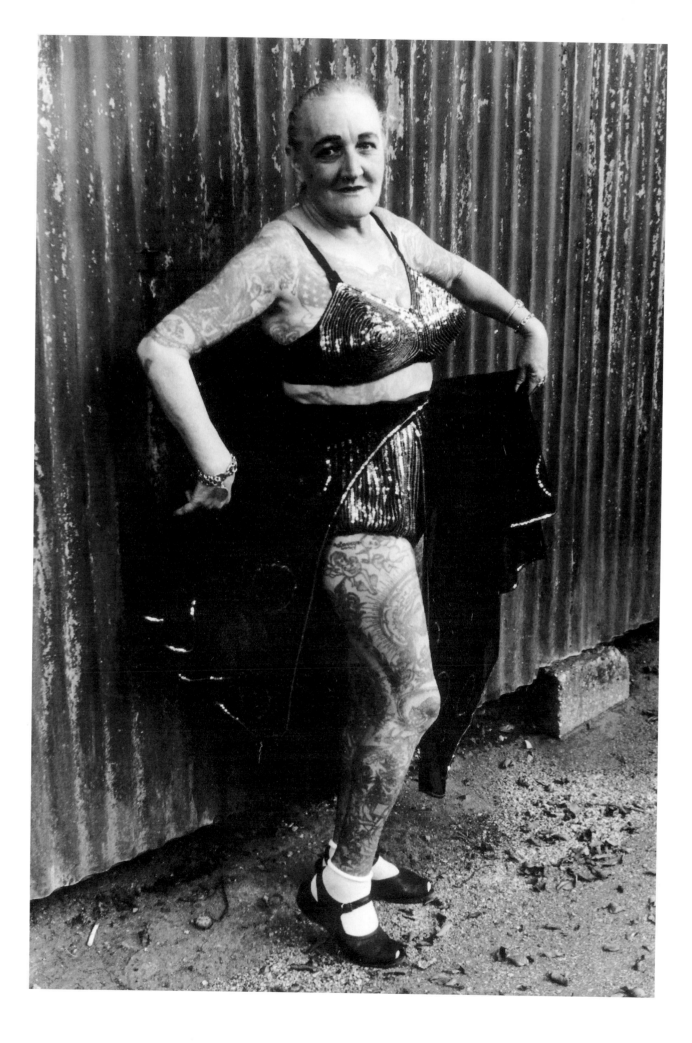

Woodward and Hildebrandt led a brigade of women who, over the next two decades, would both integrate the tattoo tent and edge men out of the limelight with their more titillating enticements: forced to bare a scandalous amount of flesh in order to show their work, women provided a sensational double whammy onstage—a peep show within a freak show. They trailed the Big Top in the summer, and in winter worked in dime museums like Bunnell's—multi-attraction curio halls that showcased magicians, musicians, lecturers, relics, dioramas, and freaks. It's unlikely that female attractions ever matched Constantine's salary, but working at a reported $100 a week, Hildebrandt made more than the average stage actor of her day.

Unlike most of their successors, Woodward and Hildebrandt were decorated with ink-dipped needles that were "hand-poked" into the skin—a method as old as tattooing itself. In the 1770s, Captain Cook had discovered tattooing on his travels in the South Pacific and reintroduced it to Europe, precipitating the first tattoo fad in Western history. In 1891, with the invention of the electric tattoo machine—a sort of mechanized quill pen whose sharp tip injected ink into the skin—tattooing became less painful and more commercially accessible, drawing not only circus wannabes to parlors, but also society women, who collected tattoos as custom couture.

Opposite
"Tattooed Wonder," Circus poster by
J. Sigler, circa 1950-1960.
(Collection of Cheri Eisenberg,
Photo Courtesy Carl Hammer Gallery)

Heavily illustrated circus performers often embroidered their acts with stories of forced tattooing. In the fabricated memoir she sold at shows, Hildebrandt described the day she and her widowed father, whom she said had learned tattooing as a sailor, were kidnapped by Sitting Bull and his tribe, who promised to spare them if Hildebrandt senior tattooed his tribe. But complications arose, wrote Hildebrandt, when,

> One of Sitting Bull's warriors accused him of trying to poison them, and the chief told the prisoner if he would tattoo his daughter he would give him his liberty—that he must tattoo her from her toes to her head.... She was tied to a tree and the painful operation commenced. He was compelled to work six hours a day for one year before she was rescued, accomplishing three hundred and sixty five designs.

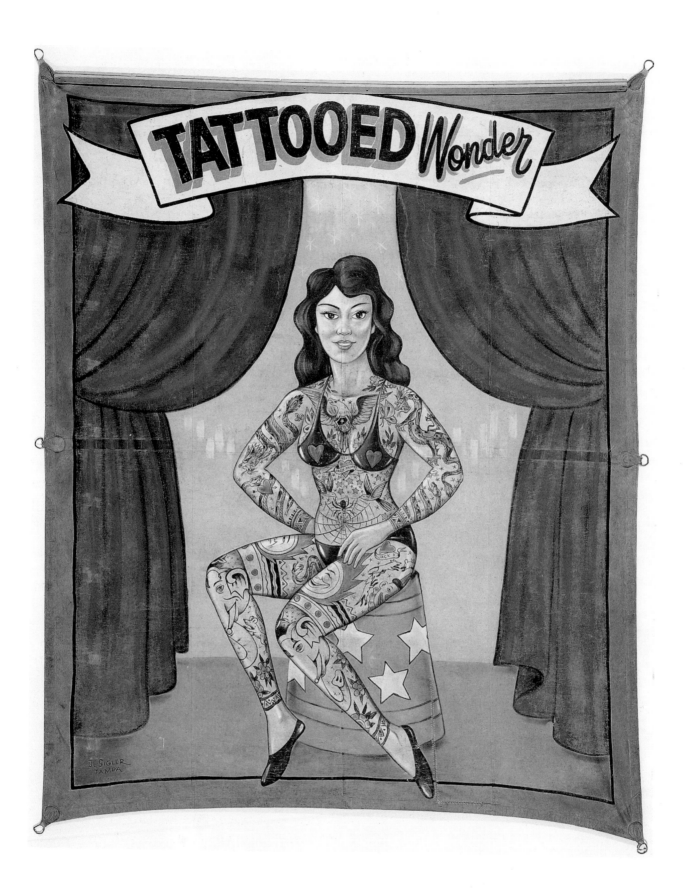

Woodward told her first audience that her father had begun tattooing her when she was six, in order not to lose her. In fact, she was tattooed by Samuel O'Reilly, the inventor of the electric machine, and his apprentice, Charlie Wagner, who would later become a celebrity in the trade, leaving his mark on hundreds of circus performers.

It's tempting to interpret the fables with which circus women embellished their histories as bids for sympathy used to soften the stigma of their dishonorable profession, but the ploy was an old one conceived to sensationalize attractions, not excuse them. In 1828, the English sailor John Rutherford, the first Western tattooed man to cash in on his acquired condition, said he had been captured and tattooed by New Zealand Maoris, adopted by the tribe and married into the family of the ruling chief. By the 1840s, when commercial freak shows began to thrive, tattooed men were regularly introduced with farfetched fictions, usually conceived by a promoter and sometimes printed up and sold after the show.

Opposite
Annie and Frank Howard
(lower left), circus poster, 1891.
(Tattoo Archive, Berkeley, Ca.)

Kidnappings constituted the most common tattoo fables, with South Sea savages and Wild West Indians cast as the abductors. A century earlier, real-life stories of kidnappings by Indians had sparked an explosion of memoirs by Puritans; reviving a proven formula, carnies cashed in on the device. The brother-sister team Annie and Frank Howard, a celebrated Barnum and Bailey act of the 1880s, claimed to have been forcibly tattooed by natives after a shipwreck in the South Pacific. Frank was tattooed by Martin Hildebrandt among others, and Annie got her work from both O'Reilly and her brother.

Woodward's fake biography was unique in that she alone professed to have enjoyed being tattooed. Her story explains, "At first the father implanted a few stars in the child's fair skin. Then a picture was indelibly portrayed by the father's hand. In spite of the pain the girl was delighted, and coaxed her father to continue."

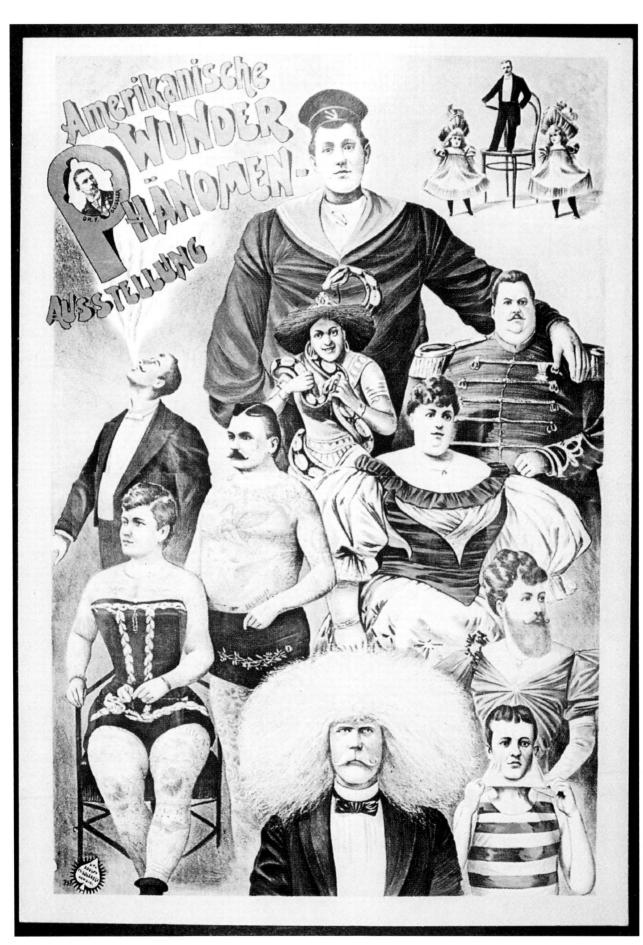

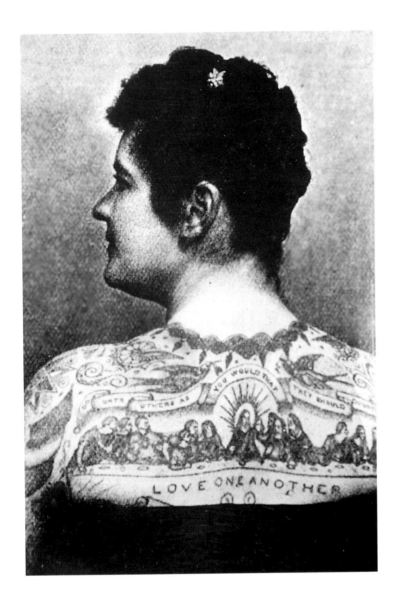

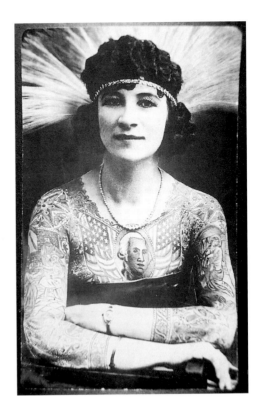

Above, left
Emma deBurgh, circus attraction.
Date unknown.
(Tattoo Archive, Berkeley, Ca.)

Right
Artoria (Anna Gibbons), circus attrac-
tion, 1920s. Her porcelain skin and
vivid tattoos, which she kept
well-protected from the sun, awed
admirers well into the 1980s.

Emma de Burgh, a giant of the genre in more ways than one, was also tat-
tooed by O'Reilly, who transformed her into a poster girl for patriotic and
religious rectitude. With an American Eagle on one knee, the Union Jack
on the other, and Da Vinci's "Last Supper" on her back, de Burgh joined
her tattooed husband, Frank, on a successful tour of Europe in 1893.
Unfortunately, her waistline expanded with her profits, sinking her career
and setting her tattoos adrift. Seven years after she entered the circus, the
pre-Raphaelite painter Sir Edward Burne-Jones, a long-time fan, observed,
"she had grown very stout...and when I looked at the Last Supper all the
apostles wore broad grins."

22

Religious and patriotic themes were common for tattooed circus attractions of both sexes, who tried to legitimize their careers with respectable iconography. In the '20s, a 14-year-old Wisconsin farm girl named Anna Gibbons went under the needle in the name of religious fervor, taking the nom de guerre "Artoria." A devout Baptist, she sported a baby Jesus, a Madonna, Botticelli's "Annunciation," and Michelangelo's "Holy Family," all created by her husband, Charles "Red" Gibbons, a tattooist she met at a carnival that visited her town and took her with it. Artoria wore her patriotism not on her sleeve, but between her breasts, where a portrait of George Washington nestled.

Exotic stage names heightened the mystique of decorated ladies; there was Artfullete, Serpentina (reputed to be a fake who posed in body paint), Lady Viola (who wore the visages of six presidents, Babe Ruth, and Charlie Chaplin), Princess Beatrice and Pictura (the chosen pseudonym of multiple attractions). Because few of these women selected their own imagery, they were a tattooist's dream come true: blank canvases on which the grandest epidermal excursions could be staged. Onstage, they took questions after a "talker" lectured audiences about the content and origins of their imagery; offstage, they covered themselves both to protect their work from the sun's damaging rays and to ensure that only paying customers took in the show. Most sold small photos of themselves called "cartes de visite" or larger, hard stock "cabinet photographs" after performing.

Below

Serpentina, circus attraction reputed to be a fake who wore body paint. Date unknown. (Photo courtesy Chris Pfouts)

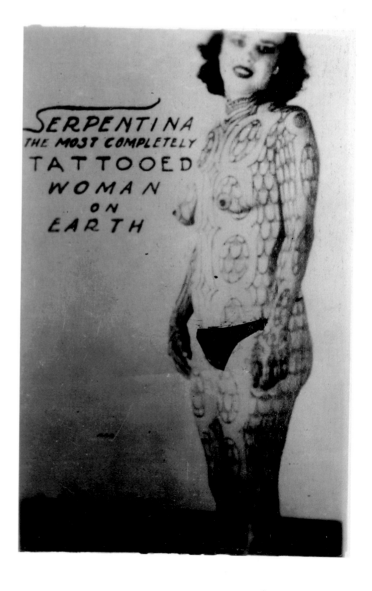

23

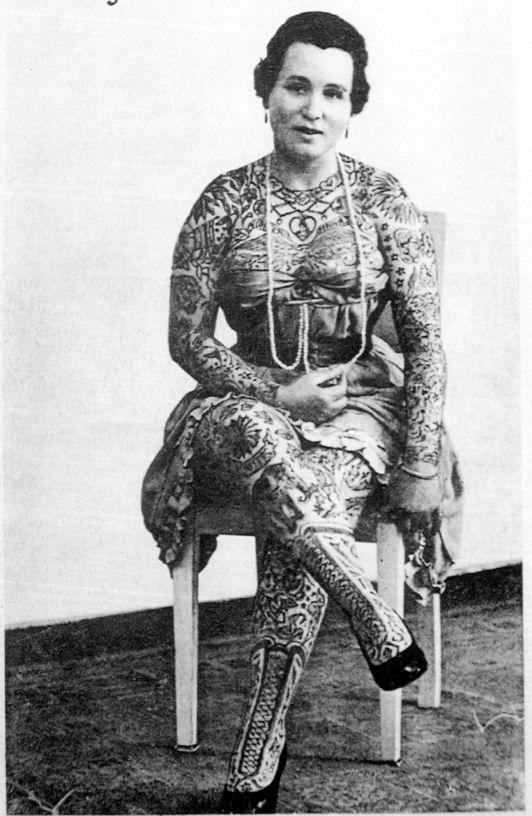

La bella Angora
die Königin der Tätowierten

At the turn of the century, competition among tattooed circus people was so fierce that tall tales grew, performances became more gimmicky, and handbills promised the impossible. Tattooed lady La Bella Angora had boot laces inked onto her ankles—a typically European flourish—as an added novelty. Sideshow *frau* Annette Nerona, who wore an assembly of German statesman, artists and intellectuals including Bismarck, Wagner, and Goethe, also performed as a snake charmer and magician. A poster for a European attraction called Dyita Salome read, "Salome...the one and only oriental beauty tattooed in 14 colours. Salome's body represents a value of 30,000 Marks...Salome will pay a reward of 10,000 Marks to that person who has already seen such gorgeous colors on a body before!"

By the early 20th century a few women—mostly the wives of tattooists—were learning to tattoo. In this intensely competitive profession, wives could be trusted to boost business without opening competing shops, and in seaport cities they attracted sailors on leave who hadn't seen, much less been touched by, a woman in months. Some women colored in their husband's outlines while others worked straight from "flash," the sample sheets from which clients selected stock designs. The idea was to process as many customers as fast as possible on pay day, when business boomed.

Maud Stevens Wagner, a contortionist and aerialist, met her husband, Gus, at the 1904 St. Louis World's Fair, and agreed to date him provided he both tattoo and apprentice her. A former seaman, Gus had learned the trade from the

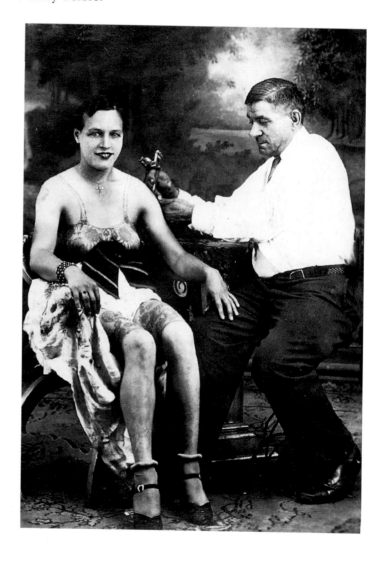

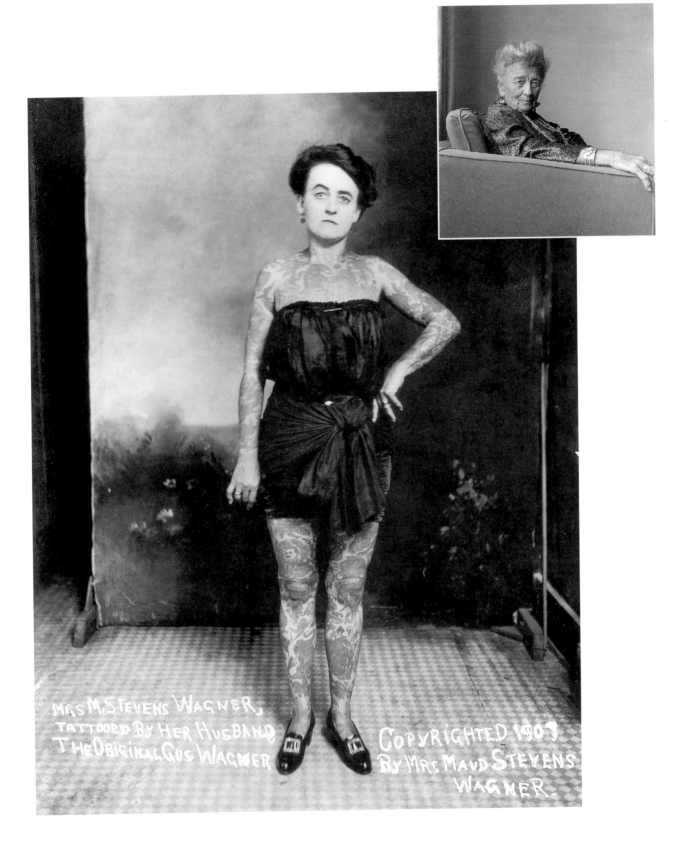

MRS. M. STEVENS WAGNER,
TATTOOED BY HER HUSBAND,
THE ORIGINAL GUS WAGNER

COPYRIGHTED 1907
BY MRS. MAUD STEVENS
WAGNER.

English artist Albert South, who was said to have inked Queen Victoria with a Bengal tiger fighting a python. In 1907—ironically, the same year that an organization called The American Society for Keeping Woman in Her Proper Sphere was formed—Maud, now generously tattooed, took up what would become a family tradition: hand-poking. Although her practice was largely avocational, Maud Wagner is the first-known American woman tattooist.

Three years after her tattoo initiation, Maud had a daughter, Lotteva, who grew up on the road and was tattooing by the age of nine. Acting as both teacher and guinea pig, her father taught her to use British sewing needles tied to the end of notched chopsticks secured with silk thread for hand-poking. But Gus never left his mark on Lotteva, making her a rarity in tattoo history: an artist whose own canvas was bare.

"Mama wouldn't let Papa tattoo me," she told *The Dallas Morning News* in 1993. "I never understood why. She relented after he died and said I could get tattoos then, but I said that if Papa couldn't do them like he had done hers, then nobody would."

Although she experimented with a machine over a two-year period, Lotteva couldn't get the control she wanted from it, and used the old-fashioned method for the remainder of her life. She also worked as a sign and circus banner painter (a common sideline for tattooists), restored carousel horses, raised exotic animals, and had a brief career as a circus clown. Shortly before her death in 1993, 83-year-old Lotteva hand-poked what was probably her last tattoo—a rose—on tattooist Don Ed Hardy.

By 1920, hundreds of fully tattooed people were said to be traveling in circuses and sideshows across America, making illustrated people common curiosities. Because they afforded less sensationalism than women from the start, tattooed men were forced to combine talents, moonlighting as knife throwers and sword swallowers or working as "human picture galleries," as they were called, who also wielded a needle. Women, however, were still

Opposite
Maud Stevens Wagner, San Antonio, 1907. The first known Western woman tattooist, she agreed to date her future husband, Gus Wagner, on the condition that he teach her to tattoo.
(Courtesy Alan Govenar, *American Tattoo*, Chronicle Books 1996)

Inset
Lotteva Wagner, San Antonio. She learned to tattoo from her father at age nine and worked by hand until her death in 1993.
(Photo by Dianne Mansfield)

Bobbie Libarry, circus attraction,
illusionist, carny barker, and tattooist.
Date unknown.
(Tattoo Archive, Berkeley, Ca.)

rushing out for tattoos, sometimes, as in the case of Bobbie Marshall Libarry, landing a job even before their work was finished.

Libarry was tattooed by a man who would much later become her husband, "Long Andy" Libarry, during a three-week period in 1918. Immortalized in a portrait by Imogen Cunningham, she was a circus factotum who worked as an illusionist and carny barker as well as an attraction. She ran her own sideshow, "The World's Strangest People," in the '30s, and learned to tattoo, opening her own shop on San Francisco's Market Street in 1939. She got tattooed, she told *Ms.* magazine in 1971, because, "I knew a living when I saw one." Her needlework included likenesses of friends and movie stars, roses and spider webs, and a practical detail folded into the imagery on her leg: her social security number.

Tattooed women provided free advertising for their husband's work, both on and off the carnival midway. Thinking (mistakenly) her childbearing days were over, Edith Burchett, the wife of the famous English shop tattooist George Burchett, agreed to allow her husband to tattoo her in 1913, after the birth of four of their six children. Her collection featured serpents, a geisha, an Indian, a crucifixion scene, a Red Dragon, copies of Old Master paintings, and (added during World War I) a set of Allied flags displayed proudly on her breast.

"I have covered nearly every inch of her body," Burchett wrote in his memoirs. "And I think I made a beautiful job of it." Indeed, Edith's body suit was much better choreographed and integrated than most of the ad hoc work that was typical of the day. Burchett's only regret was that his wife, whose tattoos stopped at the wrist and neck, covered herself in later years, effectively pulling down the curtain on his masterpiece.

While many early tattooed circus women were pushed into sideshow acts by business-conscious husbands, some saw an opportunity for adventure and self-sufficiency in carnival life, and came to it independently. Betty Broadbent, one of the century's most photographed, best loved tattooed

women, was 17 when she quit a babysitting job in Atlantic City to join the circus in 1927.

"She wanted to be her own woman—she never wanted to be dependent on anyone for anything," says Charles Roark, a ventriloquist who was one of Broadbent's many husbands. Betty started out working as a Spidora—an illusionist whose head is projected, through mirrors, onto a stuffed spider's body to create the effect of a human-headed spider. "She told me she was just a kid, and it didn't pay much money, and some old carny told her if she'd get tattooed she'd make a lot of money so she went to New York and Charlie Wagner [and Joe Van Hart] tattooed her."

A Ringling Brothers and Barnum and Bailey act, Broadbent was billed as "the youngest tattooed woman in the world," and enjoyed a 40-year career during which she traveled with every major American circus, as well as independent shows in Australia and New Zealand. She wore Pancho Villa on her left leg, Charles Lindbergh on her right, and a Madonna and Child on her back. A soft-spoken brunette with a dimpled smile who projected a girlish charm well into her retirement, Broadbent described her first job, for Ringling Brothers and Barnum and Bailey, in a 1982 interview with *The Tattoo Historian*:

> In the summer I wore a floor-length satin robe and in the winter a
> velvet one. The platform lecturer would announce, "And now, ladies
> and gentlemen, the lady who's different!" Up till then, nobody had
> the slightest idea what was different about me. I'd unzip my robe
> and I'd be wearing a costume underneath, sort of a long bathing suit
> that came four inches above my knees.

Opposite
Circus attraction Betty Broadbent
in the first televised beauty contest,
at the 1939 World's Fair.
(Collection of the *New York Daily News*)

Broadbent distinguished herself from what she called "those carnival floozies with one or two tattoos who would bump and grind," and took her wholesome looks to the 1939 World's Fair to compete in the first televised beauty contest. She knew that as a tattooed contestant she didn't stand a chance of winning, but gladly reaped the free publicity.

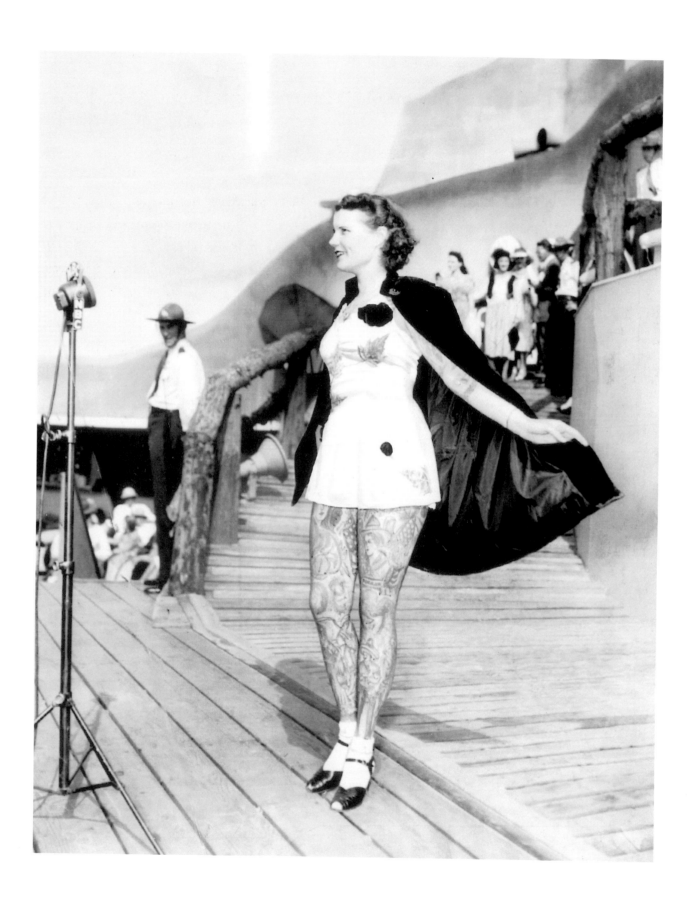

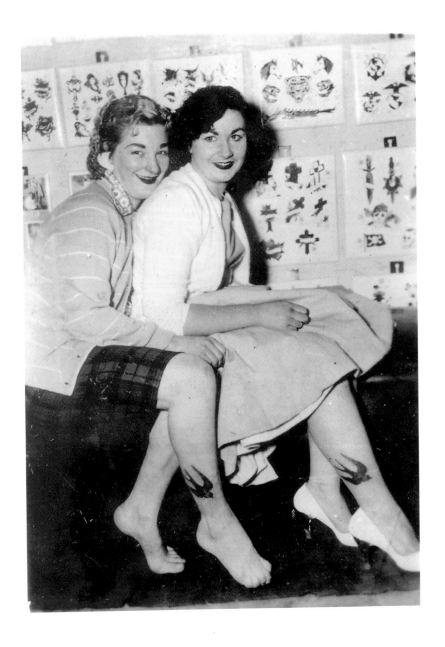

Tattooed circus ladies may have sacrificed social respectability for their vocation, but they were rewarded with travel, money, and public recognition, as well as an active social circle that, for those who were disowned by disapproving relatives, functioned as family. Artoria continued to perform in her 70s, even after she began receiving healthy royalties from her husband's oil investments. Now retired in Louisiana, Lorette Fulkerson was tattooed in the '50s by Tats Thomas in Chicago, having joined the circus when she was 16. "I've had a ball," she says. "I worked until 1992, so evidently I liked it. I still correspond with a lot of people [who were fans]." A year before her death in 1983, Broadbent waxed nostalgic in *The Tattoo Historian*, saying, "Boy, do I miss the people and the travel."

Women showing love bird tattoos, date unknown. (Photo courtesy Chris Pfouts)

While circus women approached tattooing as a business investment, society women indulged a recreational taste for it. As early as 1880, *The New York Times* coyly speculated that "at least 7.5% of fashionable London ladies" were "tattooed in inaccessible localities," that is to say, on their upper arms, legs, and shoulders. Six years later, a London tattooist boasted of having tattooed 900 women with imagery ranging from portraits of

husbands and lovers to automobiles. Tattooing became voguish among Europe's upper classes; newspapers even described tattoos worn by German, Danish, English and Greek royalty, and Winston Churchill's mother wore a symbol of eternity—a snake eating its own tail—on her wrist. Like other wealthy Londoners, she was also tattooed with patriotic imagery in honor of the 1901 coronation of King Edward VII, whose reign ushered in a period of opulence that signaled the end of Victorian conservatism, and for women, the elimination of a ban against facial makeup.

In the Gay Nineties, the flamboyant railroad heiress Aimee Crocker, known as "the Queen of Bohemia," caused a sensation by appearing at New York and Paris society functions with a red and blue tattooed wristlet. Described in a 1921 *Daily News* article as a "globe-trotter, cosmopolitan, priestess of occult faith, woman of a thousand fads and fancies" and "the most daringly unconventional woman of her time," Crocker, like the circus women of her day, had a story to go with her tattoo. After her first of five marriages, according to the *News*, she traveled to India and fell in love with a 20-year-old guide:

> She followed the uncharted trails with her young savage. They lived in the open, with the untamed of the animal kingdom...In their resting moments, under the trees, her Indian companion began decorating the beautiful texture of her perfect skin with the indelible tattoo of his people.

Middle and upper class women's first sustained flirtation with tattoo peaked in the suffragist '20s, just as a second women's tattoo wave coincided with the women's movement of the '70s. During both decades, women challenged their identification with nature, which had long been used to justify their marginalization within public and cultural life: throughout Western history, women's maternal and domestic responsibilities had confined them to the physical and emotional sphere. Seen to embody nature's hidden cyclical and spiritual forces, they existed in counterpoint to rational, scientific Man.

But women's "nature" was as much socially imposed as it was biologically based, and, as repressive fashions from the hoop skirt to the corset confirm, it was men who dreamed up and enforced its definition. In the '20s, women were liberated from the corset, which had at once denied and underscored their sexuality: exaggerating feminine curves while it limited mobility, it also inhibited breathing and curbed the appetite, making for provocative heaving breasts and dramatic fainting spells. This simultaneous enhancement and repression of femininity sent a mixed message about womanhood. As Stewart and Elizabeth Ewen observe in *Channels of Desire*:

> The enfeeblement of women was a crucial aspect of nineteenth-century middle class fashion...As the predominant ideology denied women any pleasures of the flesh, it simultaneously fixated on female flesh, molding and restricting it. On the one hand, women were the embodiment of spiritual purity, on the other, purity was not intrinsic and had to be imposed.

Tattooing was a dramatic inversion of such 19th century presumptions. It not only called attention to the flesh, which had become increasingly exposed through rising hemlines, plunging necklines, and sleeveless dresses of the era, but also flouted conventions of feminine conformity and understatement at a time when women were becoming more outspoken and enjoying greater cultural visibility: they were going to college and joining the rising industrial work force; they had earned the vote and were even entering public office. As a statement of their tastes and individuality, tattooing was a bold intrusion into the masculine realm.

In 1923, the oldest extant tattoo was exhumed in a tomb near Luxor, dating from around 2000 BC (The 1991 discovery of a tattooed hunter in the Italian Alps pushed tattoo's origins back yet another 3,000 years). A series of discreet dots and dashes were found on the shoulder, neck, breast and abdomen of this priestess, named Amunet, whose tattoos were thought to have medicinal or fertility powers. "No sooner was the story [of her discovery] printed," Burchett wrote in his memoirs, "than I was besieged by ladies of all ages with orders for a 'dainty tattoo like the Egyptian princess's.'" Flowers, birds, butterflies, and scarabs began to appear on

women's wrists, breasts and shoulders. Burchett also tattooed the names of husbands and lovers on society women's toes. "The fee was never less than three guineas," he wrote. "It was the best business I ever did."

Burchett enjoyed a 15-year run on tattooed women and traced its decline to the outbreak of war in 1938, when wealthy Londoners fled the city. Across the Atlantic in the same year, a newspaper article sneeringly catalogued 50 prominent tattooed Americans—and many of their tattoos—taking this upper crust diversion down a notch. Soon, society people's tattoos were being airbrushed out of beachfront photos in glossy magazines, sleeves came down and thick bracelets were worn to conceal women's wrist pieces, since the fad had peaked. That year, Burchett savored a last blast of publicity with a television appearance in which he tattooed a butterfly on his daughter's shoulder. Then he switched to sensible work for frugal times: cosmetic tattooing—a lucrative practice in which he created permanent blush, beauty marks, and eyeliner.

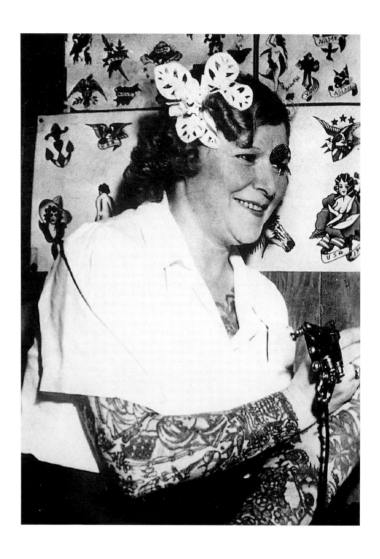

Mildred Hull, who billed herself as "the only lady tattooist" on New York's Bowery from the '20s to the '40s. Date unknown. (Tattoo Archive, Berkeley, Ca.)

Unlike women who worked in their husbands' parlors, the rare maverick who set up her own shop was anathema to her male competitors. In the '20s, the legendary New York tattooist Mildred Hull billed herself as "the only lady tattooist" and was as respected for her work as she was ridiculed for her success during her 25-year career.

"You know how men are in any business," she told *Foto* magazine. "Always sort of jealous if a woman does as well as they do. Some of the men tattooists along the Bowery are now cutting prices trying to put me out of business. But I have plenty of customers just the same—14 or 15 a day. I think men rather like having a woman tattoo them. They think a woman is likely to be more careful."

A former embroiderer whose proficiency at old-fashioned needlework translated successfully to new-fangled skin art, Hull said she got "plenty" of women customers, many of whom requested hearts containing a lover's name, and—surprisingly—tattoos of the word "mother." In a neat reversal of the traditional tattooed wife who wears her spouse's work, Hull's husband, a former circus attraction named Thomas Lee, sported her handiwork. Hull called him "the most tattooed man in the universe...over 400 holy pictures, and many by me." Her own tattoos were most likely done by her mentor, Charlie Wagner.

Hull and Lee, who also tattooed, worked in a booth in the back of a barber shop at #16 Bowery, where 25 cents bought a cut and a shave, a shower, or a small tattoo. Crusty with character and crowded with photographs of satisfied customers, the shop served, decades later, as a model for a Universal Studios 1920s street scene, mounted with a sign that read "Millie's Tattoo...Electric Tattoos at Low Prices...Expert Artiste."

The Chatham Square neighborhood where Hull worked was one of the roughest in New York, and her success there derived as much from her street smarts as her talent. Remaining a lady in the tattoo business, said Hull, was "strictly a man's job." She loathed the drunks who staggered through her door angling for a fight, and boasted of having done "fistic combat" with more than 100 men, painting "pretty pictures on glass chins."

But despite her success at the gritty epi-center of the New York tattoo world, Hull poisoned herself in a local tavern in 1947. According to artist Stoney St. Clair, she had fallen hopelessly in love with "a no good son of a gun" who happened to be one of Wagner's clients.

Like Hull, Nell Bowen was remarkable as a woman who held her own in this macho profession, the difference being that she not only made a name for herself, but also acquired a near monopoly on tattooing in San Diego during and after the Second World War.

Known as "Painless Nell," she ran assembly-line operations in which she and her co-ed staff worked from flash, cranking out designs on one sailor after another. Nell owned as many as five shops at once during a time when, according to tat-tooist Zeke Owen, her direct competitor in the late '50s, there were less than 200 full-time tattoo artists in the country.

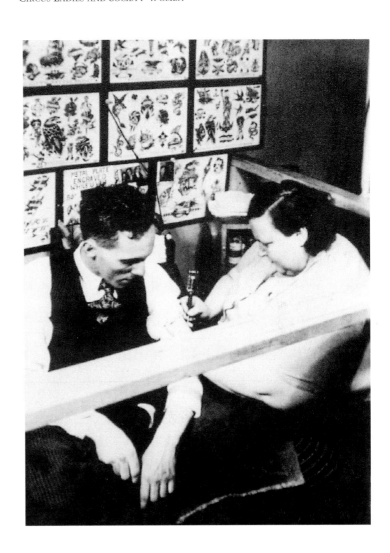

Dainty Dottie, circus fat lady turned tattooist. Date unknown. (Tattoo Archive, Berkeley, Ca.)

Although the details of Nell's early life have slipped through the fingers of history, she probably learned to tattoo in the circus. She married a for-mer carnival owner, Hugh Bowen, and worked with her twin sister, "Painful Jo." Her work is remembered as crude and heavy, her shops were low maintenance "sponge and bucket" operations, as tattooist Chuck Eldridge recalls, and her personality was reputedly as lukewarm as the dirty water in her washbuckets. She was one artist who didn't uphold any stereotypes about women tattooists' sensitive touch.

But for the time, says Owen, "her work was on par or above par with most of the street work being done in those days. The sailors loved her." A classic Old Timer, Nell died in the early '70s, on the cusp of a creative explosion that was about to hit California. With the traditionalist Doc Webb, says Owen, she represented "the very last era of the old days of tattooing."

Not every woman artist made a splash when she took the dive into tattooing: Texan Edna Sanchez debuted with a belly flop. In a 1991 issue of Don Ed Hardy's magazine, *Tattootime*, tattooist Bob Shaw remembered working in San Antonio in the late '40s, when Sanchez, the "Queen of the South," was taking photographs in the "mug joint" she shared with a now forgotten tattooist. After her partner died, Sanchez had trouble finding a replacement, so she loaded up the machine and took matters into her own inexperienced hands. When a G.I. wandered in and asked her to remove a tattoo, she obliged, and through a combination of deadly acid and tragic ignorance, relieved him not only of the image, but also a sizable hunk of flesh.

"He never got any farther than walking from the bus to the gate and passed out," recalled Shaw. "The acid had burnt through half an inch of tissue on his chest. 'Course they got to looking for her and she left and went to Oklahoma City, which she eventually helped to close up." It was unsanitary "scratchers" like Sanchez who helped get tattooing outlawed in some cities during the postwar years.

While undergoing a demographic downshift after the war, tattooing suffered from a burgeoning perception problem: during the Depression, hordes of people had gone under the needle in hopes of finding work as sideshow exhibits, driving the medium deep into the shadows of disrepute. Its lowbrow associations were cemented in the '50s and '60s, when it was banned in some states after outbreaks of hepatitis were linked to dirty tattoo needles. Now officially an outlaw art form, it was adopted by male bikers, gangs, and prisoners as an emblem of their renegade status.

The stigma of the marked woman, which only the rich had ever truly surmounted, became so extreme at this time that a guilty verdict against a Boston rapist was overturned after a small butterfly was discovered on the leg of the victim.

Meanwhile, venues and audiences for "human picture galleries" were disappearing. During the '50s, when movies and television captured people's attention, providing inexpensive home entertainment, circuses became almost obsolete. In 1956, the Greatest Show on Earth nearly went bust, forcing Ringling Brothers to downsize by folding its tents for good and moving to indoor coliseums. Tattooed women faded from the public eye, and women were seen more often as the subjects than the bearers of tattoos. In the late '50s, tattoo art's masculine associations were bolstered when the Philip Morris Company gave Marlboro cigarettes—until then promoted as a women's brand—a testosterone injection through a new ad campaign that featured brawny men, some of whom wore painted-on military tattoos.

"Tex," a Texan and proud of it, date unkown. (Photo courtesy Chris Pfouts)

Nonetheless, a subculture of tattooed women continued to flourish, and an enterprising photo dealer named Bernard Kobel preserved it for posterity through his vast collection, which chronicled women artists, circus veterans and casual enthusiasts. Kobel told author Bill Carmichael that when he started collecting he knew there were hundreds of "professional tattooed ladies," but was amazed to discover so many leisure devotees; more

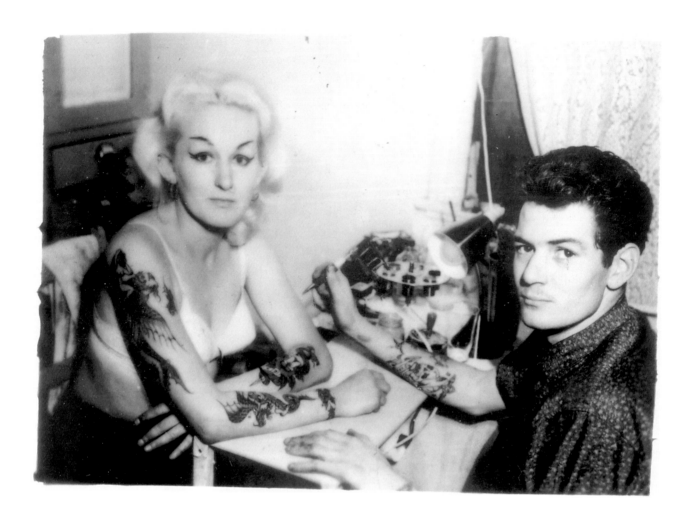

Circus attraction and tattooist
Cindy Ray with her husband-to-be,
Danny Robinson, 1961. (Photo
courtesy Chris Pfouts)

rapher named Harry Bartram, who persuaded this 19-year-old office clerk to get tattooed over a six month period in 1961 and go on the road. Ray got her work from the man she would marry, Danny Robinson, who was assisted by his then-wife, Railene (now a successful tattooist in her own right, working in Queensland).

Billed variously as "Miss Technicolor" and "The Classy Lassy with the Tattooed Chassis," Ray toured with small circuses in Australia and New Zealand, earning a flat fee from Bartram. Without giving her a cut, this sideshow Svengali also sold signed photographs of Ray, used her image to advertise his tattoo equipment, wrote and sold books under her name and

corresponded with her fans, pretending to be her or getting his secretary to write for her. His two-year scam ended as suddenly as it began, when Bartram disappeared without a word. He later resurfaced in London and attempted the same con with tattooist Rusty Skuse, who snubbed him, having heard his big-bucks promises to Ray were, in Skuse's words, "a load of codswallop."

Although he essentially forged the books he wrote under her name, Bartram did interview Ray for them, and she vouches for their accuracy. *The Story of A Tattooed Girl* is a vivid account of a tattooed lady traveling with agricultural and small country shows Down Under. Ray confirms one striking difference between her actual and recorded experience of show life: the latter concentrates events to make her story sound action-packed. In fact, she says in a bubbly Australian accent, "It was very boring. You couldn't go anywhere. You couldn't get replaced for a lunch break or anything. I felt like an animal in the zoo. It was a terrible job, really."

In *The Story of A Tattooed Girl*, Ray recalls children who attempted to scare her with rubber spiders; skeptics who tried to rub off her ink; and a "bumptious blonde" who told her, "Anyone can see you're a bloke, you've got nude girls tattooed all over you." She indulged patrons who wanted to show her their tattoos, including 30 women who independently flashed her their art during a single Sydney show.

Ray's picaresque adventures are studded with snappy rebuffs to boorish oglers ("My excuse for being an idiot is that I'm paid for it," she told one, "What's yours?") and it clearly took a woman of mettle to handle the indignities she endured. But *The Story of a Tattooed Girl* also contains moments of vulnerability: "Sometimes when I'm standing there and suddenly recognize a relation, or a girl I went to school with, or a late school teacher...well there are times when I feel very small, and wish I had found some other way to earn my bread."

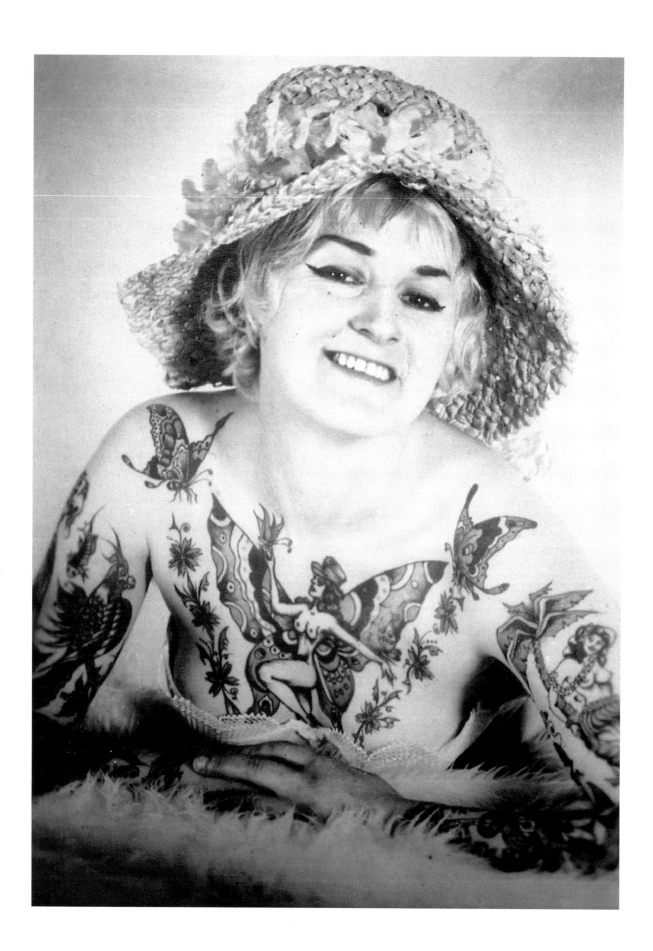

Within a few years, she did, learning tattooing from her husband and opening a shop in Williamston, a port town near Melbourne, where she works today. Although her parents initially disapproved of her tattoos (her engineer father called her a "p.r."—"proper ratbag"—for getting them), her mother later came around, volunteering to be Ray's first test subject when she was learning. Today, Ray is well-loved in international tattoo circles and her work is sought out by insiders, less for its Old School style than for the piece of history that comes with being tattooed by the woman who, as she was once advertised, "puts the *oo* in tattoo."

As she reports in *The Story of a Tattooed Girl*, sideshow life had its long-term benefits: along with introducing Ray to a trade that would become her livelihood, it made this small town girl a citizen of the world. "Before I interested myself in tattooing I was just a very ordinary working girl…I seemed to live in a very small pool, and tattooing for me has broken open that pool, it has opened my way to the whole world." It's a sentiment that's echoed by women artists and collectors through the century.

Although she wasn't the last tattooed circus lady (small circuses and state fairs featuring tattooed people limp along even today, and the revivalist Jim Rose Circus Sideshow—a hit with twentysomethings—includes the famously tattooed man, "The Enigma"), Ray signaled the end of an era. By the '60s, medical progress had yielded cures for some of the conditions that were the bedrock of freak shows, and a better educated public was less inclined to laugh at and more willing to question such displays, making tattooed attractions superannuated at best, and reviled at worst.

As Broadbent, who did her last show in 1967, reflected in *The Tattoo Historian*, "Body paint was 'in' then. The youngsters would come in wearing paint and they'd be rude—they'd say my tattoos were just paint. And of course by then you had to wear little or nothing to attract any attention. I was too old—it wasn't for me. I decided it was time to sit back and let the young folks have it."

Opposite
Cindy Ray, early 1960s.
(Tattoo Archive, Berkeley, Ca.)

47

But even as sideshows were dying out, tattooed women found alternate routes to the public eye. In 1958, Elizabeth Weinzirl, a doctor's wife from Portland, appeared on Jack Linkletter's variety show, *On the Go*, to display her growing skin art collection. She posed first for her husband in the "Party Room Pictures" the couple staged in their basement (some of which ended up in the Kobel archive), became a regular at tattoo conventions after their inception in the '70s, and by the time she died in 1992, was a living legend in the tattoo community.

Even before she was tattooed, Weinzirl was no stranger to publicity: she had first made the news in 1918, when she, her single mother and female cousin took a round trip road trip from Seattle to Brooklyn, astonishing middle America with their dauntlessness—and their men's trousers. In newspaper accounts of the junket, made before highways connected Chicago to Seattle, these "bloomer clad girls" described running for cover in farmyards during thunderstorms and sitting out desert sandstorms in tents they pitched by the side of the road. "We found that when we entered civilization we were treated like a circus," Weinzirl's mother told *The Salt Lake City Tribune*. She described one gawker who was so shocked at the sight of women in pants that "he ran his old gray mare halfway up the telegraph pole looking after us."

Weinzirl married in the '20s, moved to Portland with her family in the '30s, and got her first tattoo in 1947, after her husband, who had seen tattooed women in medical journals, suggested it. "He really wanted a tattooed wife," she was quoted as saying in *International Tattoo Art*, "and I wasn't leaving home." She was 45, with three teenage daughters.

Weinzirl got her early work from a variety of artists, but found her private Rembrandt in Bert Grimm, an established artist she and her husband Adolph discovered while attending a medical convention in St. Louis. Grimm became her exclusive tattooist. Among other old-fashioned imagery linked by sprinkles of stars, he gave her a spiderweb on her stomach, butterflies on her back and buttocks, and—her favorite tattoos—birds on her upper arms, inspired by a Cindy Ray design. When her hus-

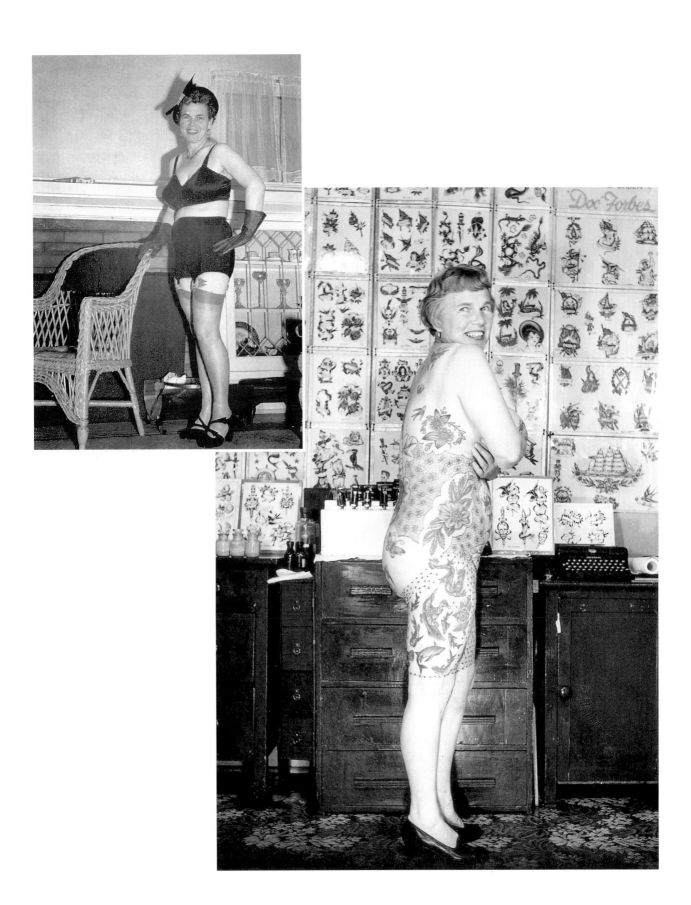

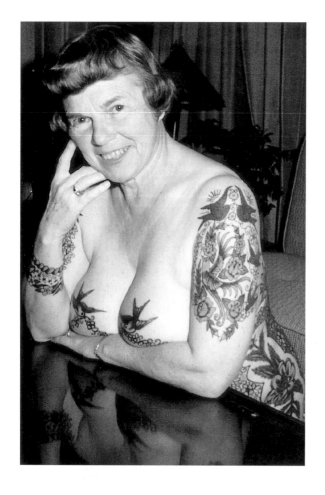

band balked at her decision to get tattooed in such a prominent place, she insisted she would simply cover up when necessary. But half the fun of her tattoos—especially when she was a great-great grandmother in her 90s—came from springing them on people.

"She really liked being the center of attention," says tattooist Mary Jane Haake, who was a close friend of Weinzirl's. "If that meant pulling her skirt up in a restaurant, that was OK with her." None of Weinzirl's three daughters or myriad grandchildren is tattooed, and Haake's 1989 documentary video about her, "World's Number One Tattoo Fan," contains strained moments in which her children's contempt for her hobby simmers beneath the surface civility of their interviews.

When Adolph Weinzirl died in 1967, Elizabeth quit her hobby, but continued her passionate correspondence with the large circle of tattooed pen pals she'd established. In the pre-convention days of the '60s and early '70s, tattooists tended to be prolific letter- writers, and some credit Weinzirl with bringing the community together through the mail. She finally met her new friends at the first national convention, held in Houston in 1976, where she was named "Fan of the Year." In 1981, The National Tattoo Association created an award for best tattoo "fan" (or collector) in Weinzirl's name. She competed in many subsequent conventions until, at 90, she appeared, wheelchair-bound in Philadelphia, at her last.

Although Weinzirl always said she got tattooed for her husband, and she allowed him and Grimm to choose most of her imagery, there's no doubt that she was a self-styled iconoclast who held the reins to her exhibitionist lifestyle. Her pastime may have been Adolf's idea, but she became a dedicated collector and tattoo advocate in her own right, presenting her

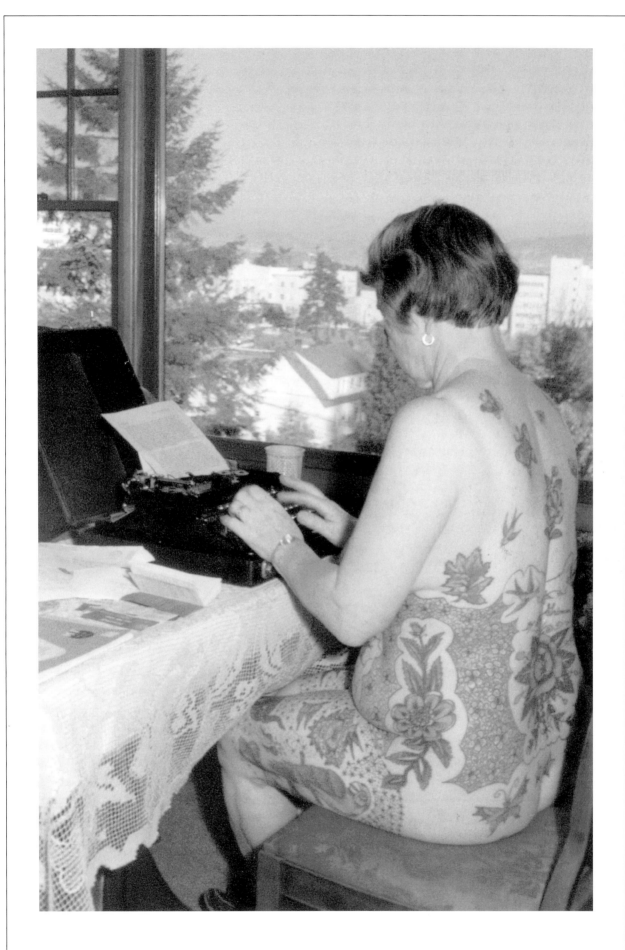

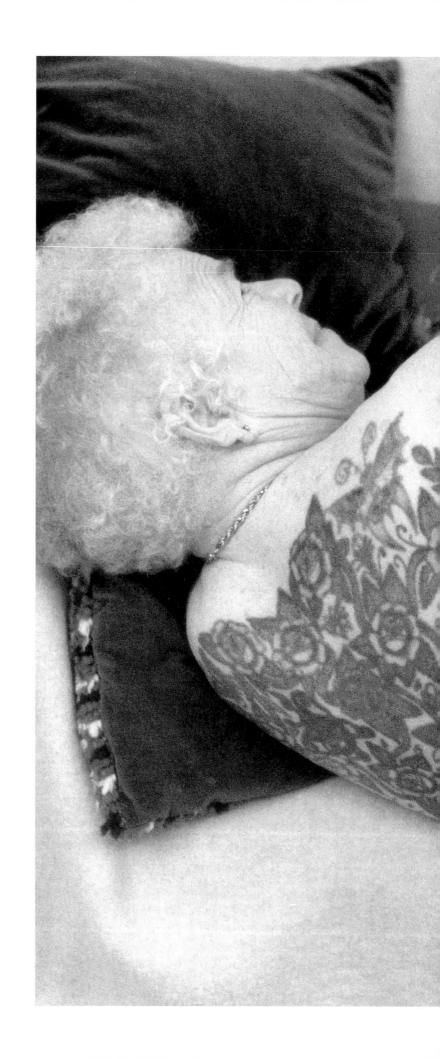

Elizabeth Weinzirl, "World's Number
One Tattoo Fan," 1989.
(Photo courtesy Mary Jane Haake)

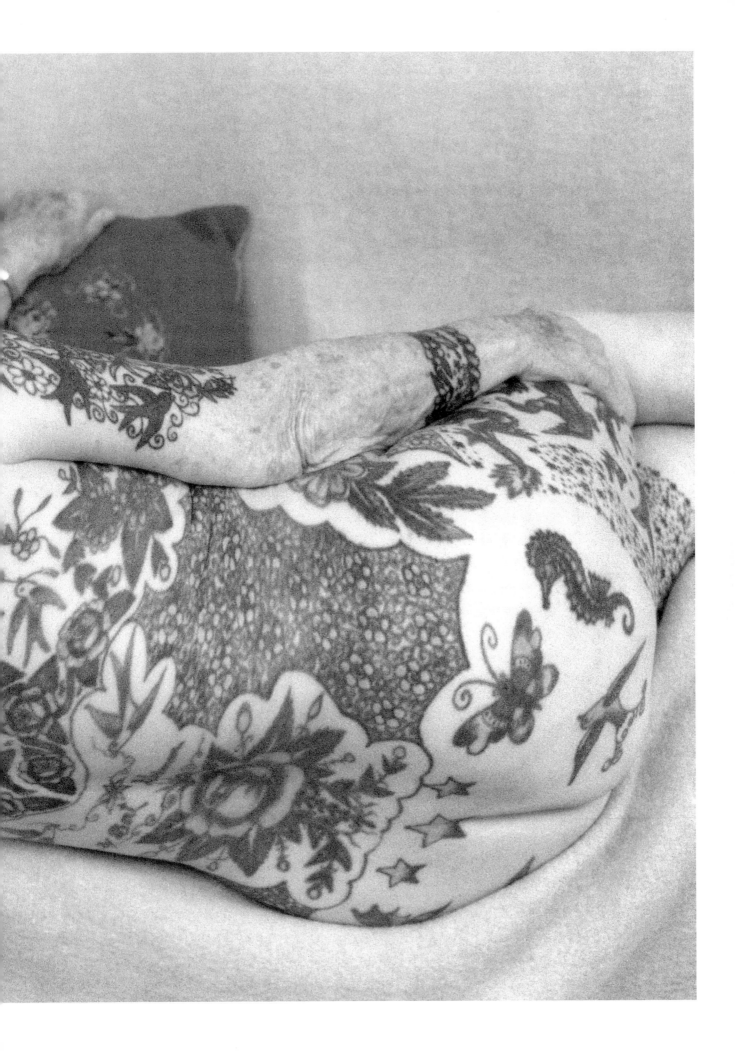

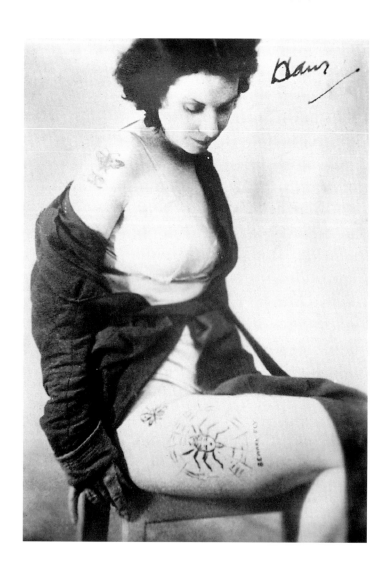

British tattooist Jessie Knight.
Date unknown.
(Tattoo Archive, Berkeley, Ca.)

bird-bedecked breasts as proudly for tattoo magazines as an overweight widow in her 80s as she had as a lingerie-clad housewife in her 50s.

More significantly, she marked a major transition in the history of tattooed women, collecting not as a professional attraction or as the wife of a tattooist, but rather for the love of it. With the inauguration of conventions in the '70s, recreational collectors like Weinzirl discovered a new venue in which to exhibit their work, and participated in a fresh form of spectacle that afforded all the hype and showmanship of a sideshow.

The British have produced a steady trickle of women tattooists since the '30s, when the artist Jessie Knight, who learned from her father, began tattooing soldiers at Aldershot and marines at Portsmouth. England's annual "Most Tattooed Lady" competitions kept British tattooed women in the limelight through the '60s and '70s. Collector Rusty (Field) Skuse not only dominated the title, but also went on to win a (still-standing) 1970 Guinness Record, married a tattooist and learned to push ink.

Skuse got started on a dare from a friend in 1961 when she bought the first of her crudely etched designs of panthers, butterflies, devils and lizards from her future husband, artist Bill Skuse. She made the papers in 1964 as a 20-year-old private in the British army who was forbidden to display any of her 62 tattoos while in uniform. Her story broke, she recalls, after "one of my friends in my barrack wrote to the newspaper saying, 'Why is it

alright for male soldiers to have tattoos and be allowed to wear short sleeve order, but women can't?' And the press jumped on it."

The British media dug into the drama with a mixture of salacious delight and perfunctory disapproval, working references to her "dimpled knees" and "shapely frame" into descriptions of her tattoo collection. Her commanding Lieutenant, Marilyn Masson, sniffed, "Private Field is a very nice and intelligent girl, but she is something of a character and doesn't seem to care what other people think...I'm sure she will regret it someday."

"I was fascinated by tattooing," says Skuse, now 53, who works privately in Derham Norfolk. "When I came out of the army I got a flat in Aldershot, and I decided I was going to be a tattooed lady in the carnival. I got on so well with the tattooist that he asked me to work for him. He taught me tattooing," she laughs, "and then he asked me to marry him!" Dropping her carnival plans, she worked in partnership with her husband until his death in 1995, and became part of a close knit, party-loving British tattoo circle.

"It was very male, but I had no trouble at all" says Skuse. "Bill was famous, so people more or less had to accept me. If I'd been on my own I think I might have had difficulty. I got a lot of customers; people asked for me because they thought a woman would be gentler than a man."

Like Cindy Ray, Field would hold fast to the traditional style passed on to her through her patrilineage. Both women would inspire younger artists who applauded their initiative in penetrating the boys' club of tattooing and admired their brio as heavily tattooed women. But with the conceptual shifts that would shake up tattoo art in the late '60s and early '70s, they would become guardians of an Old School style whose appeal would soon be largely nostalgic.

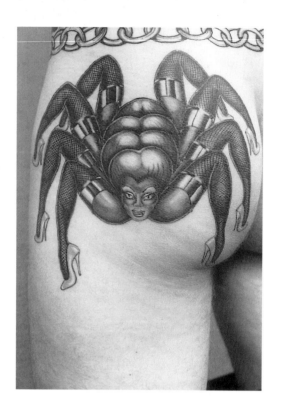

The 70s Revival

With the sexual revolution of the late '60s, when women began casting off their bras as they had their corsets a half-century earlier, tattoos were rescued from ignominy and resurrected in the counterculture by women who were rethinking womanhood. The arrival of the Pill in 1961 had given women new sexual freedom; a little over a decade later legalized abortion secured their reproductive rights. Not surprisingly, the breast became a popular spot for tattoos—it was here that many women inscribed symbols of their newfound sexual independence.

Women like Marcia Rasner began to see tattoos differently at this time. "When I was a girl, even *men* with tattoos were sleazeballs," says Rasner. "And if a woman had a tattoo she was the worst of the worst. I got married straight out of high school in 1966 and tried to be the straight housewife, and it didn't work. Five years later I dropped into the hippie generation. I got talking to this woman [in a bar] one night and she had this beautiful rose tattooed on her hand and it stopped me—I thought, she's saying something about herself there. I stepped aside from my prejudice and looked in this woman's eyes and saw the person that was in there. That was my first experience with a tattoo. And after that I just started noticing them."

56

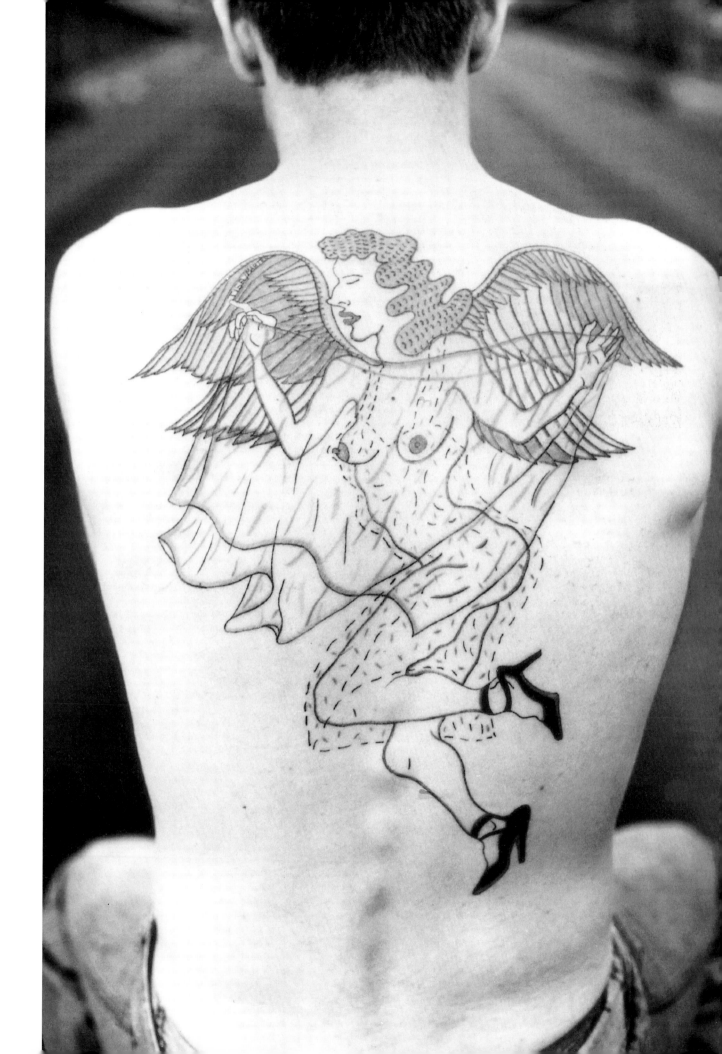

Then, as now, celebrities spearheaded trends the way society women once had. Janis Joplin was tattooed by San Franciscan Lyle Tuttle, who recalls, "I put a heart on her chest, and the day after her death there was a girl standing in front of the shop wanting the heart I put on her, in remembrance. Hundreds of them got the same idea at the same time."

If tattooed women were becoming more common, female tattoo artists were not. When Sheila May began working in her husband's Kenosha, Wisconsin shop in 1966 at age 19, she knew of only a single female competitor: Painless Nell. It would be nearly 10 years before May began hearing about other women artists. "It was radical, there was no getting around that," says May. "I don't know that I had a feminist attitude about it; I've just always been a person who went out and did whatever appealed to me. Guys would come up to the shop and I'd see them outside the win-

Calamity Jane, 1979. Two years before this photo was taken she chose a career in tattooing over cabinetmaking. "Tattooing was a mystical underground art, a subculture not available to just anybody, especially women," she says. "Like my mother, who was a pilot in World War II, I was not out to prove anything. I'm just a tomboy." (Photo courtesy Calamity Jane)

58

dow and you'd hear one say to the other, 'Oh my God—look! There's a broad in there doing that!'"

In 1977, May opened an appointment-only shop in LA that catered to women. "I would say about half the men [I worked on] got tattooed just to get tattooed, whereas almost all the women were getting a tattoo for a reason," says May. Men's standard repertoire—maritime imagery, military insignia, birds of prey, or slogans such as the biker motto "FTW" (Fuck the World)—advertised social status or affiliations, while women preferred decorative natural imagery and often got tattooed to mark a personal transition. "Some did it just because they thought it was pretty," says May, "but usually there was some symbolism."

Although she never considered herself an artist, May was an innovator of sorts: she used pastel colors and softened her imagery by eliminating the black outlines typically used for definition. In 1981, she began specializing in cosmetic tattooing. Historically, tattooists who did permanent makeup left their customers with clownish splotches of rouge or solid black eyebrows. May had a subtler touch, but her colleagues wrongly warned her she would never make a living at it. Now, using delicate needlework, she applies natural-looking color to lips, eyes and brows as a cosmetic tattooist to the stars. James Brown, for one, has May to thank for his eyebrows.

In the early '70s, when May was still in Wisconsin, tattooists with fine arts training, led by Don Ed Hardy (known in the trade as "the Don of Tattoo") and Chicagoan Cliff Raven were refining their art by experimenting with Japanese motifs that Honolulu artist Sailor Jerry Collins had imported to the States a decade earlier. Steeped in the Japanese tradition, which favors bright colors and interlocked imagery framed by wind, waves, or flowers, their work sowed the seeds of a tattoo renaissance still flourishing today. What historian Arnold Rubin dubbed the International Folk Style— anchors, eagles and pin-ups crowded helter-skelter onto backs and shoulders—was upstaged by a more refined and integrated design concept.

Inspired by an article about Raven's work, Vyvyn (pronounced Viv-een) Lazonga—arguably the most influential woman tattooist working today—broke in by apprenticing with Danny Danzl, a retired merchant seaman in Seattle, in 1972. "Danny showed me everything he knew," says Lazonga, who had been drawing since she was a child. "The first few years were great. Everyone thought it was so unique to have this young woman tattooing. But after that it was much harder."

Lazonga, who says she didn't "get" the women's movement at the time, found her feminist consciousness raised once she hit the glass ceiling in Danzl's shop. She watched many less experienced men being groomed and promoted over her and was often forced to use shoddy, albeit daintily customized, equipment: Danzl couldn't be bothered to repair Lazonga's broken machines, but he did find time to lovingly inlay them with glittering fake jewels.

"There was sexism and prejudice and I resented it," Lazonga says flatly. "I had to use faulty equipment and I just felt jealous. The springs on the machine broke every week and I wasn't allowed to change them so I wasn't able to do good work. It was a battle with Danny to get better technology, but eventually I did."

Despite such obstacles, "Madam" Lazonga's novelty as a tattoo artist and a heavily tattooed woman provided an opening for her in the tattoo world. No one could question her commitment: she shocked even tattoo initiates by getting "sleeves" (full arm pieces) in the early '70s. Primarily because of three phoenixes—Hardy's handiwork—that extended from her right shoulder to her left thigh, she was voted "the most beautifully tattooed woman" at the 1978 National Tattoo Association Convention. But there were sour notes as well: male tattooists snubbed Lazonga at conventions, and although men enjoyed being tattooed by a woman, she was routinely ridiculed. In *Skin and Ink* magazine, she described one loiterer muttering

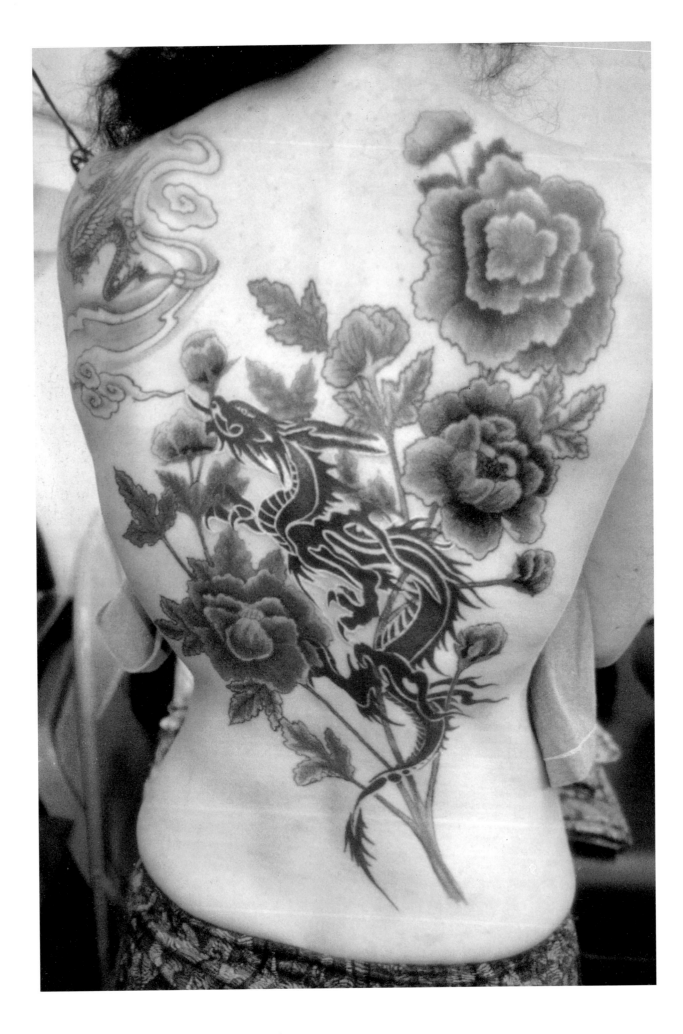

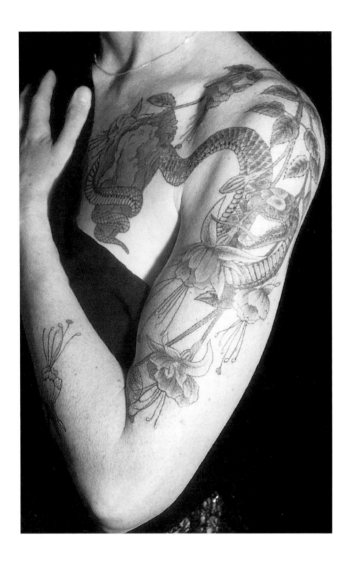

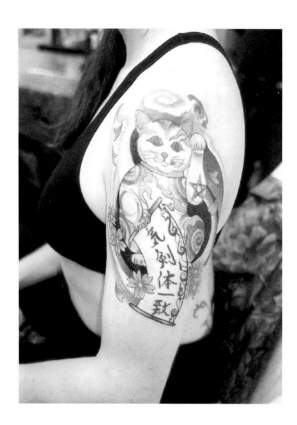

to his gaping friends, "'How'd you like to fuck a *thing* like that.' Now," she reported, "I don't let people like that in my shop."

It was on the merits of her artistry, not her novelty, however, that Lazonga ultimately made her name as a tattoo artist. In 1979, she opened her own shop, and has since become known for Japanese, Art Deco, and Victorian floral patterns that follow the natural curves of the body and enhance, rather than cover, bare skin. "Women are masters of illusion," Lazonga told the editors of *Modern Primitives*. "They always *have* been with makeup and clothing. A tattoo is just part of that illusion."

This page and opposite
Work by Vyvyn Lazonga
(Photos by Vyvyn Lazonga)

Unlike Lazonga, who began tattooing with little formal art training, New Yorker Ruth Marten came to it after studying at Boston's Museum School, also in 1972. "I had to come up with some way to support myself, and I thought that this was the ultimate drawing surface," she says. "It appealed to me, so I bought myself a little kit." Like many self-taught tattooists, she learned by practicing on trusting friends.

Because she had her own studio and did only custom work as opposed to flash, Marten took an unorthodox route that spared her the sexism women like Lazonga encountered in conventional shops. She befriended California transplant Jamie Summers, one of the early revolutionaries of modern tattoo, who died in 1982. Working under the name "La Palma," Summers became renowned for her subtle shading, pastel colors, and dot patterns, and above all, for her creative daring.

Summers, who apprenticed with Hardy in the late '70s, took a shamanistic approach to her art, attempting to conjure designs from the depths of her clients' psyches during preliminary consultations. She called tattooing a "metamorphic rite" and extolled the "higher power" of being "marked." Although Marten didn't share Summers' mystical inclinations, the two women cultivated a distinctly New York tattoo aesthetic characterized by vivid colors and arty designs conceived in collaboration with their clients. Both pushed beyond realism: Summers put frog and leopard spots on some clients, and Marten experimented with abstract primitive markings. Their high-concept custom work contrasted with the more representational style that had made California ground zero of the tattoo revival.

Marten found that being a female artist worked to her advantage because men, both gay and straight, liked getting tattooed by a woman. Throughout the '70s, she tattooed many gays with outsized, chimerical imagery, from serpents that snaked around entire bodies to phoenixes and even a transvestite angel, designed by artist Ken Tisa, that floated on the late drag performer Ethyl Eichelberger's back. "This was before AIDS," she recalls, "and [gays] were at their zenith in terms of extroversion, self-decoration and partying."

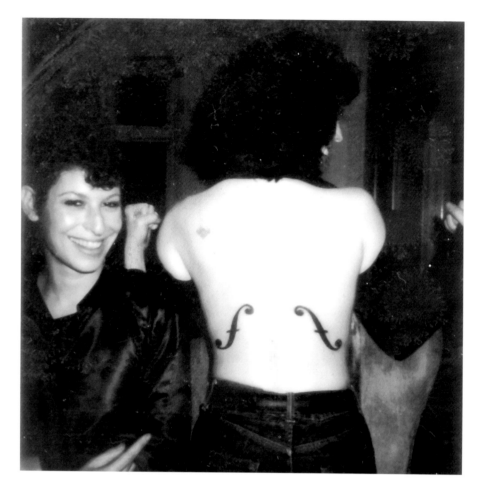

"I knew when I got tattooed that I wasn't going to live fast and die young," says singer Judy Nylon (right), who was tattooed by Ruth Marten (left) in 1977. "I wanted to live fast, wise up and die well. So I chose an image that would last through all the stages of a woman's body." (Photo courtesy Judy Nylon)

By contrast, she says, women needed to be prodded to innovate. "When I first started tattooing, the only thing that was available to women were hearts, roses, and butterflies. If you didn't want those, you were in trouble. So I filled the gap by allowing people to be more whimsical. I had lots of books of Art Deco and Art Nouveau symbols, and I tried to promote something a little more personal."

Impressed by Marquesan, Polynesian and Maori tattoo art, Marten became an early practitioner of the tribal style that Cliff Raven had been experimenting with in the early '60s. These solid black, highly graphic patterns were a refreshing alternative to intricate and polychromatic Japanese

65

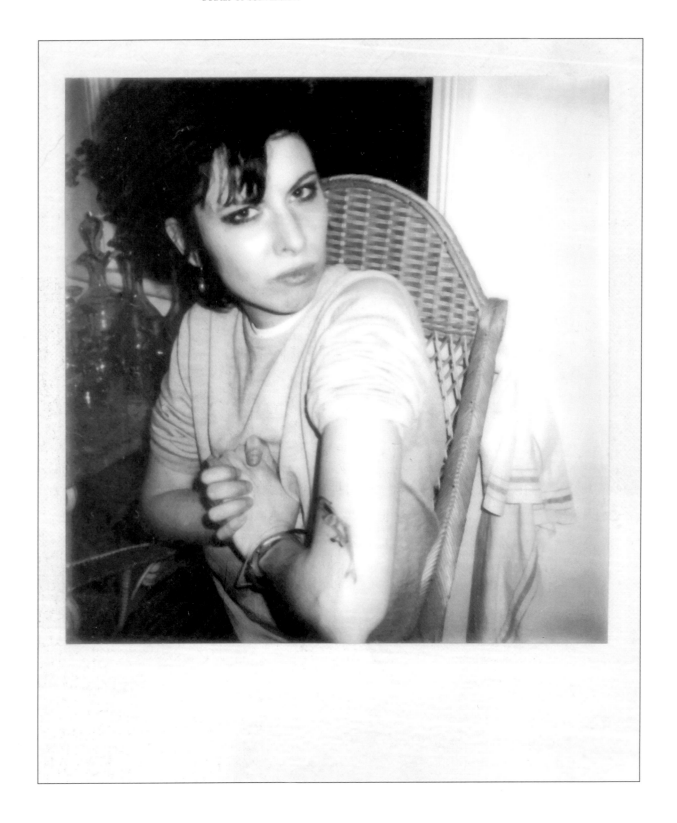

designs; they also held their shape over the years better than more nuanced compositions and were less likely to fade with exposure to the sun. In the '80s, artist Leo Zulueta would become the first Western artist to base his work entirely on tribal iconography.

Marten carried the graphic simplicity of tribal designs over to more conceptual pieces, notably her playfully inventive "Homage to Man Ray"—a pair of f-shaped violin sound-holes centered on punk singer Judy Nylon's lower back (the same image Man Ray superimposed on a photograph of Kiki of Montparnasse in his famous piece, "Violon d'Ingres").

Opposite

Chrissie Hynde showing a dolphin tattoo by Ruth Marten, 1977. (Photo by Judy Nylon)

Below

Tattoo of Mondrian's "Composition in Red, Blue and Yellow" by Ruth Marten, 1976. (Photo by Ruth Marten)

Marten, who retired from tattooing in 1980 to become a full-time (now well-known) illustrator, kept one foot in the art world during her days as a tattooist: in 1977, she set up a booth where she tattooed artists at the Paris Bienale, at which her own paintings were being exhibited. One of her first clients in New York was Marcia Tucker, director of the New Museum of Contemporary Art, then a curator at the Whitney Museum.

"I had this harebrained scheme," says Marten, "to tattoo famous works of art onto the bodies of [art] collectors as a collaboration between the artist, the collector and myself." But this impractical idea, combined with the conservative tastes of most art world denizens, didn't go far.

Marten's attempt to build a bridge between the fine arts and tattooing was an isolated overture; although tattoo art was entering a period of unprecedented efflo-

rescence—mainly at the hands of art school graduates—and though artists of the '70s were pushing art off the canvas, often onto the body, tattoo art was, for the most part, ignored by the gallery-going intelligentsia.

Tucker's 1981 *Artforum* article, "Tattoo: The State of the Art," which addressed the work of Marten, Summers, and Mike Bakaty, was a shining exception:

> Engraving on the skin requires the same draftsmanship, control and appropriateness of design that any significant drawing on paper entails. But the art of tattooing shares other qualities with more recent developments in contemporary art. Tattoos...are realized on a living (changing) person, so when the artist relinquishes the work, the product gains 'autonomy,' remaining itself while shifting with context or situation. The fact that increasing numbers of fine artists wish to control or dictate the context in which their work is seen, wish to eliminate context altogether, or wish to create their own contexts is a problem that does not exist for the serious tattoo artist.

More explicitly, tattooed women fulfilled the ideals pursued by feminist body artists of the '70s. While performance artists like Carolee Schneeman, Hannah Wilke, and Eleanor Antin used their own bodies as canvases—culling artistic meaning from female experience and biology as opposed to established masculine tradition (which emphasized ideas and, in the performance world, schematic, task-oriented actions) women tattooists were approaching their medium as a highly-charged personal statement and rejecting its male legacy.

The semiotic parallels between female performance artists and tattooists at the time are striking, especially considering each group operated virtually unaware of what the other was doing. In a challenge to the art world patriarchy she called the "Art Stud Club," Schneeman performed her 1975 piece, "Interior Scroll," naked, reading a feminist manifesto from a long paper she extracted from her vagina; Antin "carved" her figure in a five-week diet she documented in photographs; and Wilke, a lithe beauty, "scarred" herself by sticking wads of bubble gum on her body in a performance series about the beauty myth. Like them, women tattooists seized

an art form in which they had historically served as models or muses and appointed themselves mediums and creators.

As a popular art form, tattoo presented a less Byzantine professional hierarchy for women to navigate than the fine arts community did. There were no tattoo galleries, dealers or critics; an artist's clients became her calling cards, and at about $30 to a few hundred dollars a piece, tattoos simply didn't carry the cash value of a painting or a sculpture, so they lacked the high culture caché of "fine" art. On the other hand, there were also no schools, and most equipment suppliers sold only to people recommended by existing customers. Breaking in was almost impossible without a connection to a male tattooist.

Kate Hellenbrand tried her hand at tattooing early in the decade, after meeting tattooist Mike Malone, a disciple of Sailor Jerry Collins. A brief apprenticeship with Sailor Jerry, six months before his death, made a lasting impression on Hellenbrand. But while Sailor Jerry's influence would shape Hellenbrand's neo-traditional style, her connection to him was too brief to smooth her passage into the tattoo world and her career didn't gain momentum until the late '70s when she went to work for Don Ed Hardy in San Francisco.

Frances Farmer, before and after being institutionalized, tattooed by Jack Rudy on Calamity Jane.
(Tattoo Archive, Berkeley, Ca.)

In 1976, Jacci Gresham became the first prominent African American tattooist; she has never encountered another black woman artist, and met her first black male colleagues in 1997. Gresham learned to tattoo from her former boyfriend, now business partner, Ajit Singh, while both were work-

ing for General Motors in Detroit. It was at her suggestion that they moved to New Orleans and opened a shop. Singh, who felt that tattooed women were socially unacceptable, instituted a rule against tattooing women, but Jacci quickly reversed it and her female clients now account for 70% of her business.

Portland artist Mary Jane Haake found a devoted friend in her mentor, Bert Grimm, whose Portland shop she discovered on her lunch break while working in a law office in 1977. Grimm and his wife Julia were eating sandwiches and downing tumblers of whiskey when Haake, a curiosity seeker, appeared in the doorway. Bedecked in double bollo ties, a smiling, 78-year-old Grimm waved her in.

"My name's Bert Grimm. Ever heard of me?" he asked. Haake shook her head, eliciting a snort from Julia, whose husband happened to be a giant of 20th century tattooing; both Betty Broadbent and Elizabeth Weinzirl sported his handiwork. Grimm promptly delivered his standard oral business card: "I've tattooed more people all over than anyone else in the world."

For the next hour, Grimm regaled Haake with tales from his 62-year career, boasting that he had tattooed mobster Pretty Boy Floyd and the U.S. Marshall who escorted him to jail, and gesturing toward walls filled with photographs of grinning customers and framed flash. That night, Haake returned to get a small flower tattoo; soon she was spending lunch breaks with Grimm, her tape recorder rolling. The following year she began working in his shop.

Shortly after meeting Grimm, Haake entered the Pacific Northwest College of Art, where she majored in painting and sculpture. In her senior year, in what may have been an academic first, she persuaded her instructors—with no little effort—to accept tattooing as her thesis subject. The decision caused an uproar at the college; when professors in her own department refused to sit on her thesis committee because they didn't believe tattooing was art, free-thinking members of the graphics depart-

Opposite

Jacci Gresham became the first prominent black tattooist in America in 1976. She hasn't met a black woman artist since. (Photo by Jerry Rosen)

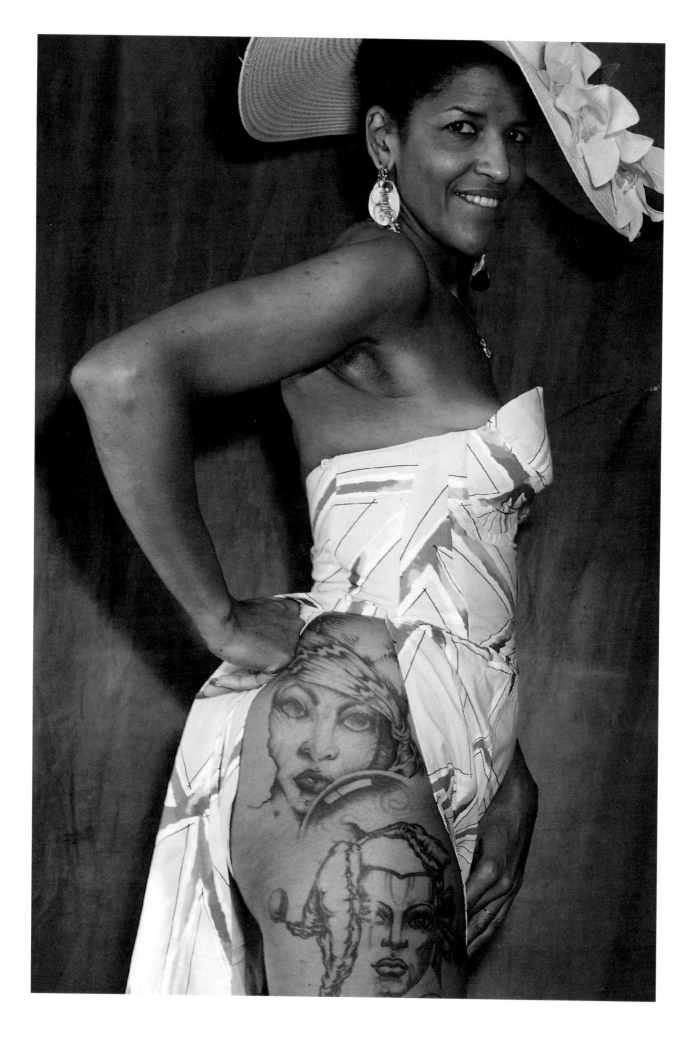

ment stepped in to replace them. "They were fascinated by the technical concept," says Haake. "They couldn't believe this effect could be produced on what they considered to be a crude canvas." Grimm, a fourth grade dropout, joined the committee.

Haake's proposal involved tattoo drawings for four models, photographs of the tattoos-in-progress, video footage of her subjects to show "the kinetic aspects of the design," and live appearances by the completed "canvases." Her proposal asserted:

> In all societies, the man or woman who is not decorated in some way—changed from their natural state—is, in a sense, decoratively inarticulate...body decoration is a type of language or code, which is spoken through hairstyles, mutilations (pierced ears), tattooing or painting (makeup). In the West, because of our obsession with clothing for almost all parts of the body...we have restricted the amount of skin available to be used as a cosmetic language. Most of us have forgotten that perhaps the first works of art dedicated to the combination of form and color were carried out on the skin.

Below
Mary Jane Haake and Bert Grimm, 1985. (courtesy Mary Jane Haake)

2-10-85

At her thesis presentation in 1982, Haake trotted out her flesh canvases— two men and two women—both, interestingly, mothers and full time executives—whom she had recruited through a newspaper ad. Each model exhibited about 30 hours' worth of Haake's work.

"The thesis committee was intimidated," Haake recalls. "They didn't want to criticize because the subjects were sitting right there and they weren't used to the canvas talking back." After debating the comparative merits of folk art and fine art and discussing the kinetic and sculptural aspects of Haake's project, the panel turned to Grimm for his professional opinion. "Give her an A," he said. "She gets the ink on the skin good, and I should know...I've tattooed more people all over than anyone."

In 1977, Hawaiian artist Kandi Everett landed her apprenticeship through serendipity, after appearing in a print ad for a drawing class she taught and catching the eye of tattooist Mike Malone. A mover and shaker in tattoo circles, a smitten Malone marched his shopmates into her class for instruction, which she wisely bartered in exchange for tattoo lessons. Malone later hired her, but before putting her to work, he took her on a grand tour of California to observe other artists, from meticulous *artistes* to what she calls "buns up" high speed tattooists.

"She's one of the best tattooists in the country," Malone says of his former girlfriend. "I got a lot of flack from my colleagues about breaking in a woman at that time—I had really crossed the line." But Malone's recent claim that he had to "break Kandi from drawing like a girl" (a style he's hard-pressed to define) shows that old biases—even for a champion of change—die hard.

Below
Tattoo by Kandi Everett, 1982.
(Photo by Shuzo Uemoto)

Everett took her share of flack as well. She compares her entree to tattoo's inner circle—where she was routinely excluded from shop talk and expected to mingle with other tattooists' wives and girl-friends—to trying to enter The Citadel.

"At the time I didn't know what I was getting into, but it worked out just fine," says Everett, who mastered Old School tattooing and South Pacific designs and experimented with her more adventurous customers, including one who allowed her to etch his portrait on the crown of his head.

Kandi Everett with Hawaiian dancers
who wear her tattoos, 1992.
(Photo by Shuzo Uemoto)

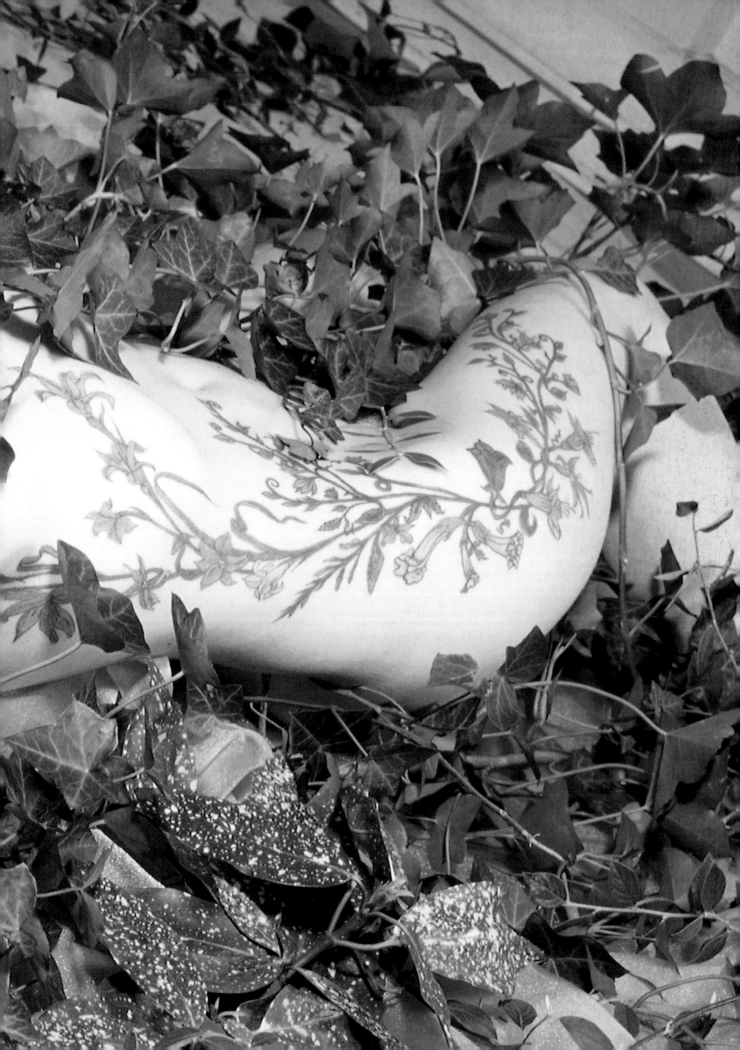

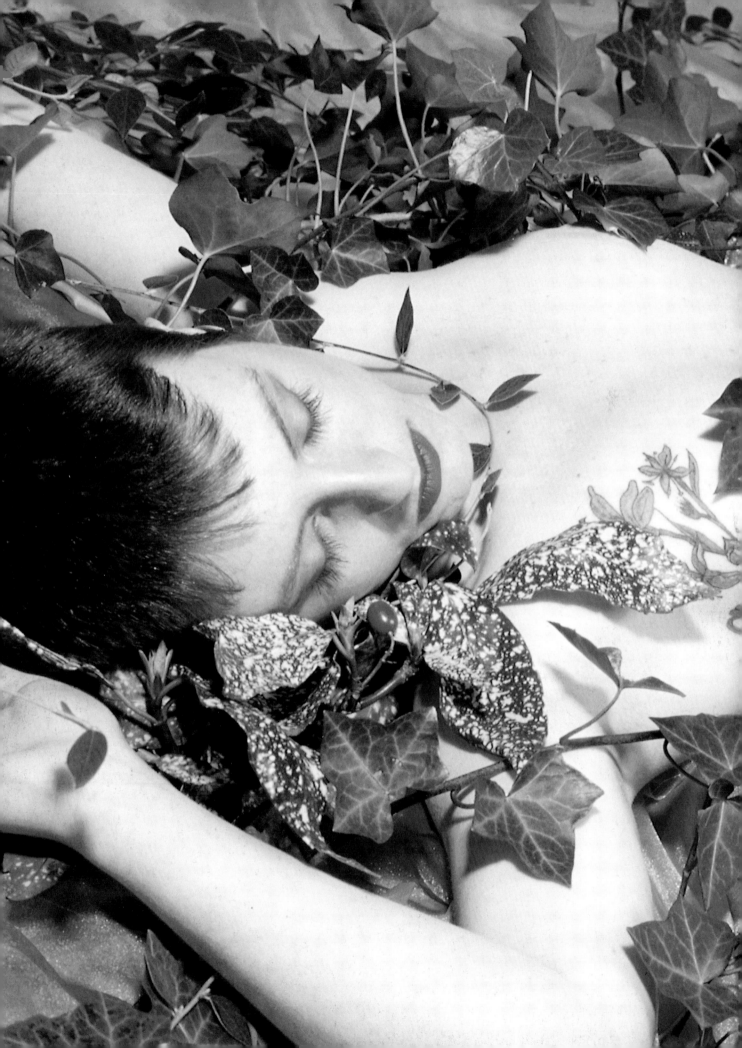

Haake got her A, but not with Grimm's unqualified support. Having worked long enough to see how tattoos age, he didn't believe hers—done without traditional black outlines—would hold up. When, under his tutelage, she'd experimented with fine line single-needle work, Grimm growled, "Tried that back in '38. Doesn't last." Now Haake, who has run her own shop since 1981, agrees with him: "I'm relearning all the things I rejected that Bert told me," she laughs.

This page and following
Work by Mary Jane Haake
(Photos by Skip Williams)

The same banner year—1977—in which Everett was apprenticing with a Young Turk, Haake was learning from an old hand, Marten was tattooing at the Paris Bienale, and May was opening her first woman-only shop, Pat Sinatra was emerging from the biker community with needles sharpened. An aspiring artist married to a biker, she hoped to "transform the image of tattooing from something only bikers and junkies and criminals did, to something that people could find honorable," she recalls. But her insecurities about her talent—specifically her fear that the tattoo cognoscenti looked down on self-taught artists—held her back, and it wasn't until the late '80s that she overcame her stage fright, served an apprenticeship with artist Shotsie (Carl) Gorman, and launched her career in earnest.

Opposite
Pat Sinatra
(Photo by Robert Butcher)

This page
Work by Pat Sinatra
(Photos by Pat Sinatra)

This page
Work by SuzAnne Fauser
(Photos by SuzAnne Fauser)

Opposite
SuzAnne Fauser
The phrase "Even the Black Sheep are
Blessed" is tattooed across her chest.
(Photo by Anna Gersh)

SuzAnne Fauser served an apprenticeship with a veteran that did little for her career. An MFA who was looking for a way out of teaching high school art classes, Fauser began tattooing in 1979. But her initiation into tattoo circles was grueling and dragged on for a decade, despite her apprenticeship, which, she says, amounted to "the runaround" with a man she refuses to name. ("That's my revenge," she laughs.)

"Being a '60s kid, I thought, 'I can do this,'" she says. "I didn't really realize what a struggle it would be. The men were very threatened, and still are. I used the I-don't-know-anything- I'm-just-a-silly-little girl, what-can-you-show-me? [tactic], flattering male egos so they would drop out all the information. I went around to conventions and visited tattooers, and [tried not to] look like competition. It was ten years before I was accepted, and that was because of one thing—longevity. I kept turning up despite everyone's best effort not to help me."

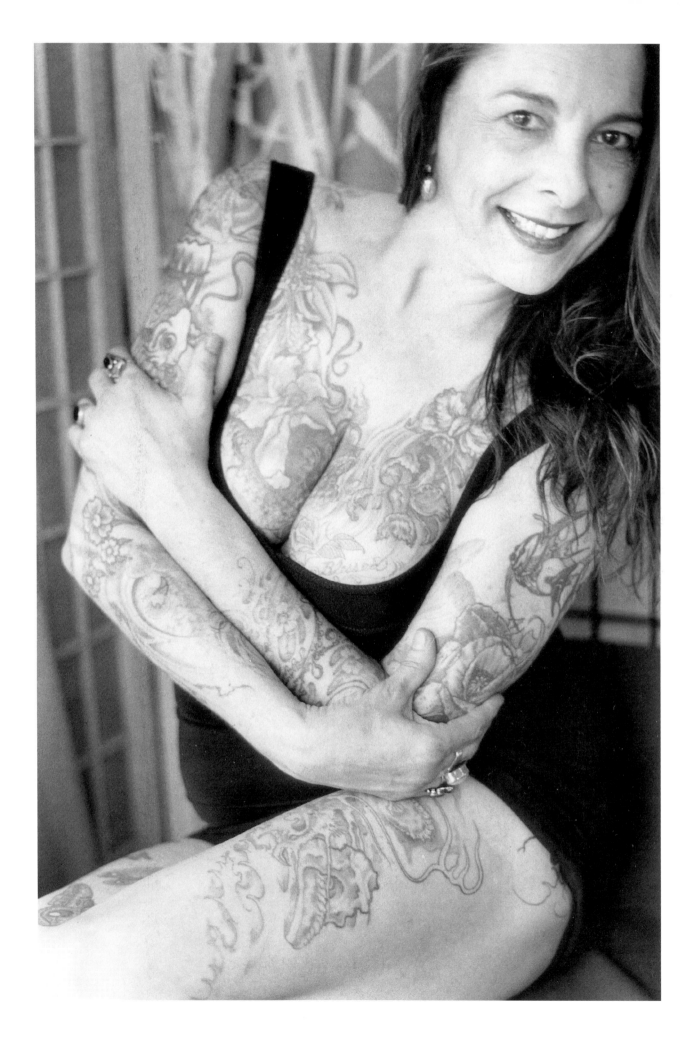

Paul Rogers, a tattoo machine-builder and veteran tattooist of the carnival sideshow circuit, was an exception. Rogers called Fauser in 1980 and offered to help her with the finicky technology of tattooing. Historically, artists were notorious for withholding information to prevent competitors from stealing their business. Trade secrets were passed down from father to son, or from mentor to apprentice. But Rogers, says Fauser, "was a saint. He believed you should give it to everyone and God would determine who would succeed." Rogers lent a hand to many women, including Deborah Inksmith (now working as Ms. Deborah) and Deborah Yarian, who later inked a portrait of Rogers' wife, Helen, on his chest.

This page and opposite
Works by SuzAnne Fauser
(Photos by SuzAnne Fauser)

Above
Sarah Vandrey wearing Haida
tattoos by Kari Barba
(Photo by Jan Seeger)

Californian Kari Barba began tattooing in the late '70s at the suggestion of her husband, learned while he did, and opened a shop with him in 1983. Within two years, Barba—a high school dropout who had previously worked in a foundry, had quadrupled her income. (Ironically, the tattoo boom of the '90s has spawned such a profusion of new shops that her business—and profits—have since been halved).

"When I started," Barba told *Skin and Ink* magazine, "it was completely for him—it was about pleasing him and being there for him. It wasn't about me." Since then, she's raked in scads of awards and made her name tattooing technically impeccable—if stubbornly conventional—wildlife imagery (what detractors have dubbed "taxidermy tattoo"), TV and movie stars, and tribal and Japanese designs. "Almost every man I've interviewed mentions her as an influence," says Jean-Chris Miller, editorial director of four Larry Flynt-owned tattoo magazines.

Although some "first wave" women tattooists of the '70s learned from or alongside spouses or boyfriends, it's a common misconception that women generally break in this way. Most needed a connection—inevitably a man—to gain entry to this secret society. But as the self-starters mentioned above overwhelmingly prove, the new generation entered the trade with specific ambitions, unlike their forebears, most of whom sidled into it to lend a hand to their husbands.

Perhaps no one flew higher without a net than San Diegan Judy Parker, who met her first employer as a 17-year-old in Alaska in 1978. Parker had been traveling around the U.S. doing odd commercial art jobs when, too broke for a hotel room, she found herself wandering the streets of Juneau

Above
Work by Kari Barba. "Almost every man I've interviewed mentions her as an influence," says Jean-Chris Miller, editorial director of four tattoo magazines. (Photo by Kari Barba)

and happened on a shop in which a man was busily tattooing a woman's chest. Parker entered, watched for a half hour, was invited to show the owner her portfolio, and got hired on the spot. An hour later she was tattooing while her boss drank in the bar next door, and she stayed for a year and a half. "He didn't even work after I started," says Parker. "He didn't need to. I was constantly booked." In 1984, after working illegally in Hawaii (at the time, the only state that licensed tattooists) and for Doc Webb in San Diego, she opened her own shop, also in San Diego.

Unlike female visual artists who banded together in New York and California, women tattooists were so few and far between in the '70s that they barely constituted a subculture within the subculture, and they certainly didn't consider themselves united in any cause. Some say they simply weren't aware of their female colleagues. Lazonga sees it differently: "A lot of us bought into the idea of divide and conquer. We weren't supposed to get along, we weren't supposed to be friendly to each other. I felt like this lone island for most of my career, until recently."

Historically, competition was as integral to the tattoo tradition as skin and ink: shop owners discouraged their artists from carousing with competitors and went out of their way to spread technical misinformation. With the introduction of national conventions in the '70s, tattooists found a new outlet for their competitive zeal. Some artists have suggested that the sexism women reportedly encountered at them was simply the initiation rite any young upstart is forced to endure.

Opposite
Mary Jane Haake tattooed by Vyvyn Lazonga. "When I was a kid," says Haake, "my favorite game was where you use a finger to write a word or draw an image on your buddy's back, and he guesses what it is. It felt great—it was consensual and non-sexual. In a lot of respects, getting tattooed is a version of that." (Photo by Skip Williams)

"I went to my first conventions with Bert, so people were very nice," says Haake. "He was an Old Timer so everyone revered him. At my first convention without Bert at the Queen Mary [in 1982], I went with Vyvyn Lazonga, [collector] Krystyne Kolorful, and my husband, and I was so excited. I walked up to a guy and introduced myself, and he said, 'I've heard of you—your work is shit!' I was so naive, I didn't get it."

Whether or not such hazing was specific to women (and Haake believes the same thing probably would have happened to a novice male), it was alien to them. "Tattoo artists in the best sense are show-off artists," says Kate Hellenbrand. "They want to sling ink—it's about getting it on faster and better than the next guy. At conventions, they're always busting on each other's work. I'm a 55-year-old woman. I wasn't encouraged to engage in that kind of conduct. I was raised to be a deferring good girl and most women of my generation were. I think that's why so many women have had such a hard time surviving and why those that did, like Vyvyn, were scarred."

By the late '70s and early '80s, however, trailblazers like Marten, Summers, and Lazonga (who herself had found inspiration in correspondence with Cindy Ray) were becoming role models for other women. In 1977, after seeing a photo of Lazonga in Esquire, Juli Moon persuaded Virginia tattooist Dani Fowler to apprentice her. A few years earlier, Moon, impressed by Lyle Tuttle's handiwork, had gotten her first tattoo in emulation of her hero, Janis Joplin. But it was the image of a sleeved Lazonga at the 1976 convention that gave her courage to go farther.

"She was my idol," says Moon. "She was the first woman I'd ever seen who was heavily tattooed, and I was mesmerized. She became an icon instantly." A quick study with a background in textile and tee-shirt design, Moon spent a year working under Fowler, then struck out on her own, earning kudos for her luxuriant flowers, lifelike portraits, jewels, and gem-like bugs. In 1982, she was named "Best Artist in the United States" at The National Tattoo Association Convention.

Opposite
Juli Moon and her children
(Photo by Jan Seeger)

Pat Fish, a Santa Barbaran known for her intricately braided Celtic designs, was impressed by Lazonga's generosity when she began her career in 1984, learning from Cliff Raven. "Vyvyn was just this beam of light," she says. "She would say, 'Oh, there's plenty of work for everyone,' and I'd look at her and say, 'What?' Because all the men would talk about was hating the other guys. How could she be in this occupation with all these guys who are tooth and nail against each other?"

This page
Work by Pat Fish. Her mentor,
Cliff Raven, taught her that
tattoo art "isn't something you do,
it's something you are."
(Photos by Pat Fish)

90

Pat Fish
(Photo by Cassandra Spangler,
courtesy Pat Fish)

After reading about Summers in *Artforum*, New Mexico artist Cynthia Witkin tracked her down in San Francisco in 1981 and got her first tattoo, an angular solid black abstract "energy pattern" that was a departure from Summer's usual pastel organic fare. Ruth Marten (then retired) later taught Witkin to tattoo and encouraged her to pursue the art. Although she says Summers was too "California cosmic" for her taste, Witkin regards her as a formative influence, and has extended both Marten and Summers' legacy of abstraction, using a combination of Native American and Russian constructivist motifs. She also collaborates with her husband, the photographer Joel-Peter Witkin, on print projects.

This page
"Automatic Writing,"
tattoo by Cynthia Witkin
(Photo by Joel-Peter Witkin)

Opposite
Jamie Summers' tattoo,
"A Stitch in Time" on Cynthia Witkin
(Photo by Joel-Peter Witkin)

Following pages
"Calculated Birthmark"
tattoo by Cynthia Witkin
(Photo by Joel-Peter Witkin)

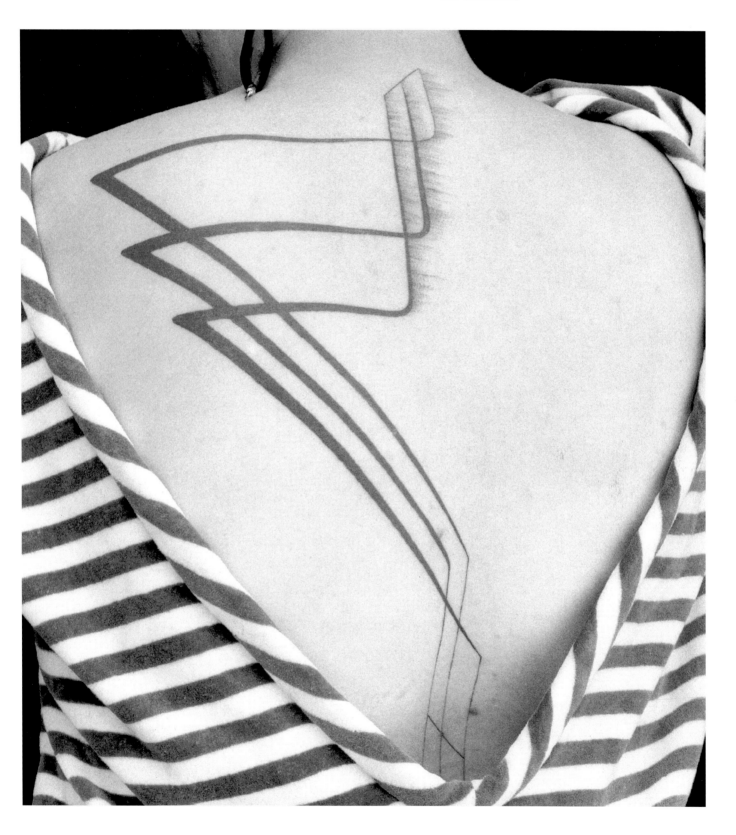

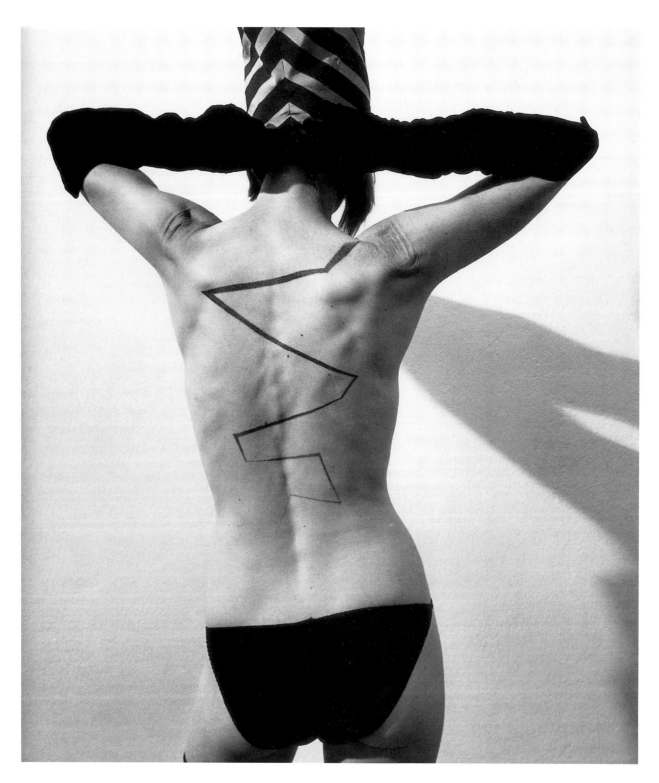

"Tattoo as Medicine," tattoo by Cynthia Witkin (Photo by Joel-Peter Witkin).

Witkin, who is part Navajo, began doing American Indian themes after dreaming of a rattlesnake the night before working on a customer for whom she'd had trouble conjuring ideas. Since then, she's developed Southwest imagery from thunderbirds to lizards to paw prints, in rust reds and oxidized blues. The dream led her to a rich and obvious creative well-spring: "I'm used to seeing native American imagery—in my grandmother's house, churches, and Indian pueblos where there were petroglyphs and weaving and pottery," she says.

One tendency some women trailblazers of the '70s handed down to their '80s heirs was a heightened concern for the spiritual shelf life and private significance of tattoos, and a willingness to draw the client out on the subject. Witkin takes a psycho-spiritual approach to her art, sometimes asking customers to recount their life stories, explain how their tattoos will fit into them and imagine the work as it ages with the body. Nearly all Witkin's clients are women, many of whom, she says, feel alienated from popular tattoo culture and imagery.

In 1981, just as women tattooists were gaining the greatest collective professional momentum they'd ever known, Bob Brooks' movie, *Tattoo*, came out, reviving some of the most threadbare clichés about tattooing in general and tattooed women in particular. In it, Bruce Dern plays a psychopathic tattooist who becomes obsessed with a model (Maud Adams) he's been hired to body paint for a shoot. When she spurns him, he kidnaps her, tattoos her perfect body and holds her hostage in a beach house until she kills him by stabbing him in the back with his own tattoo machine.

Asked what sort of women come to him for tattoos, Dern's character responds, "Women that are ready to be identified; women that need the mark in order to exist." His character plays on the analogy between tattoo as sexual assault (some tattoo historians have had Freudian fun with the idea of phallic tattoo needles squirting liquid into the body) and squeezes sensationalist mileage out of the 19th century forced tattoo scenario, updating it with a drugged victim and an over-the-top sex scene in which

Dern masturbates while watching his quarry through a peephole as she touches her tattoos.

Except in Nazi Germany, the fantasy of forced tattooing has yet to be played out in reality, and thankfully, there aren't many Dern-like creatures lurking among male tattooists. But, since the '70s, women have been drawn to female artists for a variety of reasons. Some feel safe from come-ons (seedier male tattooists have been known to make women take their shirts off for a wrist tattoo); others are sent in by boyfriends and husbands who don't want "their woman" touched by another man; and still others, like some men, find women to be gentler with the needle and more personally accommodating.

This page and opposite
Work by Patty Kelley.
(Photos by Patty Kelley)

"Women take the rough edge off the industry," says Patty Kelley, a San Diego tattooist who began working with her husband, Fip Buchanan, in the early '80s. "If you walk into my studio it's obviously got a woman's influence—there are flowers and the bathroom is clean. We have a gallery in the front lobby, which is set up like a doctor's office; we have portfolios lining the front wall; and [the artists I employ] have their own separate rooms that they've decorated themselves."

Of course, not all women tattooists work or think alike. Shop tattooists like Everett, who calls herself "a 20-year veteran of taking what comes through the door...one right after the other," approach their craft with buccaneer bravado. Others view it with an almost maternal sense of propriety: "It's totally intimate," says New York artist Emma Porcupine. "The bizarre thing is you have a bond with the people you tattoo, and then the person goes. It's like having a child that you won't see again."

More significantly than how they arranged their shops or viewed their clients, pioneering women tattooists offered a new range of imagery. Adjectives like "softer," "prettier," and "more feminine" are often used to describe their contributions, but many younger artists cringe at the '70s clichés these images conjure.

"It's frivolous to say women brought in flowers," says Shotsie Gorman, a tattooist who has supported many emerging women. "There were a lot of men doing that stuff too. I think what happened was in the '60s, pop iconography changed. All of a sudden it was cool for a guy to wear flowers and more delicate designs. And Japanese tattoo started making itself known, and the Japanese always used flowers."

Stereotypical as it seems now, the use of nature imagery and frilly art deco motifs was a way many women artists feminized tattoo to make it their own. The same impulse drove female visual artists of the '70s to attempt to validate crafts such as quilting as fine art, to weave goddess imagery into their work, and to focus on the female body—ideals some contemporary feminists consider in retrospect to be quaintly retrograde. But for some women tattooists, like their fine arts counterparts, embracing feminine tradition was an obvious way of renouncing masculine convention. Since then, women's work has exploded in a sunburst of new imagery ranging from Tank Girls and black Betty Boops to aliens, fallopian tubes, and butterflies with wingspans as wide as a woman's back.

Totem and Tattoo

The Reagan '80s ushered in a generation of women tattooists who would become soul doctors to a nation afflicted with new and manifold anxieties about the body. It was a decade when AIDS killed more than 70,000 people and when millions jumped on the fitness bandwagon hoping to stay, as Rod Stewart sang in 1988, "Forever Young." The female body was sculpted, starved, and surgically altered: new legislation which threatened legal abortion, championed fetal protection, and reduced surrogate mothers to "human incubator[s]" (as one contract mother put it) cast an Orwellian shadow over women's reproductive rights. Bodybuilders pumped iron until they stopped menstruating and looked like men, then lost competitions for being unfeminine; nine-year-old girls dieted; teenagers starved themselves into anorexia; and legions of women anxiously bolstered their femininity through breast enlargements, then watched in horror as their implants burst or migrated beneath their skin.

Tattoo art both refracted and relieved such anxieties. Like bodybuilding, it afforded a means of control through "modifying the only temple over which one is sovereign," as one enthusiast put it. Of course, tattoo was just one avenue of transformation. Adrienne Rich's assertion in 1976 that "we

100

This page and opposite

Photos by Kent Noble

need to imagine a world in which every woman is the presiding genius of her own body" took on a sinister double meaning in the '80s, when nearly two million American women were cosmetically reconstructed. The parallel rise of cosmetic surgery and tattooing drew a line between disparate camps during the backlash '80s: there were the conformists, who wanted to blend in, for whom surgery was an admission of inadequacy, and the resisters, who wanted to stand out, whose tattoos were emblems of self-validation. Some women did both. These contradictory impulses underscored the conflicted state of feminism in a decade when women were both enjoying new freedoms and backsliding against the forces of unexpected demons.

Meanwhile, tattooing—a rebellious fashion statement that punk rock bands helped to popularize in the late '70s and early '80s—spread like wildfire throughout youth culture. MTV, a breeding ground for herd-like non-conformity, packaged it for the masses. Tattoos of band names and logos—notably the ubiquitous, glyph-like stick figure adopted by the German industrial band Einstürzende Neubauten—functioned as club jackets for the counterculture. "This is all part of my denouncing modern restrictions," one woman wearing the symbol said in *Option* magazine, "[of my] saying I'm not like you, I don't *think* like you...I'm of a different tribe."

(In New York City, where tattooing was illegal from 1961 to 1997 because of outdated medical concerns that the health department rarely bothered to pursue, tattoo parlors have enjoyed an added outlaw mystique. One East Village shop asked customers to call from a pay phone on the street before entering; others operated out of unmarked storefronts).

This page and opposite

Photos by Kent Noble

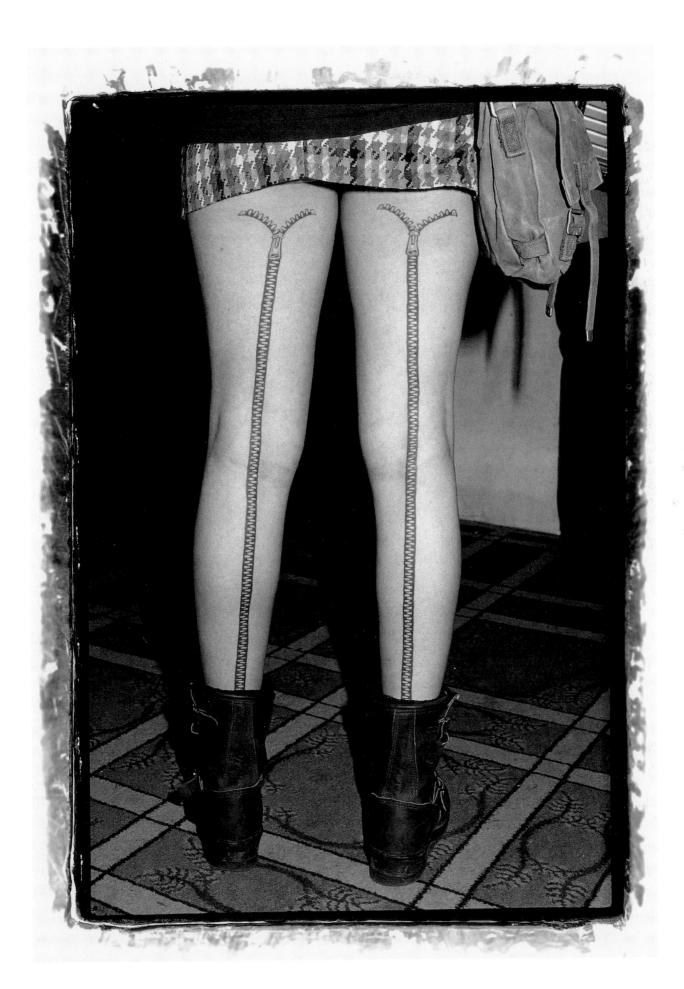

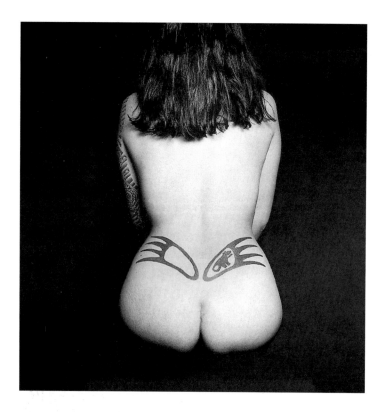

Jill Jordan, tattooed by Bob Roberts. Using a Rapidograph pen, she did her first "tattoos" on her Catholic school girlfriends and was rewarded with a spanking. (Photo by Vicki Berndt)

Opposite
Jill Jordan, showing tattoos by Fip Buchanan (daggers) and Don Ed Hardy (upper arm). (Photo by Vicki Berndt)

Unlike piercing, which has also become an MTV staple, tattoo allows for visual and symbolic gradations of meaning, and has assumed both ritual and therapeutic significance for many women. LA artist Jill Jordan has tattooed celebrities from Billy Idol to designer Thierry Muegler, but her typical client, she says, is a professional woman between 23 and 55. "She's independent [and] usually spiritually inclined in some way, whether [she's] a witch or in A.A.," says Jordan. "She's somebody who's discovering or rediscovering herself."

The term "psychic armor" is sometimes used to describe tattoos acquired during periods of change. "My first tattoo is/was of a turtle," explained one collector on the electronic bulletin board, ECHO. "I got it not long after getting out of a back brace I wore through most of my adolescence. I literally had a physical shell separating me from the world. Consequently...I built up a lot of personal/emotional shells and defense mechanisms. I got the tattoo to remind me of that, and to remind me to try [to drop] them."

In her 1949 book *Male and Female*, Margaret Mead (rumored to have had her thigh tattooed with a traditional Samoan cross-hatch pattern), theorized that in tribal cultures, men modified their bodies to mark important transitions that were signaled biologically for women: menstruation, pregnancy, and menopause each offer tangible evidence of life changes. Even today, a lyric sung during a typical Samoan "tatau" ritual goes, "The woman must bear children, the man must be tattooed." In our culture, the onset of menstruation and menopause are rarely discussed publicly, pregnancy is hidden or downplayed (expectant mothers are complimented on "carrying well," which is to say they don't look pregnant), and in some cir-

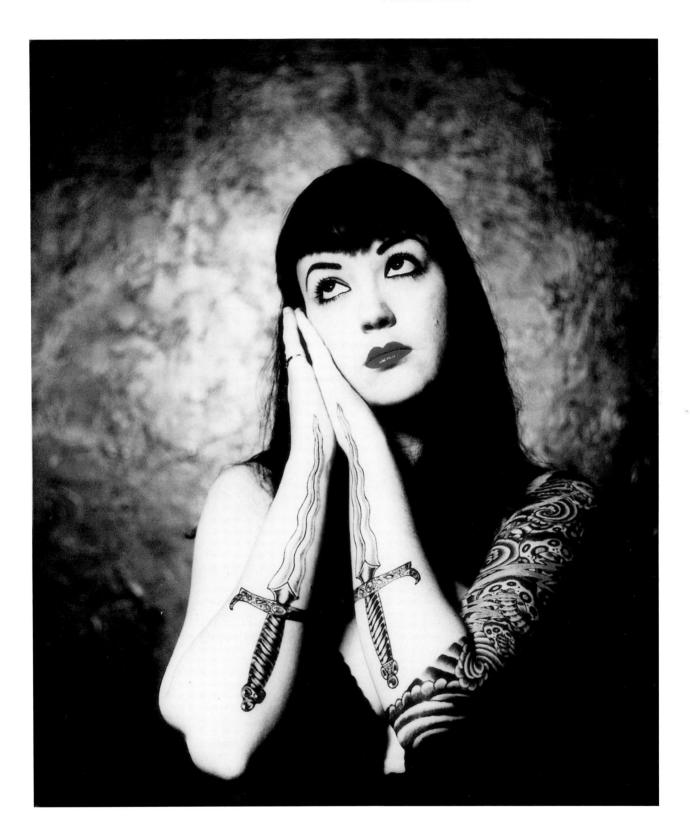

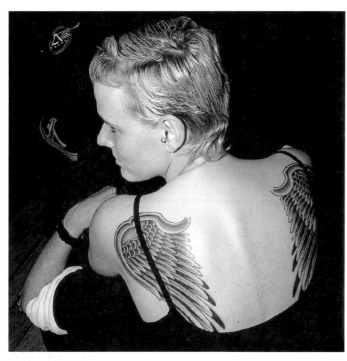

This page and opposite
Photos by Kent Noble

cles, it's still considered impolite to comment directly on a woman's pregnancy. Perhaps because they lack public recognition of private passages that seem so elementally important, many more women than men tend to ritualize tattooing.

Some artists, for example, incorporate drumming and chanting into sessions for customers who request it. Pat Sinatra, who believes tattoos have the power to transform people both spiritually and psychologically, has arranged ceremonies that coincide with a phase of the moon or engage Wiccan or native American rituals. She also lectures at conventions on what she calls "The Magical Marks." In *Outlaw Biker Tattoo Revue* magazine, Sinatra described a typical ceremony at her Woodstock, New York studio:

> The tattoo ceremony...usually takes place during one of the eight traditional celebrations of the cycles of the year, or during the dark or full of the moon. The tattooee, or celebrant, can invite friends to participate in the ritual. We start by smudging or purifying the space by burning sacred herbs.... We then form a circle, join hands, and begin breathing silently and deeply. We are all connected as we gather together to support and help nurture the growth and transformation of the celebrant. I usually break the silence by speaking about the symbolism of the chosen design, and the auspiciousness of the time chosen for this transformation. I then ask the celebrant to tell, in his or her own words, what the tattoo will accomplish. Each remaining participant then offers a word, idea, blessing...whatever... to help charge this tattoo talisman. The energy is raised, grounded, and the clasped hands are released. We begin the tattoo.

Women's emphasis on tattoo as an expression of personal growth has made it a magnet for self-help and New Age enthusiasts in search of new skin for old ceremonies. Juli Moon describes her art as a way of "healing that

wounded child, that hurt place, the pain that's left over from the slings and arrows of outrageous past lives."

But some artists, Fish among them, question such claims. "When you speak too loudly about being a shaman," she says, "it proves to me you're not." Fish remembers "spouting" this kind of talk at the start of her career, and receiving an admonitory letter from Lazonga. "She said, 'if you feel that your marks can heal or effect a transformation, if [the client] has the ears to hear it, they'll bring it up—they'll talk that way and light sage and candles and have their best friend hold their hand. If you talk too loud about spirituality they'll just call you a witch. It just won't work in the average tattoo parlor.'"

Writer Margo DeMello links tattoo's new legitimacy to its self-help associations. "When it started," says DeMello, "it was in the counterculture. [Now] it's not so much about rebellion. It's [done by] middle-class people who basically have all their needs met and are searching for something more. The yuppies that started the [tattoo] renaissance have already dabbled in other movements—astrology or 12-step programs—and some of the language is borrowed from these groups."

For some spiritually-inclined collectors, tattoo's talismanic potential can shade into bald superstition, betraying not empowerment, but impotence. "I had one client," says Lazonga, "who was so ritualistic; every little thing I put on her had a meaning, and she was so extreme that it really made me wonder about her feelings of powerlessness, and [whether tattooing] was a way for her to have some control in her life."

In her 1993 horror novel *Skin*, author Kathe Koja carried this idea to its Grand Guignol finale, describing a woman whose piercing and tattooing led to other kinds of "body engineering," including disfiguring cuts and brands, and surgery to remove bones. "It's not a circus, it's not a *freak* show, it's catharsis!" she tells her nauseated lover when her atrocity exhibition reaches pathological proportions. Her lover, in turn, remarks that this was "no path, no road to enlightenment...she was finding nothing or else there would never be such crippled animal need...."

Others invest tattoo art with more pedestrian powers of transformation. In *Customizing the Body: The Art and Culture of Tattoo*, Clinton Sanders quotes a tattooist whose ethics were sorely tested when a woman client asked him to tattoo her heartthrob's name on her breast. The story falls into a tattoo genre San Francisco artist Laura Vida wryly dubs "crimes against the female breast":

> The girl came in and she said she wanted—a really stupid name—
> Larry Joe Vitelli tattooed around her nipple. I spent about 20 min-
> utes trying to talk her out of getting this guy's name tattooed on
> her...[But the owner] comes out [and] says, "You're going to do this
> tattoo because that is what I hired you to do and that is what she

110

wants"...So I decided I'll do the tattoo. I'm halfway through it—I
got Larry Joe on there—and she starts making passes at me...So I
said to her, "Well, you and Larry must have quite a relationship...you
must really care about each other." She goes, "Yeah, I really love
him, but I have no idea about how he feels about me." She had built
up this totally unreal expectation that tattoo was going to win Larry
Joe Vitelli. I shuddered, I really did, I felt sick...I came back the next
day and I told (the owner), "You can fire me right now, but the next
time somebody comes through the door and wants a tattoo and I
don't want to do it, I'm not going to do it."

Sanders' story is an unsettling example of tattoo's ability to degrade as well
as to enhance, to invoke the sacred *and* the inane. The circumstances sur-
rounding a tattoo, of course, can make it a mark of humiliation regardless
of the iconography it carries. Fish has done cover-ups on women on the
rebound from other parlors, where, she says, "the girl was told she'd get it

for half price if she got completely naked, and
she did. She sat there buck naked and drunk
with her legs spread while the guy tattooed
her butt. And I said, 'Oh my God, you *let* him
do that?' To me, it's a horror—it's a self
esteem thing [that] invokes society's judg-
ment that 'you asked for it if you got raped.'
But she was taken advantage of."

DeMello is quick to point out that although
tattoo has been culturally validated by people
who extol its artistic and expressive poten-
tial, it's still used demeaningly. "People
aren't interested in the women who get men's
names on them," she says, "or who get what
their men want on them because it's sexy and
feminine, rather than 'empowering.' This
still happens everywhere: the man's stamp of
approval goes on their bodies."

Below
Flash by Deborah Valentine
(Photo by Deborah Valentine)

While this mentality isn't limited to the biker community, it prevails there. The stereotype of female bikers as cave women on wheels is roundly reinforced by their tattoo choices: "Property of...." tattoos bearing boyfriends' names are still popular, along with "brands" that read "Property of Hell's Angels" or any other club, and armband "slave bracelets" that spell out the name of a club on the upper arm. One female former biker points out the logic, however, of tattoos that irrevocably connect women—many of whom grew up in dysfunctional or abusive families—to a clan that gives them a sense of belonging.

Like their male counterparts, women bikers also bear mottoes such as "Live to Ride, Ride to Live," and "FTW" (Fuck the World) on their knuckles or on the inside lower lip—an excruciating place to be tattooed. In a more decorative vein, roses are common, along with feathers, both because of their American Indian association and because biker women wear feather earrings to avoid getting slapped by beads or metal on the road.

Tattoo imagery is limited and highly codified in this closed society, whose members usually patronize parlors that cater to their own. But when they occasionally spill into mainstream shops, tattooists are faced with an ethical problem. Appointment-only and private artists are more likely to refuse to do what they find offensive, while tattooists in street shops, who eschew psychological entanglements with clients, more often take a please-the-customer approach.

While some women tattooists assume a guru-like relationship with their clients, many prefer not to know the stories behind people's tattoos because of examples like the above. "I don't want to hear," says Everett, "that the reason they're getting tattooed is that they're getting back together with their husband who beat them up two days ago."

But sometimes the artist's involvement is unavoidable. California artist Chinchilla once opened her door to a couple holding a Japanese box containing the ashes of the two-day-old baby they'd recently taken off life

Opposite
Photographer Kent Noble met this biker at a bus stop in Pittsburgh where she waited to visit her boyfriend in jail. Her right forearm bears a "Live to Ride, Ride to Live" tattoo and part of a "Property of..." tattoo is visible on left upper arm. (Photo by Kent Noble)

112

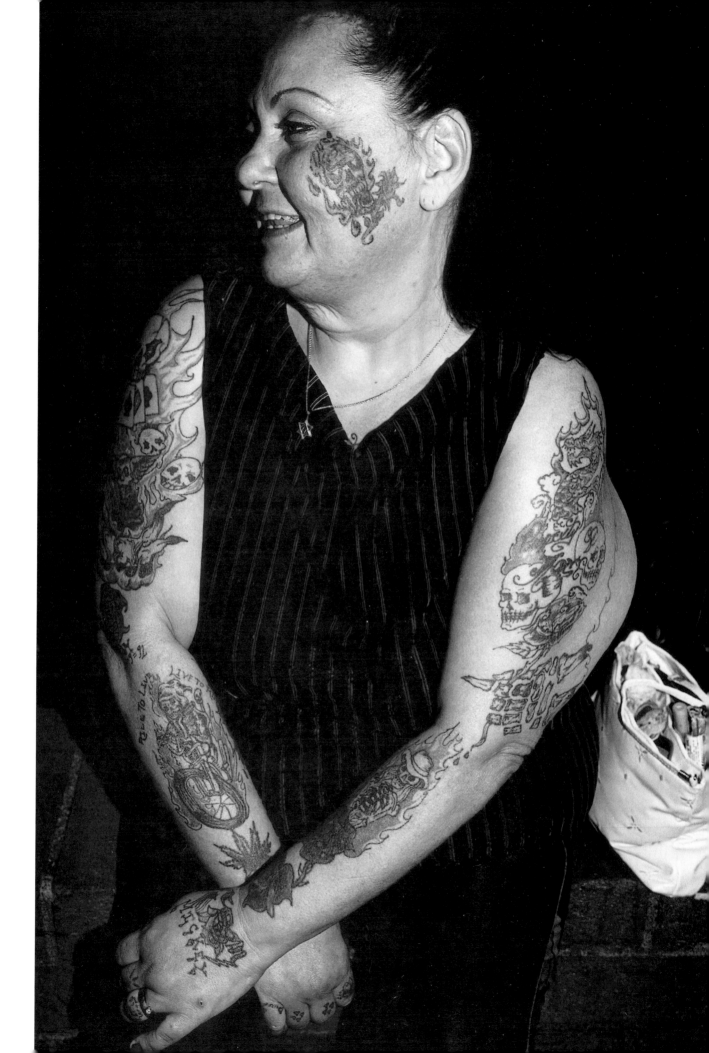

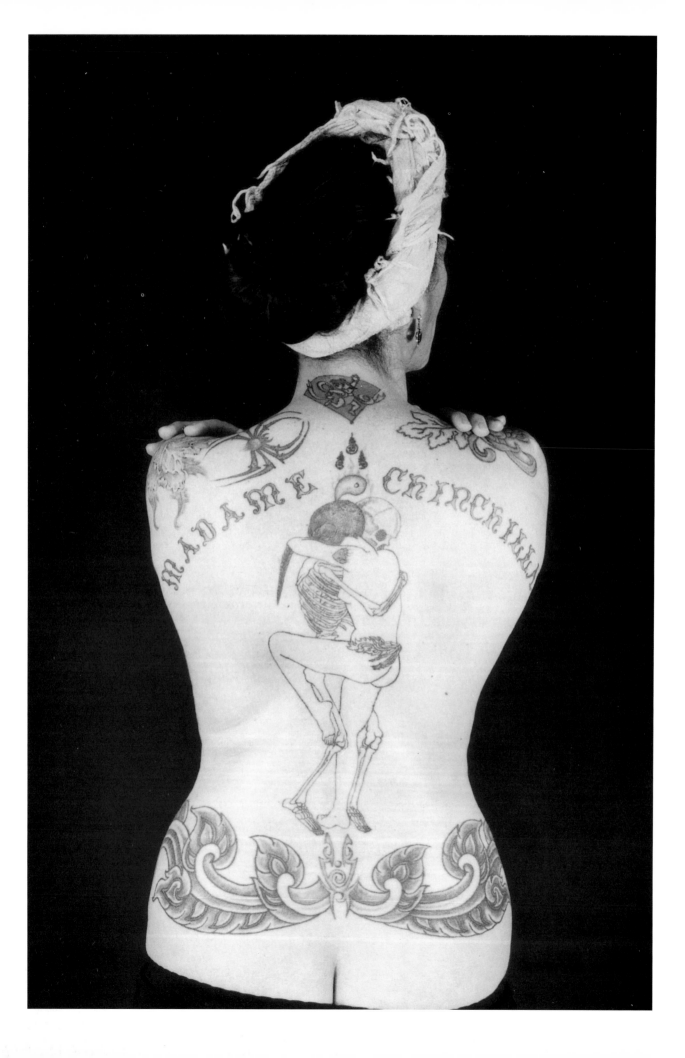

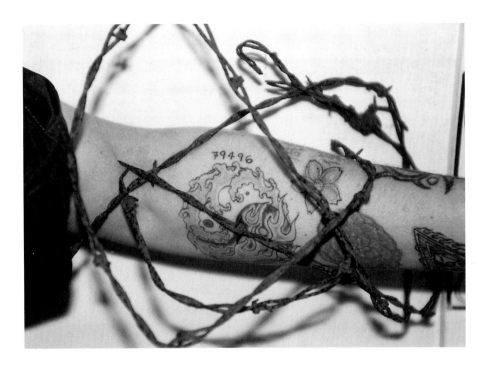

support. They told her their story through tears, and Chinchilla tattooed a purple heart on the mother's ankle, in remembrance. "This was part of her healing process," Chinchilla wrote in her book, *Stewed, Screwed and Tattooed*. "We do many tattoos in our...upstairs studio that are a ritual part of grieving and healing."

Some customers get "healing" tattoos without imparting their meaning to the artist beforehand. Vida tattooed a woman around her lower abdomen, and in the process learned the tattoo was her way of rebuilding her self-image after having been sexually abused as a child. "This woman was doing it for herself, but in a healthy way," she recalls. "She wasn't expecting the tattoo to do more than it could."

Although she's disparaging of the highblown symbolism women accord their tattoos, 34-year-old DeMello got her first tattoo, 12 years ago, in the same spirit: "I was an undergraduate. I was dissatisfied with my life, with school, unhappy with the relationship I was in. So I quit school, became a cocktail waitress, got my nose pierced and got my first tattoo. It was a

Above

While organizing an exhibition called "Tattooing Without Consent," Chinchilla discovered the diary of a tattooer who had put the number 79496 on a baby girl born and killed at Birkenau in 1944. On what would have been the baby's 51st birthday, Chinchilla had the same number tattooed on her arm. (Photo by Mr. G)

Opposite

California artist Chinchilla decorated the interiors of Boeing jets in the '60s. She runs Triangle Tattoo and Museum in Fort Bragg. (Photo by Jan Hinson)

115

This page and opposite
Work by Laura Vida
(Photos by Laura Vida)

dragon on my shoulder blade. I picked it because it was my Chinese astrological sign and it was about strength. [Now,] every middle-class woman I interview has the same story: it was a rite of passage, they were having a difficult time with a relationship—it's a little embarrassing. I actually did feel better after my first [tattoo], like I was taking control of my life, and I still love my tattoos, but now I just define them by saying I like the way they look. It's no longer about inner growth. It's just—wow, I have an empty spot on my arm, I think I'll fill it."

Critics of women who use tattoo as a means of empowerment often question its "real world" impact, arguing that tattooing shifts the focus of women's issues from society to the self; that tattooed women are empowered only in their minds; and that women who find solace in tattoos are no different from women for whom shopping and exercise are substitutes for problem-solving.

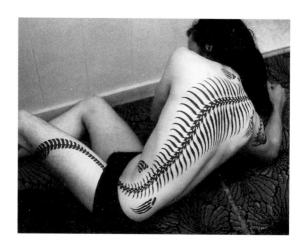

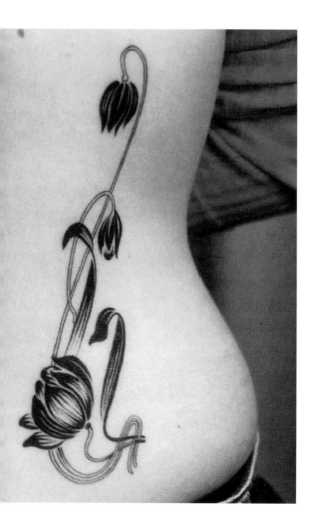

But along with their personal significance, women's tattoos do have "real world" ramifications to the extent that they defy conventional standards of feminine beauty and force the recognition of new, largely self-certified ones. As DeMello has written, "Heavily and publicly tattooed female bodies...liberate the objectified body, literally inscribing it with alternative forms of power."

No one has been in a better position to test this theory than 45-year-old Krystyne Kolorful, who holds the Guinness Record as "the world's most decorated woman" (with 95% percent of her body covered). Soft-spoken yet assertive, Krystyne tramples the cliché of the wanton tattooed woman. With the single exception of her message machine greetings—eccentric aphorisms delivered in the mellow drawl of a self-styled guru—she comes off as grounded and articulate, and resolute about the feminist underpinnings of her tattoo philosophy.

"Heavily tattooed women really confront people with their independence," she says. "Even if you get just one, you're doing something that is so contradictory to the morals of our society. That's why women like me took it to the level that we did: we wanted to make a really big statement that this is my body and I'm doing with it what I choose."

Raised in Edmonton, Alberta in a middle class Canadian family by parents she describes as strict and conservative, Krystyne began getting tattooed in 1970, both as a form of rebellion and for the love of the art. During the early years of her tattoo odyssey she was a zookeeper, a farmer and an office supervisor; later, visibly tattooed, she worked as a hotel desk clerk; after leaving Canada for Seattle in the late '70s, she began a four-year stint as an exotic dancer. By the mid '80s, she was covered from neck to toe.

A commotion of color, Krystyne's body suit more than justifies her stage name. With tattoos by 14 people, including name artists Don Nolan, Don Ed Hardy, Kevin Brady and John "The Dutchman" van't Hullenaar, she sports 13 dragons, one of which is six-feet long and clambers over her chest and back. Her dragons are seamlessly integrated with patches of Japanese calligraphy, waves, phoenixes, flowers, flames, snakes, lizards and vampires. With the exception of small Indian and Japanese erotic figures and the image of a decapitated woman with a bloody hand (the expression, she says, of the dark side of her character), the content of her work isn't unusual, but the quality is exceptional, and her tattoos are artfully mapped across the contours of her body.

Krystyne Kolorful.
(Photo by Dianne Mansfield)

Unlike old-time circus attractions whose quickly-acquired tattoos were tantamount to meal tickets, most contemporary fans buy skin art as a hobby. Krystyne ended up in the *Guinness Book of Records* at the recommendation of her friend, artist Chuck Eldridge, as an afterthought to her pastime. She entered convention competitions for fun—there was no money to made there—and though an appearance on *Donahue* in the early '90s landed her marginal parts in a few films, her tattoos were not a profit-making commodity. In a cultural sense, she paid for them.

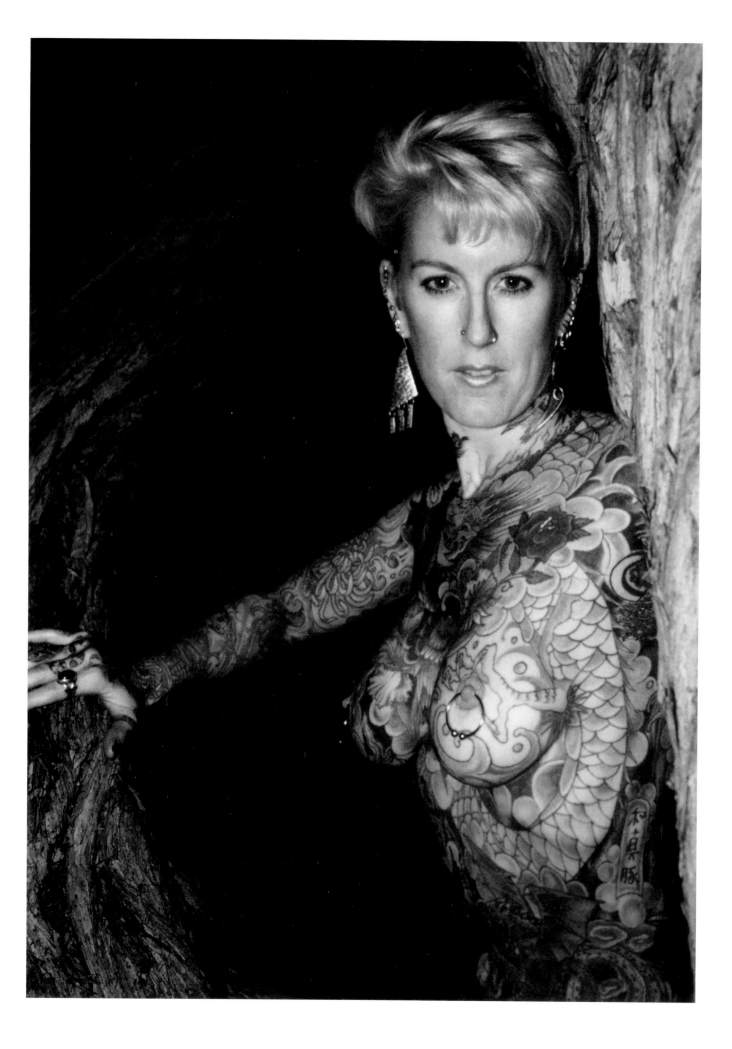

"When I tattooed my hands and my neck, I knew that I was putting myself way beyond the fringes of society," she says. "I was never going to be able to do a million jobs, and I was writing off virtually 90% of the men on this earth. I don't have any regrets about that, but I do regret that [although] I'm a real friendly, gentle soul, before people meet me and even see me, they instantly think I'm this wild woman and I must be really hard to talk to and maybe I'm not very intelligent and maybe I'm a biker babe. I've lost the ability to communicate with people without being judged before I have a chance to open my mouth."

While working on her body suit in the '70s, Krystyne used as incentive a set of Bernard Kobel prints she owned, (the famous Artoria's image among them) admiring them daily and vowing to become "more solid." She revered the circus women who were her forbears and once interviewed for a job with a Florida sideshow—despite friends' warnings that she had a romanticized vision of sideshow life—but she was turned down after being told she wasn't tough enough to withstand the abuse the job would entail.

In America, Krystyne's tattoos brought her novelty as a stripper, but also opened her to the critical scrutiny of the general public. "Because I hung out with like-minded people," she says, "hearing what the masses thought of a tattooed woman just blew my mind: 'You must have been really attractive before you got tattooed,' 'You had no right to do that to your body,' and 'No man is gonna want you looking like that.'" (In fact, she's been married twice.)

But even the tattoo world was not a safe haven for this illustrated woman. Like Cindy Ray before her, she was prey to predatory photographers who bootlegged her photos, and she lacked the business acumen to control, much less cash in on the sale of her image. More than once she consented to a friendly photo by someone who professed merely personal interest, only to find her pictures circulating on $500 posters or turning up in men's magazines. Such piracy, she says, made her see "why people in Third World countries think photographs steal your soul." When she began to

refuse photographers at conventions, they reviled her. In 1983, she finally left her community of painted peers and moved to Vancouver.

Back in Canada, Krystyne made a business decision that would end her working life, tragically, once and for all. To gain a foothold in Vancouver's upscale, highly competitive strip scene, she got breast implants.

"I rationalized that it fit in with my whole idea that I had a right to do what I want to do with my body," she reflects with profound regret. But the implants never served their purpose: they ruptured, releasing an army of toxins into her system and leaving her with what is likely to be a permanent disability. She was forced to quit dancing and has since had five corrective operations. In her Icarus-like compulsion to tinker with her body, she had finally ventured too close to the sun.

Still, she has no regrets about her skin art, which was not only expressive and symbolic, but also transformational. "I found that getting tattooed made me a lot stronger emotionally because of the incredible flack I had to face in the outside world," she says. "It made me assertive in expressing myself, and in defending my own belief that this was a beautiful art form."

Having been sexually abused as a child, Krystyne also used tattooing as a way of writing over the sense of physical violation she'd carried into adulthood, and publicly exorcising it. "Tattooing became a way to tell my secret," she says. "The average person on the street would see my tattoos and think to themselves, she must have had a troubled childhood. It is a public statement in my case. [But] it wasn't my only reason for being tattooed. My tattoos also represent my strong spirit and my spirituality."

Flipping open the novel *Dangerous Attachments* by Sarah Lovett, Krystyne reads a father's description of his pierced and tattooed daughter, in which she sees herself: "somebody's punk nightmare with her pain on display. She has everything a girl could want but she stains and stabs herself for public consumption. It's the exposure I hate, it's the idea that others can see what should remain private."

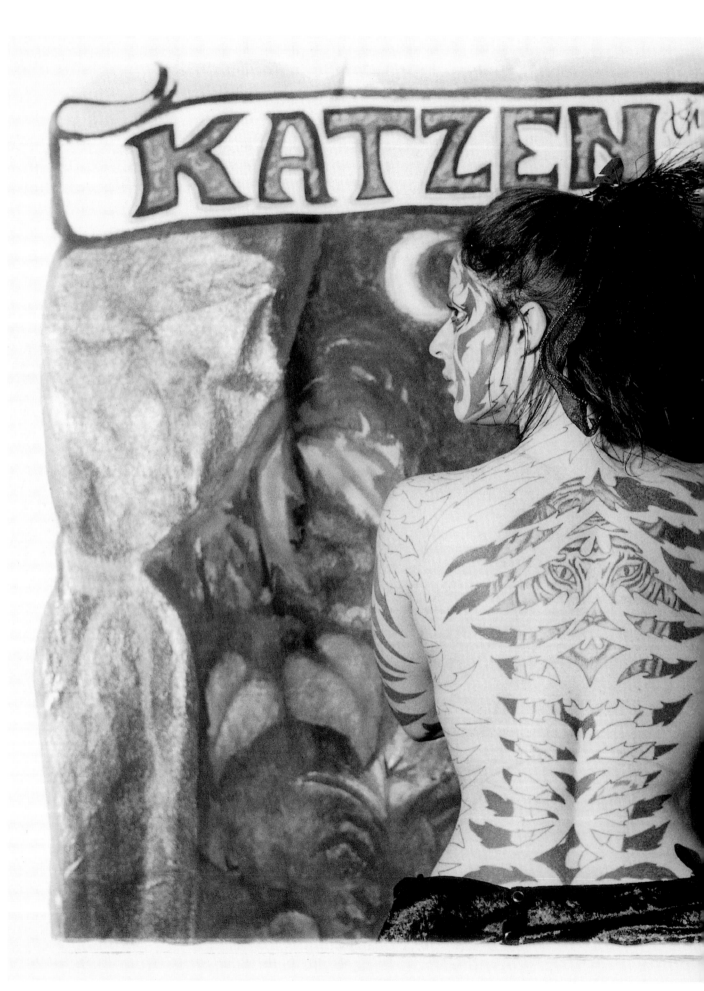

Twenty-three year-old Katzen Lawrance claims to be the first woman with a full thematic body suit. She first saw the markings she wears in a dream: "They were from head to toe, so there was never any option to have the full body suit without the face." She sees herself in the circus tradition of the Great Omi, a popular tattooed attraction of the '20s and '30s who wore zebra stripes from face to feet. For the past five years she has tattooed her husband, The Enigma (a member of the Jim Rose Circus Sideshow), with the blue puzzle pieces that will ultimately cover his face and body.

"People who put a tattoo on their face take it seriously," says Katzen, "or else they're so far out on the edge that you're probably never gonna see them again." She compares everyday reaction to her tattoos to UFO sightings, but says she's happy to field inquires about them. One of the most common questions she's asked is if her tattoos are permanent, to which she responds, "Nothing human is permanent." (Photo by Emily Tucker)

Krystyne relishes the display, and uses it, as many collectors do, as a social touchstone. As Hardy notes in *Modern Primitives*, "A tattoo is never *just* what the appearance is.... You can only *really* know about the tattoo by getting to know the person wearing it. Tattoos are indicators, or little vents to their psyche."

While Krystyne's decision to buck cultural norms through body alchemy may have been personally liberating, it also closed her off from a host of social and career options, which raises an important question about tattooed women: how free can visibly tattooed women really be in a society where they're forced, economically at least, into society's margins? The question is only relevant to serious collectors who can't cover up, few of whom take tattooing as far as Krystyne has without thinking seriously about their futures. Since most serious enthusiasts come to it as nonconformists to begin with, their choice has already been made. They're where they want to be.

"It takes so much guts to be a heavily tattooed lady," says Krystyne, "because usually, you have no support whatsoever. Your family and friends think you're nuts, so you're winging it totally alone. I've been so impressed with the tattooed women I met at conventions: they were such brave, intelligent, conscious, amazing women—that was true for almost every one I met—exactly the opposite of the stereotype."

Mary Jane Haake observes that to an outsider, tattooing may look like a way of quarantining oneself from mainstream society, but to an insider, just the reverse is true: it screens out social flotsam. "When your whole body is a performance as hers is," says Haake, "tattoos work as a filter—no one approaches you unless they can deal with it."

Opposite
Photo by Kent Noble

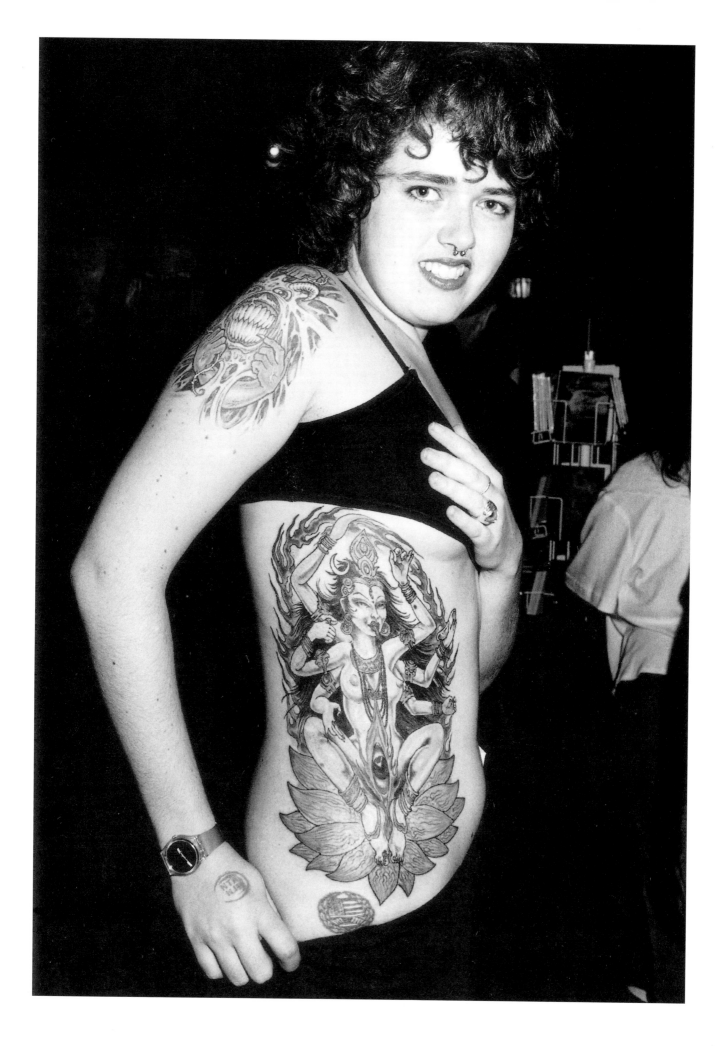

WORKPLACES

Left
Calamity Jane's Tomboy Tattoos in Carbondale, CO
(Photo by Calamity Jane)

Below
Kandi Everett at work in Honolulu, 1984
(Photo by Shuzo Uemoto)

Opposite, top
Jacci Gresham in front of her New Orleans shop
(Photo by Fred Mifflin)

Bottom
Pat Fish in her Santa Barbara shop
Fish takes a maternal approach to shop design: "I use the bassinet theory of interior decoration. While you're in the chair looking up you see flowers and butterflies and kites moving slowly, and they entrance you into being a good baby."
(Photo by Aaron Serafino courtesy Pat Fish)

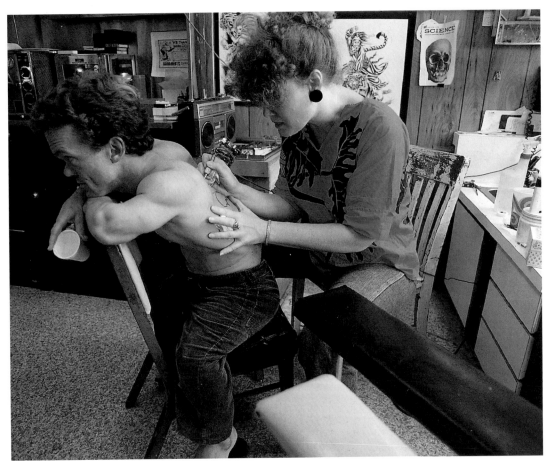

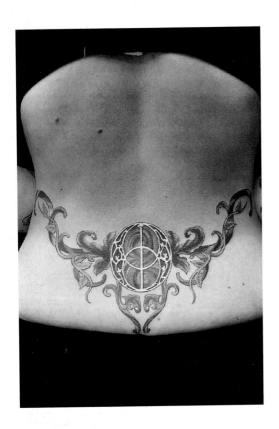

The *Chick* *Spot*

In the '70s, conspicuously tattooed women were typically tattoo artists, bikers, or both; in the '80s, female students, lawyers, models and school-teachers began going under the needle as well. By the early '90s the class and race lines that once defined tattoo art as a white, lower class phenomenon became blurred; with a broader fan base came a proliferation of new imagery drawn from pop culture and art history, and a host of tattoo applications conceived specifically for women's bodies. For the first time, tattooed women began to enjoy more than a modicum of acceptance.

But tattoo's new legitimacy is a slippery one that may attach more readily to the upper class. Just as bluebloods "got away" with being tattooed in the late 19th and early 20th centuries, professional women are at least partially shielded from prejudice by their social status. Laura Bitts, a family physician in Chicago, is one of three tattooed women doctors at Ravenswood Hospital. She wears a full back piece of a Persian sky goddess floating above a city of onion domes, with fractals (barbed, paisley-like swirls of color) climbing over her shoulders and down to her elbows. She calls her work "a kind of body canvas" that has no mystical significance. Except for one "crusty old surgeon" who deduced from them that she'd

128

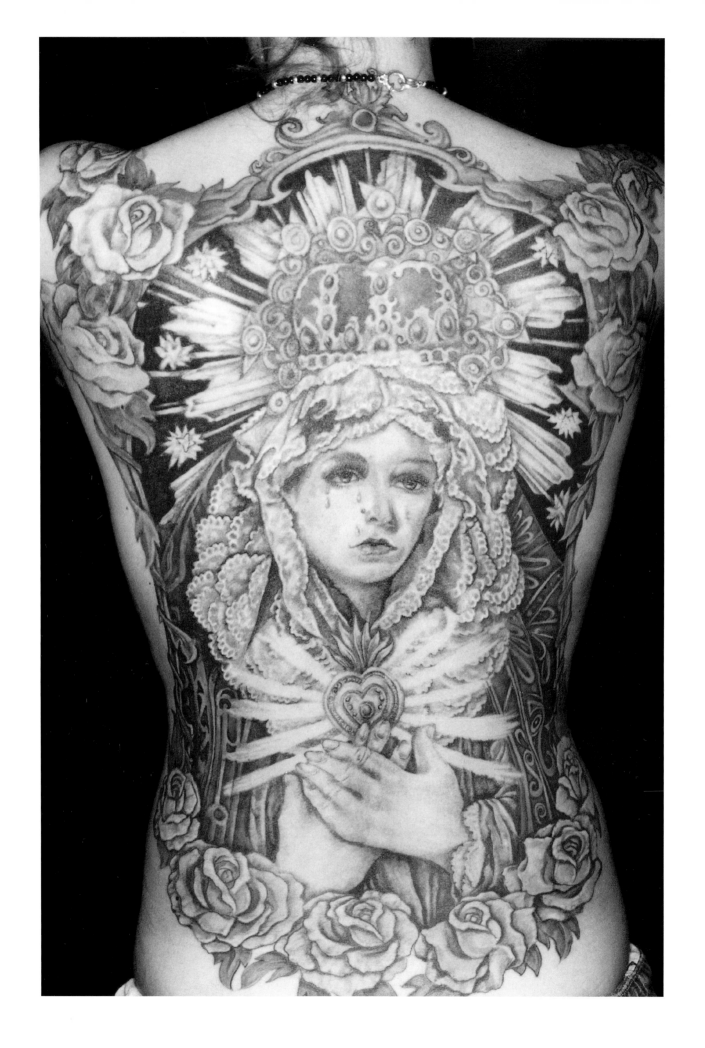

Above
San Diego Swing dancer Alicia Milo
(Photo courtesy Alicia Milo)

Opposite
Black Betty Boops by Jacci Gresham
(courtesy Jacci Gresham)

been in the marines, her tattoos have never elicited derision from her patients or co-workers.

"I think it's certainly harder for women who aren't professionals to wear tattoos publicly," says Bitts. "If you're working some crummy little desk job with a dress code, it's a lot harder to walk around wearing your tattoos in the open—you're an underling. As a professional, you have a different social standing. I wear them covered most of the time at work, except if I'm doing a delivery or scrubbing in a surgery room. Most [women giving birth] are too preoccupied to notice them. When the delivery is over they might say, 'Doctor Bitts, I didn't know you had tattoos!' Usually they're polite and don't say anything, or they're really curious."

Alicia Milo, a 25-year-old professional Swing dancer and receptionist in San Diego, has experienced just the opposite: when she worked as a waitress, she constantly fielded contentious questions about her tattoos. "I have an education and come from a good family, but people think I'm stupid until they talk to me," says Milo, who has a spider web on one elbow, a band of fairies circling one arm, and a plaid sleeve sprinkled with ladybugs on the other. "They think because you look different you have no respect for society and that you're not educated. And people [my age] are offended because *they* wouldn't do it. Well, *I* wouldn't wear the shirt that *you're* wearing—so what?"

Milo's Italian-American parents have never adjusted to her tattoos. "My mother cried when I got my last one," says Milo, heaving the sigh of the battle-weary. "I cover them in the house, or when we go bowling or to the theater, but only for my parents—no one else."

Some artists contend that it's not professional women, but rather the idle rich who alone escape the stigma that tattoos attract, since they can flout social convention without threatening their livelihood. But because so many tattooed women cover their work in public—if only to forestall inquiries about it—it's difficult to generalize about their social acceptability. Vida, for one, says that she has tattooed attorneys, doctors and executives, but never in immediately visible areas.

Although its shifting class implications remain unclear, tattooing's expanding demographic has had a decisive impact on the art itself, inspiring artists to improvise new, sometimes politically-inflected imagery. Jacci Gresham says that her black female clients are asking for increasingly bigger work. They buy African symbols and sometimes request ethnic spins on white American icons, such as Betty Boop, whom Gresham once recast as a black character, triggering a mini-trend among her black women clients.

Opposite
Laura Lee, 1990. Until her death in the early '90s, Laura Lee was the only well-known black woman collector to travel the convention circuit. (Photo by Dianne Mansfield)

Below
Laura Lee wore two portraits of Malcolm X, one (shown here) by Jack Rudy, the other by Jacci Gresham. (Photo by Dianne Mansfield)

Until her death in the early '90s, Laura Lee was the only well-known black woman collector to travel the convention circuit. Lee got much of her work from Gresham, including one of two Malcolm X portraits she wore on her leg (the other was by portraitist Jack Rudy). "She was ahead of her time," says Gresham. "She was getting total coverage before other women did, especially black women. I tattooed most of her body and talked her into getting the African-American pride stuff." Lee also wore an ever-increasing collection of skulls; she said she ultimately wanted to have a skull for every victim of the black holocaust, in which untold numbers of Africans died on slave journeys from Africa to America.

Tattoo has always had particular appeal for women gang members, specifically Latinas, who wear the names of their gangs, boyfriends and children; nicknames; rosaries; crosses (on the web of flesh between the thumb and forefinger) and teardrops indicating the number of years they or their boyfriends have spent in jail. Former LA gang member Rhoda Alvarez, a 24-year-old commercial artist who also tattoos, once inscribed the name of a gang ("Lennox") on a woman's forehead, but says her female clients want mostly "cutesy" work like hearts, flowers and cartoon characters—strangely innocuous choices for women who carry razor blades in their mouths and guns in their purses.

Alvarez has been tattooing freehand (without a stencil) since 1989, when her boyfriend, just out of prison, built her a single needle machine, a common prison device inmates improvise using motors from electric razors

and cassette players attached to ballpoint pens. "It was as if someone put a pencil in my hand," she says, and the imagery flowed spontaneously. She's never met another women tattooist, and although some of her male competitors have bad-mouthed her behind her back, they've come to her, she says, for repairs on shoddy work they did on themselves. She still uses a homemade single needle machine, charging $10 per cap of ink, which buys a small flower and a name.

At the other end of the cultural spectrum, Lisa Paravisini, a professor of literature in the Department of Hispanic Studies at Vassar, recalls two Latina students who were tattooed with the image of La Malinche, the Mexican Indian princess who was Cortez's translator and mistress—a popular figure in contemporary Chicana art and literature. Perceived historically as a traitor (la Chingada—"the fucked one") and the antithesis of the Virgin Mary, she has, says Paravisini, "acquired a following among young Chicanas because of the ambiguities and complexities of her historical role, and the belief that historians have been unfair to her and misrepresented her because she's a woman."

Not only has the ethnic demographic of tattooed women expanded over the last two decades, but so has the age range. While younger women tend to like tattoos for their subversive potential, older women get them more often in the name of self-acceptance. "I get a lot more older clients," says Moon, "[who are] coming into a sense of self, [and saying] hey, it's OK to be me—this is who I am, I really like this person. I want to celebrate this person."

Remarkably, some younger women are discovering tattooing through their Baby Boomer mothers. "My mom paid for my first tattoo when I was 16," a perky pre-med student explained as she was getting an ankle bracelet at artist Emma Porcupine's Manhattan studio, wincing intermittently as the needle moved over her anklebone. "Then she said, 'Let's go smoke a bone.' It's great being a '60s baby!"

Theo Kogan, a tattooed singer in the New York band Lunachicks, is struck by the number of young women she knows who are committing to tattoos. "I wonder if it's because we don't expect to live so long," she says, "because of AIDS and drugs and the fucked up world we're in." Others speculate that shortsighted kids living in a disposable culture simply don't consider the long-term implications of an indelible fashion statement. (Although tattoo removal is possible, it requires multiple, expensive and potentially scarring treatments).

But most tattooed twentysomethings have more invested in their body art than anomie. Everett tattoos young Hawaiians with South Pacific designs—interlocked stripes or chains of geometric patterns arranged in bands up the leg or around the arm—as declarations of ethnic pride. According to Fauser, "younger women are much more interested in being warriors. It's [about] showing their strength and their personal power—or covering up their own personal weakness. I feel that some of them are going to regret their choices in the future. When you're in your twenties, you think you know everything, and they think they know who they're going to be for the rest of their lives."

Although they're rarely worn by women, biomechanical designs are among the boldest new tattoo innovations and artist Andrea Elston is a master of the genre. Initially inspired by the work of artist H.R. Giger (who created the sets for the *Alien* films as well as the monster itself), biomechanicals invoke (or copy directly) Giger's stylized, Art Nouveau techno-gothic paintings, in which human bodies are often wedded to machine parts. Spawned in the '80s, biomechanicals reached their peak of popularity in the early '90s; artists such as Greg Kulz and Eddie Deutsche, respectively, customized them by inserting patterns of wires and circuit boards into "rippers" (trompe l'oeil renderings of ripped flesh) or tribal designs.

A self-taught, highly respected artist who has toured with the Rolling Stones and Aerosmith tattooing band members and roadies, 31-year-old Elston wears a Giger on each leg. One shows a naked woman, fastened by a metal collar to an oxygen tank, fellating a protruding nozzle. The other

Opposite
Singer Theo Kogan of the band Lunachicks. "When I got two [recent] tattoos, I was practically seizuring at one point—your endorphins go wild. But it doesn't last long. There's something very primal about it because it's such an old art." (Photo by Aaron Cobbett)

136

depicts a bug-eyed nude, hands tethered to her chest, who cowers against a tangle of cables and circuitry. Artist Patty Kelley sports a Giger alien best described as a phallus with teeth.

Biomechanicals per se are technically challenging and stylistically fascinating, but some of Giger's specific imagery builds from Freudian visions that are problematic for women, whom he depicts mummified by technology, at once physically restrained yet sexually available. Willfully resistant to the obvious psychosexual symbolism of this genre, both Elston and Kelley refuse to analyze it, saying they simply liked it and wanted it in their collections.

Conversely, one of the most unusual female tattoo images to surface in the early '90s, possibly as a sign of female power, is the uterus: Fauser tells of a Michigan woman with a tattoo of a uterus and fallopian tubes holding man-eating flowers. Sinatra once dissuaded a customer from getting a tattoo of what looked like a pierced uterus because she found its hazy symbolism disturbing. And DeMello recalls interviewing a woman who got the uterus tattoo as a way of "getting in touch with her feminine side."

These images could be construed as skin art updates of Judy Chicago's 1979 "Dinner Party," a landmark feminist artwork in which famous women were honored through dinner plates garnished with vaginal imagery; they also suffer from the same sometimes artless literalism. But there's a certain design logic to what some women loosely call uterus tattoos—V-shaped floral or scrollwork patterns on the lower abdomen that vaguely follow the layout of the reproductive system and offset the subtle curve of the lower abdomen.

Above
Biomechanical tattoo by Andrea Elston, after H.R. Giger's "Work #269, Biomechanoid 75." Elston wears the same image, tattooed by Tin Tin, on her leg. (Photo by Robert Butcher)

Opposite
Tawnja, with tattoo by Darren Rosa (Photo by Jan Seeger)

139

One of the most mind-bending tattoo collections worn by a woman shocked even the tattoo community when Stephanie Farinelli appeared at the San Diego Tattoo Tour convention in 1995. Taking the stage to accept her award for Best Overall Tattooed Female, Farinelli addressed her slack-jawed audience by saying, "What you've heard isn't true: I do like men." Her words broke the ice as the crowd took in the spectacle of a woman with 88 penises tattooed on her neck, thighs and buttocks: drooping, bobbing and dripping penises; penises bearing spiderwebs, flames, eyeballs and the word "mom"; a biomechanical penis suspended by pulleys; and a winged penis torn from its owner, a bone protruding from its mangled shaft.

Embedded in Farinelli's tattoo history is a quiet romance, a mighty act of subversion, and a tangle of confused symbolism. A 26-year-old budget contract analyst for the state of Oregon, she got her first tattoo as a Texan high school senior in 1988: "a punk rock spider web on my head, with a tarantula," she explains in her friendly Texas twang. "I got good grades and always wanted to fight that nerdy image. I failed miserably among the popular crowd in school, threw caution to the wind and got tattooed."

As a freshman at the University of Texas, she went to Austin artist Dave Lum for a cover-up, befriending her husband-to-be, Victor Farinelli, in his shop. "Victor had beautiful pinups [of fat women], and I thought, 'I'd like a pinup of a man—what would that look like? I didn't want to promote a sexist image of a man, which pinups of women do. I didn't want to perpetuate *any* imagery that shows one type of person as ideal, because I bought into that at a young age and it made me feel inadequate about myself. So I chose a necklace of penises [of various sizes]."

Imagine a man generously tattooed with labia, and the reverse sexism of Farinelli's logic becomes painfully clear; regardless of the diversity of the penises she was careful to include in her necklace, her celebration of men still reduces them to their genitals.

"I guess my idea failed in the sense that I [present] the penis [as] the most important part of the male," says Farinelli, "when I don't believe that. I just thought it was a universal symbol of manliness and virility, that I could 'wear' on myself. I thought I could defeat [men's] 'manliness' by putting it on the female body. When I was in college, I took some very good women's studies classes and that's where I was at the time. Maybe I committed a sexist act in trying to make a feminist statement."

Farinelli's tattoo choice becomes more complicated once she discloses her motivations for getting it: "I've always had a problem with my body because I've always had trouble with my weight. I'm not a very sexual person and I don't feel very feminine. I basically just wanted to cover it up. I told Dave [that] and he said, 'Well, we need to work on you becoming more comfortable with your body.'"

Known for his outrageous designs, Lum sat Farinelli down and drew freehand on her upper chest. "He kept giggling while he was drawing," she recalls. "I couldn't move my head to look down or my skin would flex, so I couldn't see what he was laughing about. About 30 minutes into it, he asked me what I thought of the sketches. When I looked in the mirror I was shocked! Once I figured it out I was very amused. And it looked much better than I could have imagined." She gave him the go ahead to tattoo the design.

There is irony in the notion of a man prescribing a string of penises as the remedy for a woman's poor self-image, especially one compounded by a sense of sexual uncertainty. Although Farinelli initially requested abstract, "phallic-looking jewelry," she ended up with a very realistic chain of penises, and has since gone on to collect 12 more, bringing her collection to 100.

Still, the tattoos, says Farinelli, accomplished what she wanted: "They definitely made me feel more comfortable with my body." But the significance of her tattoos have changed since she bought her first piece. She calls her early tattoos "part of the '80s punk rock wanting-to-be-tough look," and her more recent work, "a kind of a hobby, or a testimonial to [my] past." But the punk in her still thrills to the responses her work elicits: "At first people look and they go, 'Oh, how beautiful,' she told *Tattoo World*. "Then they take a second look and they go, 'Ewww...' That's exactly the reaction I want."

No small accomplishment in itself, Farinelli's appearance at the San Diego convention threw even the seen-it-all tattoo citizenry for a loop. "If she was trying to shock, she couldn't have contrived a better tattoo," writer Chris Pfouts later reported in *Tattoo World*. Dubbing her necklace a "Trouble Tattoo—the kind the square media fixates on and the Enemy waves like a flag," Pfouts described the whispers, titters and questions ("Is she a dyke?") she provoked, and having interviewed her, dismissed the charge that the work symbolized sexual conquest or castration.

Farinelli's tattoos stir up confusion in the public mind for the same reason many circus freaks did: they send a fuzzy message about gender. From bearded women to tattooed ladies to hermaphrodites, freaks were fascinating not only by virtue of their physical deviance, but also because of the socio-sexual conundrums they presented: What was it like to kiss a bearded lady? Where did a tattooed woman's tattoos end? Which bathroom did a hermaphrodite use? Indeed, heavily tattooed men and women use tattoo conventions in much the same way that circus attractions used freak shows—as a platform for public spectacle—the difference being that conventioneers view their audiences as like-mined enthusiasts, not thrill-seeking oglers.

Opposite

Stephanie Farinelli. She wanted a male pinup, but, she says, "I didn't want to promote a sexist image of a man, which pinups of women do. I didn't want to perpetuate any imagery that shows one type of person as ideal, because I bought into that at a young age and it made me feel inadequate about myself."

Since this photo was taken, her collection of diverse penises has grown to 100. (Photo by Kent Noble)

142

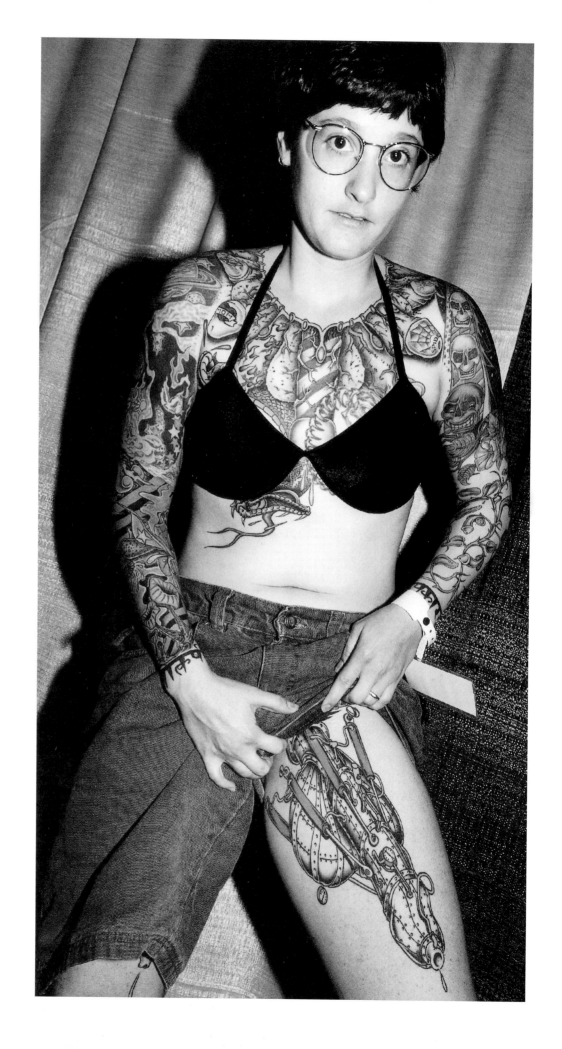

While Farinelli has inverted the symbolism of traditional pinups, some women artists are reviving it. In this era of sex-positive feminism, women are adopting classic '50s pinups as a hallmark of feminine power and eros. Calvin Klein model Jenny Shimizu, a former mechanic who has a flaming spark plug on one arm, sports a pinup straddling a wrench on the other. She got it from Jill Jordan, who says she loves cheesecake for its "feminine excess."

New York artist Denise de la Cerda, who has also done gay male pinups, says she enjoys "doing pin-up girls, mermaids, and the theme "men's ruin" [a classic piece of Americana in which voluptuous women are pictured, along with booze and dice, as a vice] 'cause I can make them more aggressive and a little bit meaner."

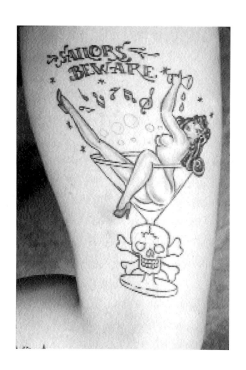

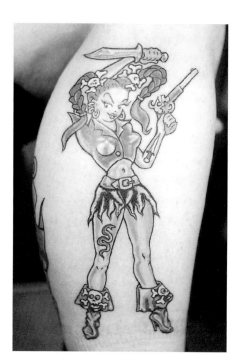

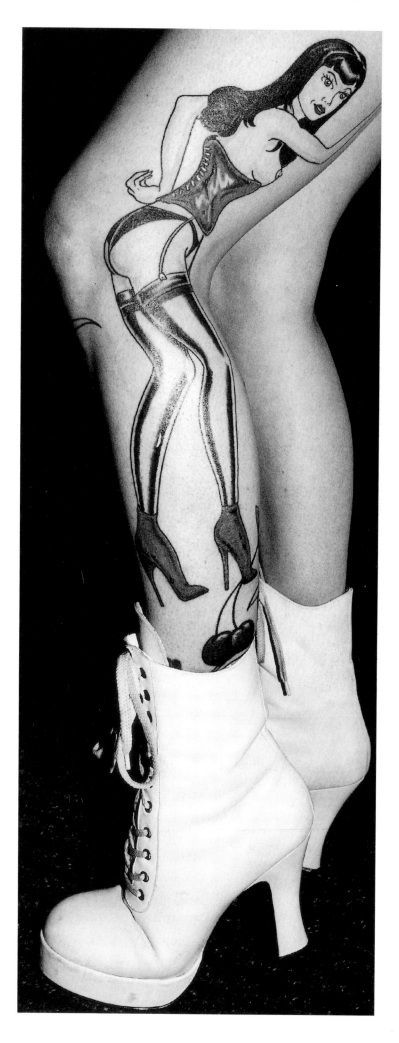

Top
Pinup by Ms. Deborah
(Photo by Robert Butcher)

Above
Pinup by Denise de la Cerda
(Photo by Denise de la Cerda)

Right
Unidentified pinup
(Photo by Kent Noble).

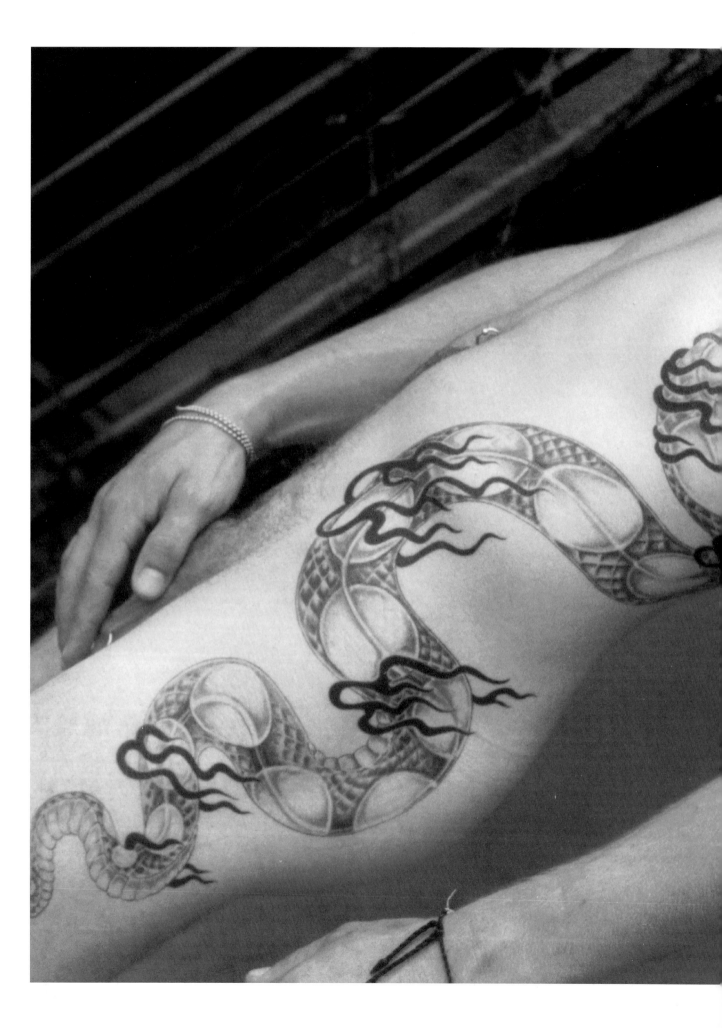

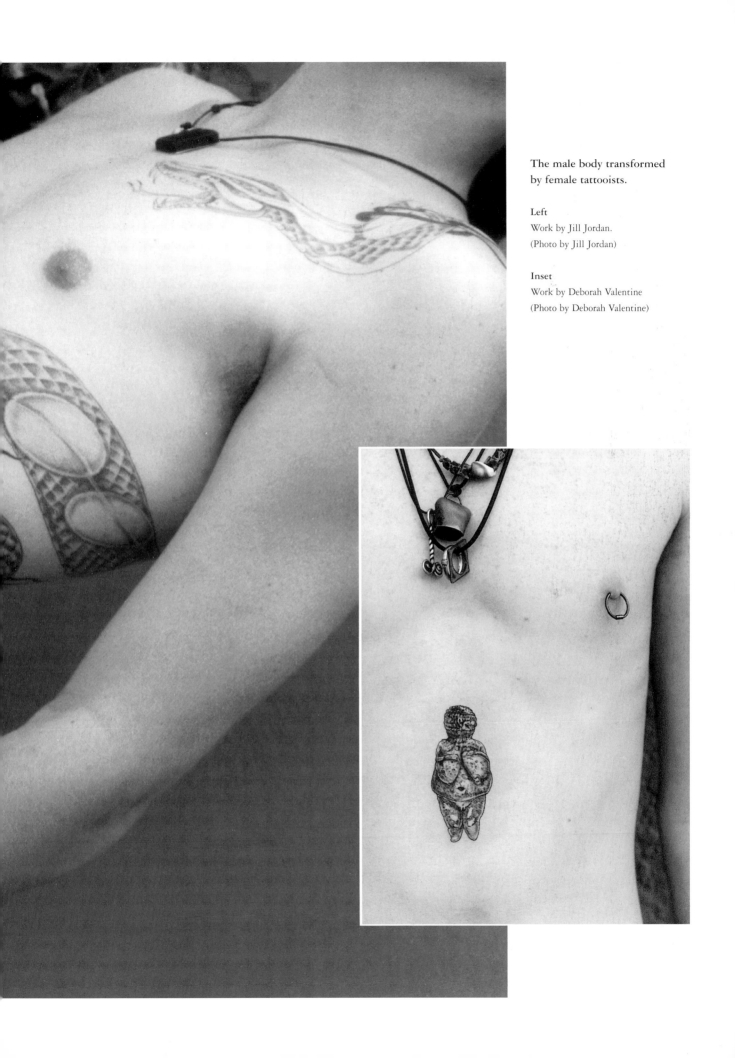

The male body transformed
by female tattooists.

Left
Work by Jill Jordan.
(Photo by Jill Jordan)

Inset
Work by Deborah Valentine
(Photo by Deborah Valentine)

Indeed, the second wave of women tattooists who established themselves in the '80s have considerably eroded the concept of a dominant women's aesthetic. Ohioan Debbie Lenz, who began tattooing early in the decade, is a diehard traditionalist. Inspired by her Irish heritage, Pat Fish specializes in Celtic tattooing—a singularly demanding style with its braiding and knotwork (which became doubly challenging for her in 1996, when she broke her arm in 20 places). She has transferred Irish illuminated manuscripts onto flesh, and, as the owner of a street shop, she also does flash. Fish says she puts a sun, usually tribal-style, on a customer every day.

A former apprentice to California artist Bob Roberts, Jordan is one of the funniest, most versatile and freewheeling tattooists working today. She began her career by "tattooing" her Catholic school girlfriends with a Rapidograph pen. Her ouevre extends from hot-rod imagery to fine art reproductions to intensely symbolic custom designs, like the flaming heart surrounded by teeth she created for an artist who loves medical imagery, whose father is a dentist. Jordan's piece, "Patio Daddy-O" features a stylized steak with cartoon arms and legs and a chef's hat, with the title bannered above and below the figure. She tattooed an airborne Alice chasing the rabbit around one client's ankle, cups and saucers tumbling in their wake; on another, she re-imagined the classic Bengal tiger—a masculine symbol of animal power—as a house cat.

Respected for her Egyptian, Oriental and tribal pieces, classic Americana, and reproductions of paintings by Gustav Klimt and Francis Bacon, Jordan attracts hard-core tattoo initiates as well as high-profile clients, including Cher, who commissioned a rosary on her upper arm. Unlike male celebrities such as Dennis Rodman and Henry Rollins, who flaunt large and often showy tattoos, some famous women choose work that ranges from the timid (Christy Turlington's ankle rose) to the tacky (newly married Roseanne Barr surely regrets getting Tom Arnold's name inked onto her rear). By hiring Jordan, Cher showed more imagination, but, proclaiming tattoos passé, she has since announced plans to have her work removed.

Opposite
Work by Jill Jordan
(Photo by Jill Jordan)

148

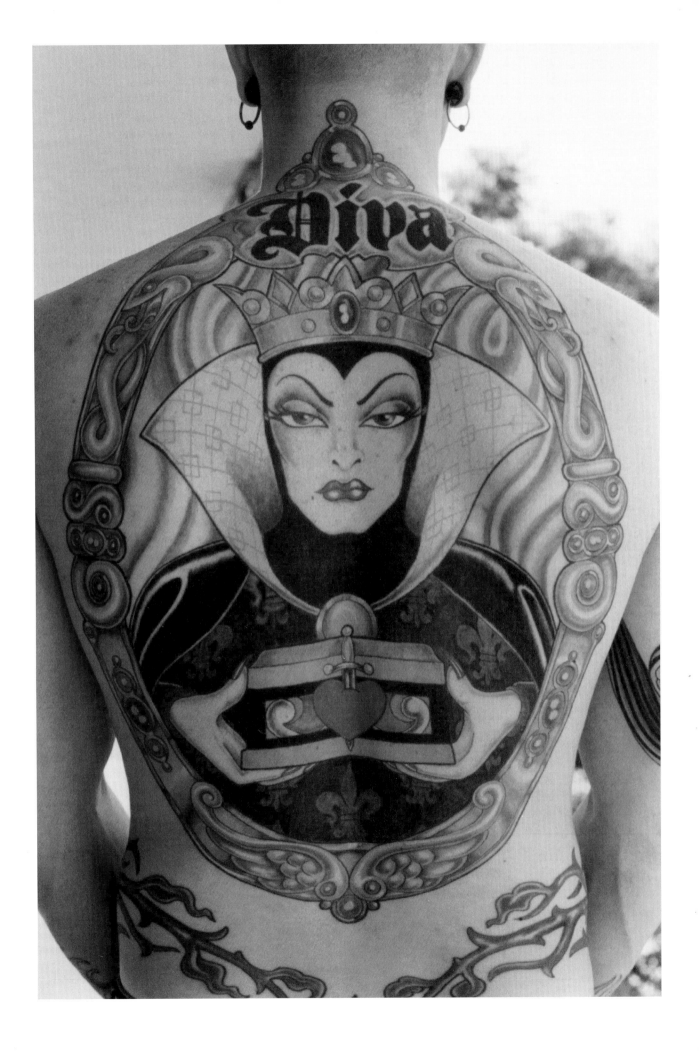

Because of their first-hand knowledge of the female body (and in many cases, their background in fashion), women artists have also brought a new sensitivity to tattoo placement. Says Jordan, who was once a fashion designer, "A lot of girls get what we call the 'chick spot,' down by the butt crack and curving over the hips. That's a tremendously sexy and really flattering way to be tattooed—it just narrows your waist."

Gresham not only advises women about color choices, which are limited for blacks, but like many artists, discourages potential mothers from getting tattooed on the lower abdomen, where a piece can stretch beyond recognition after childbirth. Cosmetic tattoos, of course, are used to conceal scars and skin conditions such as vitiligo, and to "fake" nipples and

This page and opposite
Work by Jill Jordan
(Photos by Jill Jordan)

Below, left
Tattoo by Jill Jordan on
Amy Ray of Indigo Girls
(Photo by Jill Jordan)

areolae on women who've had breast reconstruction. Cosmetic makeup, however, is a form of tattooing some women artists are quick to disparage. Lazonga recently stopped offering it because, she says, "It's like doing psychiatry on top of the technical. You have to be strong with those kinds of women because they're so neurotic for the most part. They'll wear you down in every way."

Tattoos are increasingly being used as solutions for mastectomy scars, in some cases, as an alternative to prostheses or breast reconstruction. Andrée Connors, a writer, eco-feminist and radio talk show host, had the California artist Madame Chinchilla put a rose over her mastectomy scar to balance her remaining breast. Her decision was not only aesthetic, but also political: "This is an invisible epidemic: everybody looks 'normal' cause they're wearing prostheses," Connors told *Ms.* magazine in 1992. "So the message does not get across to the world that we are being killed off by breast cancer."

Another Chinchilla client, Marcia Rasner (whose tattoo history appeared in the introduction to this book), considered getting reconstructive surgery before she was tattooed, then asked herself, "For who? To make other people feel good about the fact that I've had cancer? Prosthetics don't feel normal—they just make bumps in your clothes the right way, which doesn't make me feel any better." Her tattoo produced instant results. "For 10 years, I had been very circumspect about who I undressed in front of—for hot tubs, swimming, whatever—which was not me. Before [the mastectomy], I'd take my clothes off in front of anybody. Now, if they're lucky, I might let 'em take a peek."

Opposite
Andrée Connors
(Photo by Deirdre Lamb)

Rasner's tattoo allowed her to rebuild her physical and sexual self-image on her own terms—not those of the American Cancer Society, which, she says, all but demands that post-mastectomy patients wear prostheses in the name of looking "normal." The tattoo also gave her the satisfaction of attacking the site of her illness and spitting in the face of death. Her decision to embellish rather than conceal her mastectomy site echoes Krystyne Kolorful's sentiments about women's need to speak up about body issues—if necessary, through tattoos. For Rasner, tattoos were one of many steps she took toward emotional healing and physical self-acceptance.

"I've been quiet about [my experience] for 10 years," she says, "but I feel the story's complete now, and it's time to tell other women so they can hear it and realize that I didn't have any special training for this life, it just happened to me. I didn't become a fitness freak or find God, I'm still who I am. And I've come through the other side."

Opposite
Marcia Rasner
(Photo by Bruno L'Hoste)

Resistance Through Style

In his memoir, *Seven Tattoos*, novelist Peter Trachtenberg describes the comical moment of truth when he reveals to his Old World Russian-Jewish mother the tattoos he has hidden from her for years. "You think I'm shocked?" She asks. "I'm not shocked...disgusted maybe, but not shocked."

Having penetrated mainstream culture, tattoos—except in extreme cases like Farinelli's penis collection—have lost much of their ability to outrage. Nothing confirms the mainstreaming of tattoo art as decisively as Tattoodles, a tattooed children's doll sold with extra stencils for the serious kiddie collector. A recent Swatch ad features men with Marquesan tattoos on their heads and torsos, and in the early '90s, fashion models hit the runways wearing fake (and real) tattoos and "tattooed" body stockings. But in the public mind, tattooing still belongs to men, as the Jim Beam company confirms in an ad in which a tattoo needle attacks a hairy leg, captioned, "Get in touch with your masculine side."

156

Above and opposite
Tattooing by Women magazine.
Launched in 1991, it introduced 90
women artists from the sublime to the
subpar in its first four issues.
At least a dozen of them had been
working since the '70s.

This view prevails in the mostly male-owned tattoo media as well. Artists like Chinchilla, Lazonga and Jordan have tackled new formal challenges in customizing tattoos for women, but one would never know it from looking at the tattoo magazine market that's been booming since the '80s. The low visibility of women artists in two high quality magazines, *International Tattoo Art* and Don Ed Hardy's (now defunct) *Tattootime*, is understandable in light of their historical slant (nonetheless, *International Tattoo Art* founding editor Jonathan Shaw made obeisances to women in his 1993 debut issue, introducing it as "the first worldwide, glossy magazine dedicated to the art and history of tattooing that doesn't have a biker magazine for a father and a centerfold for a mother.") But publications like the hilariously titled *Outlaw Biker Tattoo Revue*, *Tattoo*, and *Skin and Ink* double as soft porn. (The newly revamped *Skin and Ink* even has a centerfold section unabashedly titled "Skin and Ink Babes.") While the men photographed in these magazines keep their pants on even if it means cutting into tattooed body suits, the women often go topless whether their tattoos are on their breasts, buttocks or biceps.

"If you don't have your shirt off, they don't particularly want you in their magazines," says Elston, who posed—clothed—for what she understood would be a head shot for the cover of *Outlaw Biker Tattoo Revue*. She later opened the magazine to find her image had been turned into a centerfold. "It was a sleazy-looking shot I wouldn't have approved," says Elston, who resented that the photo shifted the focus of the article from her art to her looks.

In 1991, *Outlaw Biker Tattoo Revue* publisher Casey Exton launched *Tattooing By Women* (sometimes published as *Tattoos for Women*), because, according to its female editor, Jean-Chris Miller, Exton was "interested in showing the public that there were women tattoo artists doing work as interesting and important as male tattoo artists." And so a ghetto was born. But it was a thriving ghetto: the magazine's first four issues introduced 90 women artists from the sublime to the sub-par, at least a dozen of whom had been working since the '70s.

"[Because of] the old boys network in tattooing, it's been difficult for women to get exposure at the conventions, in the competitions and in the magazines," says Miller. "Despite our magazine, this problem has increased over the past few years. [Historically], tattoo artists were very territorial and protective, so essentially when they got older they would take on one male apprentice, hand down the secrets of the trade and die. That tradition carried on in a masculine vein for years and it's just never really opened up for women."

Miller chalks up the imbalance she describes to the superstar status the cresting tattoo revival has conferred on many male artists—but few women—in recent years. In its first few issues, *Tattooing by Women* neglected to print the sur-

names of the artists it covered, the logic being that because there were so few women tattooists, readers would recognize them by their given names alone. Until Miller changed the policy, the contents page looked like a list of playmates of the month, good for a furtive peek but not worth remembering, much less hiring. Early issues also advertised sex videos touting the charms of Wendy Whoppers and Tiffany Towers (who had clearly pursued their own methods of body modification), calling into question the motivations of *Tattooing by Women*'s readership: tattoo zealots interested in women's work, or soft porn fans fixating on bare flesh?

Since *Tattooing by Women* has taken off, attracting advertisers outside the sex industry, Miller has gained editorial control and the magazine has become more overtly political and provocative (featuring, for example, a menses-obsessed Georgia artist named Lesley Allen who works tampons and maxi pad boxes into her tattoos). But the covers, which once ranged from girlishly fun to discreetly elegant, are another story. A recent issue serves up a come-hither Juli Moon in a black lace bra astride a motorcycle, her pants unzipped to reveal—a tattooless belly. Issue #18 covergirl Patty Kelley appears topless with a woman hugging her breasts from behind—never mind that Kelley's tattoos are on her upraised arms. The photo, taken by Exton himself, looks like it was shot in a cave; Kelley's upsidedown tattoos are underlit and out of focus, but her overexposed breasts are show-stealers. Even given that tattoo fans are known for proudly flaunting their bodies, this photo, on the cover of a magazine intended to rectify women's frivolous treatment in the business, is an embarrassment.

A new all-woman convention, founded by Orlando artist Deana Lippens, is plagued with a similarly dyspeptic blend of good intentions and questionable execution. The title, "Marked for Life," plays up tattooing's stigmatic associations while it neglects the convention's female focus. The brochure features an amateurish drawing (by a man) of a bikini-clad tattooed woman whose claw-like hand fondles the phallic tip of a man-sized tattoo machine. Having ratcheted up the number of women judges from none in 1996 to one (in six) this year, Lippens unaccountably trumpeted

not the addition of a female judge, but the predominance of men in the convention catalog: "Our judges this year are all male except our own beautiful Suzanna [sic] Fauser." Ramming home this patriarchal fixation, the copy continues: "Our photo journalists this year are all male except the very talented Jan Seeger." Finally, some were struck by the illogic of a women's convention with an award that honors men (coyly titled the PMS Award, for Professional Male Support) who have helped women in the trade.

Its misguided sexual politics notwithstanding, the Florida convention has drawn some top-notch artists including Kelley, Fauser and Barba. (Asked why she didn't invite luminaries Kandi Everett, Jill Jordan and Laura Vida, among others, Lippens said she'd never heard of them). Andrea Elston declined an invitation because she doesn't think women tattooists should isolate themselves from men. "Tattooing is not like a sports event where women would be at a disadvantage competing with men," she says, "and I would resent it if there were an all male convention I couldn't attend."

A contestant at Pittsburgh's Meeting of the Marked convention, 1995 (Photo by Kent Noble)

But some would argue that women *are* at a disadvantage at coed competitions. Miller claims that women artists rarely get the recognition they deserve, and some artists have observed that women collectors, like female bodybuilders, face a double standard when they compete: beautiful tattoos

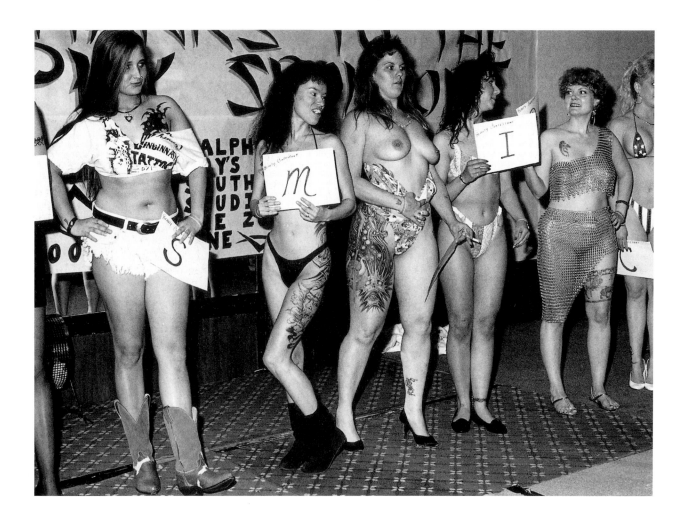

are more likely to win awards if they adorn shapely bodies. While men schlep onstage in a standard-issue wardrobe of saggy jeans and bare backs or tee shirts, women often strut their stuff wearing high heels, bikinis, and the occasional evening gown.

A year before winning the Best Overall Female award at the San Diego convention, Farinelli and her husband competed unsuccessfully in Chicago. "I felt that I was not feminine-looking enough and scantily-clad enough to win," says Farinelli. "I got a wardrobe change, went on a diet, and won first place the following year. Even with female judges, the women's contests can be biased and degrading. One judge asked this other

Above
Male contestants wearing standard-issue
wardrobe of saggy jeans and bare backs
or tee-shirts. (Photo by Margot Mifflin)

girl if she would just rest her ass on the table in front of him so he could get a better look."

The issues of sexism and separatism in the tattoo world divide women along the same feminist/post-feminist lines that define similar debates in mainstream culture: there are those who accuse women who've been helped by men of being blind to the inequities of the profession because they received special treatment, and others who say women artists who cry sexism are simply lamenting their own less than stellar careers. Indeed, women tattooists' responses to the subject of discrimination vary widely, from outrage at charges of inequality to laughter at the suggestion of parity.

Ms. Deborah [Inksmith] speaks witheringly about a former boss's "testosterone poisoning," while Vida says, "The three men I've worked for didn't treat me any differently than a guy, didn't expect more or less from me

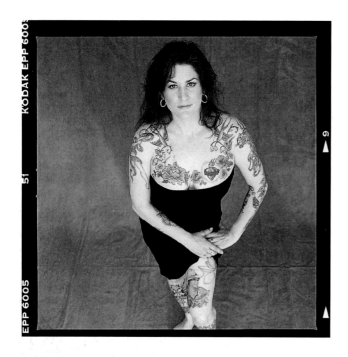

Above and opposite
New York bar owner Deb Parker.
Parker got some of her tattoos for
friends who died of AIDS, others for
friends who had babies, and recently
tattooed her breasts in memory of two
friends she lost to breast cancer.
(Photo by Charlie Pizorello)

because I was woman. Which is great, because that's how I was brought up—you're not a woman tattooer, you're a tattooer. You're not a woman lawyer, you're a lawyer."

Colorado artist Calamity Jane who started in the late '70s, worked for or with many illustrious male tattooists, including Bob Shaw and Mike Malone. Men in the trade, she says, "tolerate your existence, but they're only interested in having women in the shop as a gimmick rather than as coworkers. It took me a long time to realize you've got to have your gun belt on straight because with the old timers at least, women are not on the same level as men."

As for professional recognition, Jordan feels women haven't done the kind of work that would earn them equal status in the field: "Just as in art history—yes, [there are] great women artists," she says, "but because of history the majority have been men. It's only in the very last few years that I've seen any women artists that I admire, let alone would want to have work from. As far as really great [ones], there's maybe 10."

Some artists in their 40s and 50s resent having paved the way for newcomers who refuse to believe the trade was ever inhospitable to women, while other veterans are sensitive about embracing a victim mentality. Lazonga is constantly held up as a Joan of Arc who blazed a trail for women, suffered the cruelest indignities, and was by all accounts emotionally damaged by the ordeal. But she's adamant about taking responsibility for her own experience: "If I was scarred," she says, "I did it to myself. I didn't know to protect myself. For me, sharing was the key, not competing."

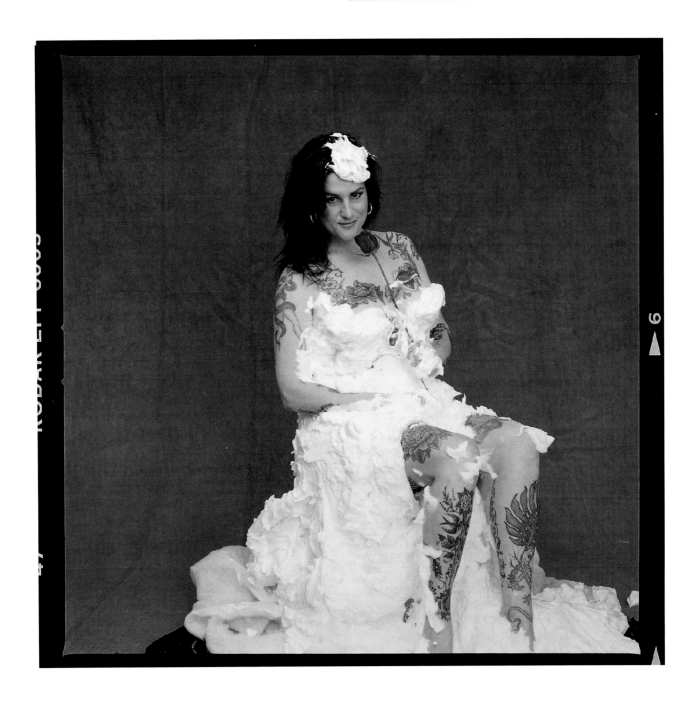

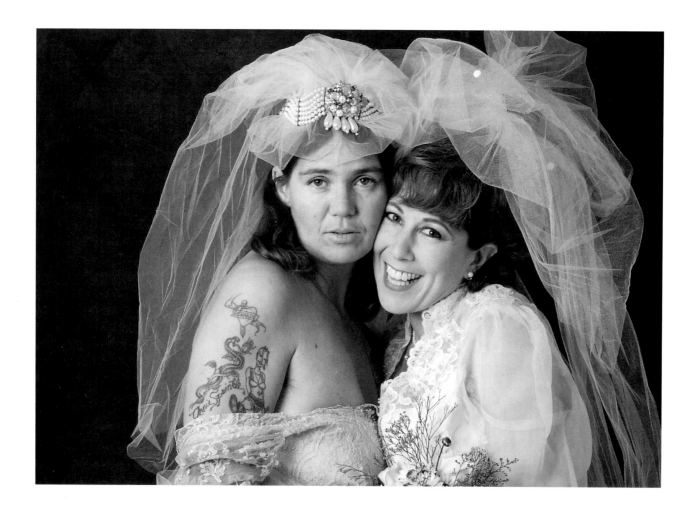

Sex activist Annie Sprinkle (right) and
her lover, Kimberley Silver, sealed their
self-sanctioned marriage vows with tat-
toos. Sprinkle, a casual tattooist who
learned from Spider Webb, tattooed her
"stage" name on Silver's arm during
their courtship. After their marriage,
Silver had Sprinkle's birth name,
Ellen, tattooed below it, along with
"Kimberley," a lovebird and two hearts
joined by a wedding ring. Sprinkle
cried when she saw it, saying, "No one
ever loved Ellen before."
(Photo by Brad Fowler)

Although some male tattooists report having overheard other men grous-
ing about female impostors infiltrating the business, most women who
began working since the early '80s confirm that they've had little trouble
arranging apprenticeships (mostly with men), commanding equal pay and
setting up their own shops. Indeed, more than half the women mentioned
in these pages learned from or formally apprenticed with men.

As artists involved in what has long been considered an ignominious pro-
fession, most female tattooists are more concerned with legitimating their
art than validating themselves as women artists, a project that nonetheless
requires the debunking of culturally ingrained myths about the sanctity of
women's flesh. They've set out to topple the notion that tattooing is a vio-

lation of nature, promoting it rather as a cele-
bration of the self. Says Fauser, "We're not
demeaning or scarring ourselves, we're trying to
beautify [our] temple and learn self-love and
self-expression."

"I can't imagine myself without tattoos,"
Lazonga told *Tattoo Advocate* magazine. "It
would be like not having an identity. When my
friends and I look at people who aren't tattooed,
especially people that have a lot of character and
personality, it seems only natural that they
should have a tattoo! They should have this out-
ward expression of their inner being."

But whether they see tattoo art as an embellish-
ment of or an intrusion on the "natural" body;
whether they build their collections, as
Krystyne Kolorful and Stephanie Farinelli did,
on a bedrock of sexual politics; and whether or
not they call themselves feminists, tattooed
women constitute a subculture whose political
implications are undisputable. In *Subculture:
The Meaning of Style*, Dick Hebdige defines sub-

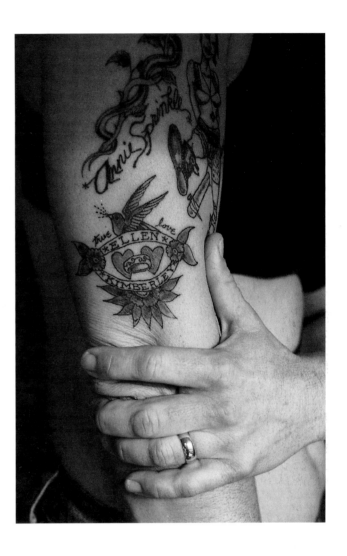

Above
Detail of Silver's arm
(Photo by Annie Sprinkle)

cultural rebellion as "resistance through style," noting that "its transfor-
mations...[interrupt] the process of 'normalization.' As such, they
are...movements toward a speech which offends the 'silent majority,' which
challenges the principle of unity and cohesion [and] contradicts the myth
of consensus."

Tattooed women achieve Hebdige's "resistance through style" by running
roughshod over socially-sanctioned visions of femininity, flouting conven-
tional expectations as well as those of some feminist factions. Like body
builders, who contest the idea that a "built" woman isn't a *real* woman, or
feminist pornographers, who puncture the myth that objectified sex is

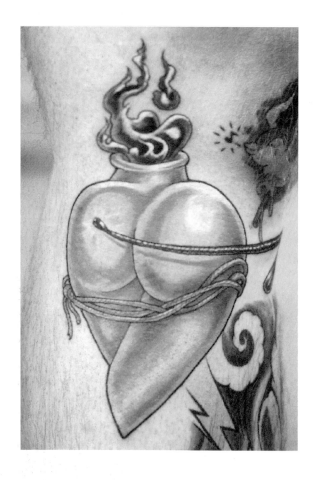

necessarily exploitative or degrading, they're rewriting the ground rules for women's self-representation.

As a "man's" art now increasingly worn by women, tattoo is also a Rorschach blot that registers society's stubborn attachment to traditional gender codes. The woman who told Cindy Ray, "anyone can see you're a bloke, you've got nude girls tattooed all over you," equated emblems of virility with manhood itself; Ray's pinups blinded the spectator to her actual sex. A similar bias applies to tattooed women in the military: despite having been accepted into a quintessentially masculine sphere, they're nonetheless expected to maintain a typically feminine front in which tattoos—despite their entrenched military associations—don't wash.

Even some who see tattooing as a statement of independence—a raspberry in the face of society—set limits on how far a woman can take it. "The person who gets tattooed is telling people that he is free enough to do what he wants to do," one of Clinton Sanders' interviewees remarked in *Customizing the Body*. But that freedom is reserved for men: "If a woman gets a woman's tattoo," he continues, "that's normal. If she gets a man's tattoo symbolizing vengeance or whatever, I feel that is too far over the boards."

While tattooed men constitute a coded and fascinating subculture—one that's inspired pointy-headed scholarly studies and admiring magazine articles—tattooed women offer especially rich symbolic soil for the sifting, because of their radically evolving public image. In the past century, women have experienced a "coming out," both physically and culturally, while ideals of masculinity have remained stagnant, with the exception of long-haired hippies of the '60s, androgynous glitter rockers of the '70s and the occasional gender-bender, such as RuPaul, of the '90s.

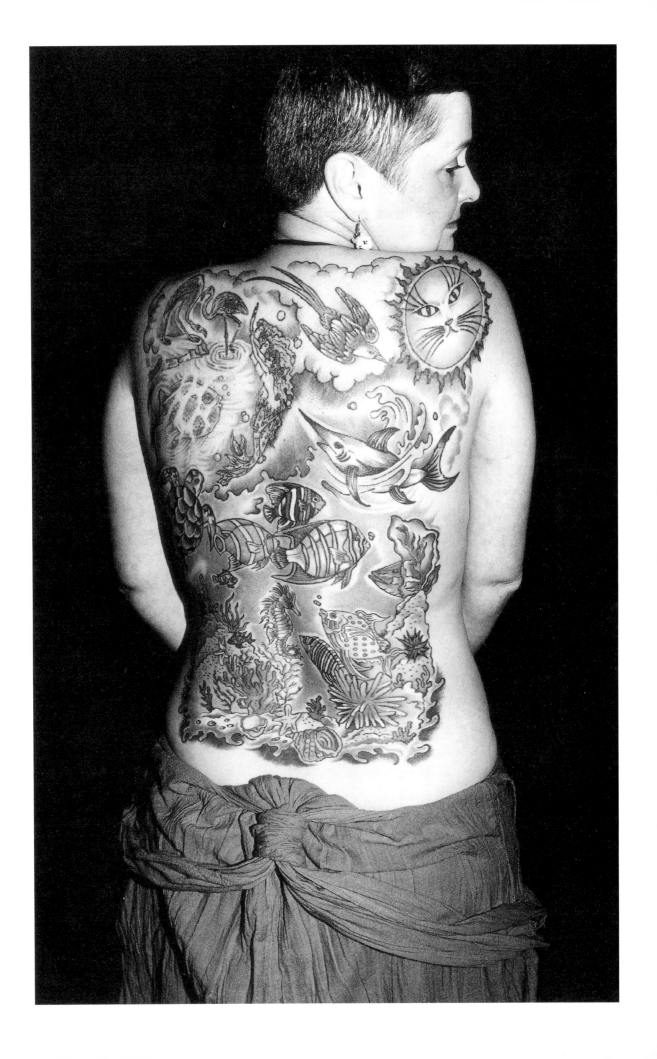

In the early 1800s, for example, the very phrase "public woman" described a prostitute. The term changed as proto-feminists shouldered their way into the political arena, legitimizing women as public citizens. By the 1860s, society women began to attend the theater, and actresses—until then tantamount to prostitutes—were welcomed into polite society. Tattooed women likewise were able to display themselves in the 1870s because of inroads made by their politically outspoken sisters. But theirs was a dual attack on social protocol: by both altering their bodies and parading them publicly, tattooed ladies represented a crack in the rockface of "natural" womanhood and feminine propriety that, by the 1990s, would become an avalanche from which a cross-dressing, sex-loving single mom named Madonna, for one, would tumble.

Opposite
Dutch Artist Morbella
She apprenticed with Hanky Panky in Amsterdam, took time out to study as a bullfighter in Mexico, and now owns a shop in Málaga. (Photo by Emilio)

Below
Carla, the only woman tattooist in Argentina with her own shop. (Photo courtesy Carla)

170

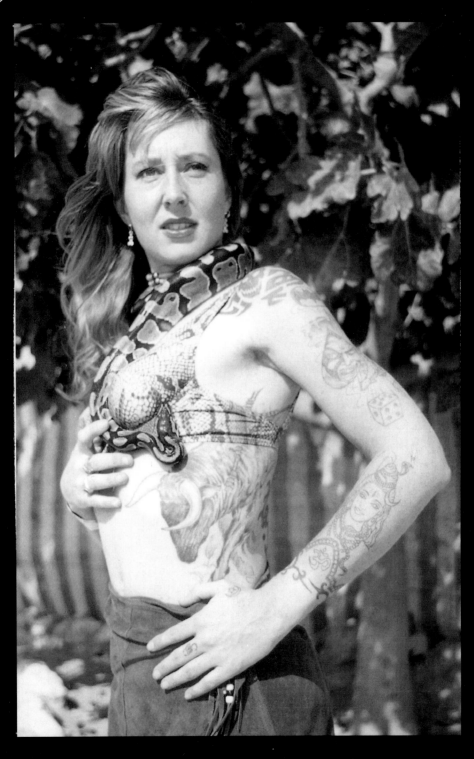

EMILIO
fotógrafo profesional
228 02 94

INSTITUTO de ESPAÑOL
PABLO PICASSO

In *The Decorated Body*, social anthropologist Robert Brain calls body modification "an attempt to put on a new skin, a cultural, as opposed to a natural skin." His observation is particularly resonant for Western women, whose ties to nature have historically been used to validate their exclusion from culture. First Wave feminists attempted to transcend the nature/culture dichotomy by reforming the political institutions that denied them an equal voice. In the '70s, some Second Wave feminists inverted this dualism, claiming women's moral, intuitive and maternal qualities made them not only different, but in some ways *superior* to men.

Opposite
Morbella's tattoo shop in Málaga
(Photo by Andres)

Below
Female bullfighter tattoo by Morbella
(Photo by Morbella)

173

This page
Tattoo flash by Jennifer Heron
(Photos by Jennifer Heron)

Opposite
Photo by Kent Noble

Today, the nature/culture conflict, specifically as it relates to the body, stands at the very heart of feminist discourse. "Difference" theorists, like Camille Paglia, urge women to accept their differences and use them—especially their sexuality—opportunistically. Conversely, "equality" feminists like Carol Tavris question the soundness of biological explanations for gendered behavior, chalking many such differences up to socialization. More important, they see the nature/nurture debate as a distraction from feminism's basic goal: equal opportunity, regardless of difference.

Out of this fundamental ideological rift, orthodox feminism of the '70s has atomized into clusters of micropolitical factions, or *feminisms* of the '90s. Often more political in deed than doctrine, some of these groups have sought expression in male-identified cultural activities, from punk music to underground cartoons to tattooing. As Katherine Dunn put it in *Vogue* magazine, "Women on the same level as men insist on using the same

174

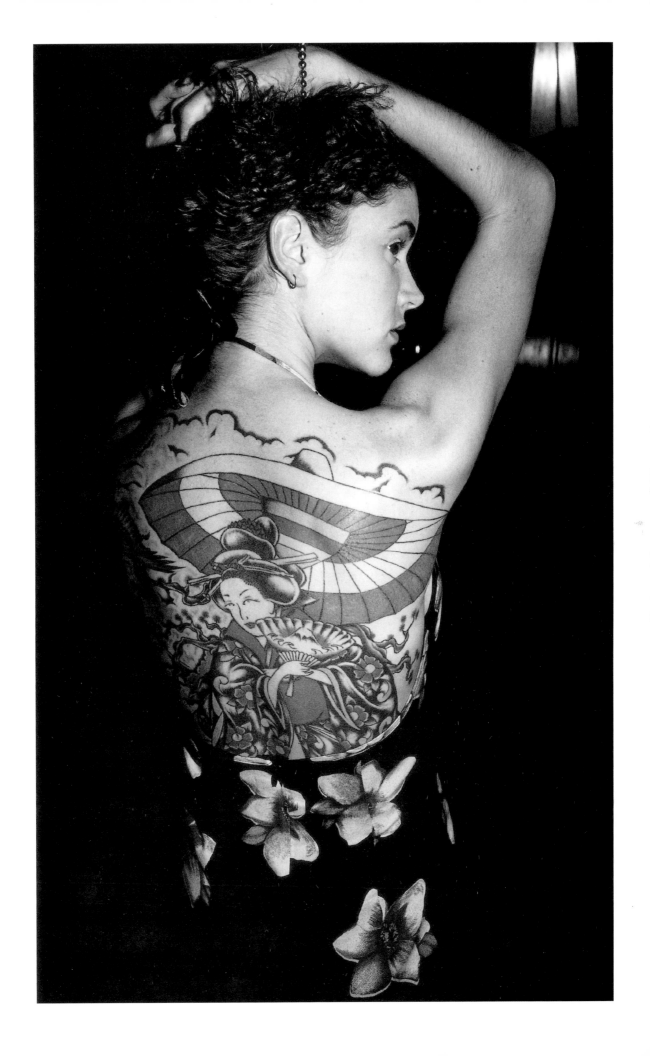

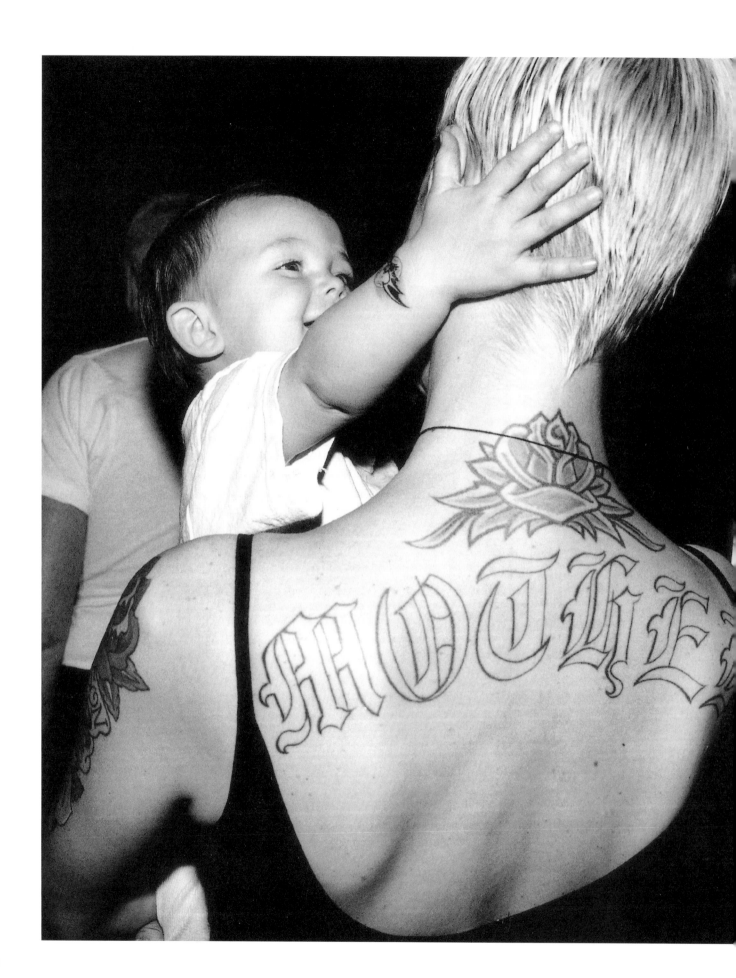

tools, not just the ones with the pink plastic handles.... They can play with the boys, as hard as the boys, without any desire to be boys. This is the latest step in the real-life women's movement."

Through a broadloom of new imagery and female-specific practices, contemporary tattoo art manifests this distinctly '90s sense of pluralism—one that dispels the idea of feminism as a unified sociopolitical movement with a single public face and a dominant guiding philosophy. New Age artists like Moon and Sinatra invoke a "difference" mentality by consecrating female thought and experience; the overtly erotic imagery of artists like Jordan, Ms. Deborah, and De la Cerda reflects a new sex-positive strain in women's expression; Krystyne Kolorful's therapeutic tattoo collection grows in part out of a women's self-help or survivor group mindset; and though Rasner's tattooed mastectomy scars are largely decorative, their very existence is a political comment about breast cancer and its impact on women's self-images. Even the specific female icons women choose to wear—from the Venus of Willendorf to Frances Farmer to Tank Girl—span a panoply of role models.

Opposite
Photo by Kent Noble

Analogies between feminist expression and tattooing fall flat, of course, when women's imagery serves no personal vision. Walk around any tattoo convention, and you'll see scores of women wearing the same lukewarm mythological scenarios and uninspired floral fantasies tantamount to off-the-rack body art, although, to be fair, even mediocre art can have vital personal significance. And certainly, women who get tattooed with what DeMello calls "the man's stamp of approval" say more about female acquiescence than empowerment.

But for those who approach it with forethought and invest it with meaning—women who see it, in Lazonga's words, as an outward expression of their inner being—tattooing is a way of cutting into nature to create a living, breathing autobiography. Written on the skin—the very membrane that separates the self from the world—tattoos are diary entries and protective shields, conversation pieces and countercultural totems, valentines to lovers and memorials to the dead. They celebrate ethnic pride and family unity; coming out, coming of age, marriage, divorce, pregnancy and menopause. They trumpet angry independence and fierce commitment. They herald erotic power and purge sexual shame. They're stabs at permanence in an age of transience and marks of individualism in a culture of mass production. Collectively, they compose a secret history of women grappling with body politics from the Gilded Age to the present—women whose intensely personal yet provocatively public art poses a complicated challenge to the meaning of feminine beauty on the eve of the millennium.

Opposite
Barbara, tattooed by Trevor Marshall
(Photo by Jan Seeger)

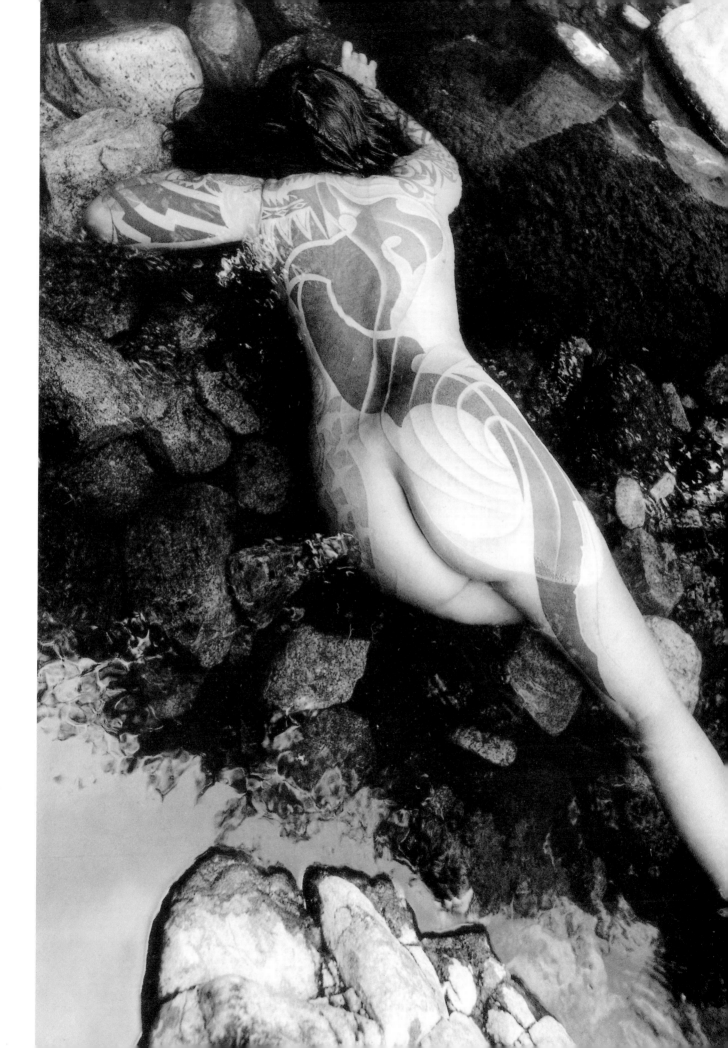

SOURCES

Diane Ackerman, *A Natural History of the Senses* (New York: Vintage Books, 1990).

Judy Aurre, "Meet Betty Broadbent," *The Tattoo Historian* (November 1982).

Author unknown, *Foto Magazine*, undated article on Mildred Hull, courtesy The Tattoo Archive.

Robert Bogdan, *Freak Show: Presenting Human Oddities for Amusement and Profit* (Chicago: University of Chicago Press, 1988).

Robert Brain, *The Decorated Body* (New York: Harper and Row, 1979).

Norma Broude and Mary D. Garrard, eds., *The Power of Feminist Art: The American Movement of the 1970s, History and Impact* (New York: Abrams, 1994).

Christine Braunberger, "Revolting Bodies: The Monster Beauty of Tattooed Women" *National Women's Studies Association Journal*, Volume 12, Number 2.

George Burchett, *Memoirs of a Tattooist* (London: Oldbourne Book Co., Ltd., 1958).

John Chapman, "Old Timer," *The New York Daily News*, December 22, 1935.

William Carmichael, *Incredible Collectors, Weird Antiques, and Odd Hobbies* (New York: Simon and Schuster, 1971).

Jean Furella Carson, "The Story of How I Became the Tatoo Queen," pamphlet, collection Tom Palazzolo.

Madame Chinchilla, *Stewed, Screwed and Tattooed* (Fort Bragg: Isidore Press, 1997).

Andree Connors, "One Breasted Woman," *Ms.* (Sept./Oct.1992).

Simone de Beauvoir, *The Second Sex* (New York: Vintage Books, 1974).

Margo DeMello, "The Carnivalesque Body: Women and Tattoos," in *Pierced Hearts and True Love: A Century of Drawings for Tattoos* (New York: The Drawing Center, 1995).

Katherine Dunn, "Call of the Wild," *Vogue* (June 1995).

Stuart Ewen and Elizabeth Ewen, *Channels of Desire*, 2d ed. (Minneapolis: The University of Minnesota Press, 1992).

"Facts Relating to Miss Irene Woodward, The Only Tattooed Lady" (1882), pamphlet, Arents Room Special Collection, Syracuse University.

"Female G.I. Has Cute Tattoos All Over Body," *National Informer*, December 27, 1964 (no byline).

Marisa Fox, "The Beauty of Body Art: Is it Only Skin Deep?" *Option* (Sept/Oct 1992).

Karen Greenspan, *The Timetables of Women's History* (New York: Simon & Schuster, 1994).

Steve Gilbert, "Totally Tattooed: The Self-Made Freaks of the Circus and Sideshow" in *Freaks, Geeks and Strange Girls: Sideshow Banners of the Great American Midway*, Randy Johnson, Jim Secreto, Teddy Varndell, eds. (Honolulu: Hardy Marks Publications, 1995).

Alan Govenar, *American Tattoo: As Ancient as Time, As Modern as Tomorrow* (San Francisco: Chronicle Books, 1996).

Alan Govenar and Stoney St. Clair, *Stoney Knows How* (Lexington: University Press of Kentucky, 1981).

Mary Jane Haake, "Bert Grimm's Timeless Legacy," *International Tattoo Art* (April 1995).

Mary Jane Haake, "Elizabeth Weinzirl: World's Number One Tattoo Fan," *International Tattoo Art* (November 1995).

Don Ed Hardy, ed., *Tattootime: New Tribalism*, 1982.

Dick Hebdige, *Subculture: The Meaning of Style* (New York: Routlege, 1988).

Nora Hildebrandt, "Miss Nora Hildebrandt, The Tattooed Lady," (1882), pamphlet, collection of Robert Bogdan.

Amie Hill, "Tattoo Renaissance," *Rolling Stone*, October 1, 1971.

Kathe Koja, *Skin* (New York: Delacorte Press, 1993).

Amy Krakow, *The Total Tattoo Book* (New York: Warner Books, 1994).

Sarah Lovett, *Dangerous Attachments* (New York: Villard, 1995).

"Marianne," posting in the Body Modification topic on ECHO (electronic bulletin board), August 23, 1993.

"Marines Ousting Woman for Tattoo," *The New York Times*, March 2, 1979 (no byline).

Glenna Matthews, *The Rise of Public Woman: Woman's Power and Woman's Place in the United States 1630-1970* (New York: Oxford University Press, 1992).

Margaret Mead, *Male and Female* (New York: William Morrow Company, 1949).

Gustav Niebuhr, "Ministries Flourishing in a World of Tattooing," *The New York Times*, March 21, 1999.

Dr. Stephan Oettermann, "An Art as Old as Humanity: A Short History of Tattooing in the Western World," in Stephan Richter's *Tattoo* (London: Quarto, 1985).

Albert Parry, *Secrets of a Strange Art as Practiced among the Natives of the United States* (New York: Simon & Schuster, 1933).

Katha Pollitt, *Reasonable Creatures: Essays on Women and Feminism* (New York: Knopf, 1994).

Chris Pfouts, "A True Tattoo Transformation," *Tattoo World* vol. 2.

Jennifer Putzi, "Identifying Marks: The Marked Body in Nineteenth-Century American Literature." Ph.D dissertation, Department of English, the University of Nebraska, 2000.

"Queen of Bohemia Back Here," *Sun News* (Sunday Daily News, Oct. 23, 1921).

Margery Rex, "Princess Galitzine, Bride 5 Times, Denies She Has Charm," *The New York Daily News*, October 9, 1925.

Adrienne Rich, *Of Woman Born: Motherhood as Experience and Institution* (New York: Bantam Books, 1977).

Clinton R. Sanders, *Customizing the Body: The Art and Culture of Tattooing* (Philadelphia: Temple University Press, 1989).

Mabel de La Mater Scacheri, "Millie, Only Lady Tattooist'" (New York, 1920s), source unknown, collection of Danny Danzl.

Lillian Schlissel, *Women's Diaries of the Westward Journey* (New York: Schoken Books, 1982).

R.W.B. Scutt and C. Gotch, *Art, Sex and Symbol: The Mystery of Tattooing* (New York: A.S. Barnes, 1974).

Jan Seeger, "Vyvyn Lazonga: Keeping the Sacredness Alive," *Skin and Ink* (December 1993).

Jan Seeger, "The Outer Limits of Kari Barba," *Skin and Ink*, (November 1994).

Jonathan Shaw, "A Brief History," *International Tattoo Art*, (November 1993).

Pat Sinatra, "The Magical Mark," *Outlaw Biker Tattoo Revue*, (June 1992).

Rebecca Stephenson, "Pink Ink and Lycanthropy," *Tattoo Advocate*, (Spring 1989).

"The Tattooed Woman," *The New York Times*, March 19, 1882.

"Tattooed Woman Dies," *Billboard*, December 11, 1915.

Rosemarie Garland Thomson, ed., *Freakery: Cultural Spectacles of the Extraordinary Body* (New York: New York University Press, 1996).

Peter Trachtenberg, *Seven Tattoos: A Memoir in the Flesh* (New York: Crown Books, 1997).

Marcia Tucker, "Tattoo: the State of the Art," *Artforum* (May 1981).

V. Vale and Andrea Juno, eds., *Modern Primitives* (San Francisco: RE/Search Publications, 1989).

Spider Webb, *Tattooed Women* (Woodstock, (New York: R. Mutt Press and Spalding and Rogers Mfg. Inc., 1982).

Naomi Wolf, *The Beauty Myth* (New York: William Morrow, 1991).

Art Wolfe, *Tribes* (New York: Clarkson Potter Publishers, 1997).

Chris Wroblewski, *Tattooed Women* (London: Virgin Publishing Ltd., 1992).

INDEX

New Titles!

TATTOO ART/BODY POLITICS/CULTURAL HISTORY
Hardcover & paperback editions, 8.5 x 11 inches,
244 pages hundreds of drawings and full-color pics

ISBN 1-890451-07-X (hc) **$49.99**
(Cnd $77.50)

ISBN 1-890451-06-1 (pb) **$29.99**
(Cnd $46.50)

THE TATTOO HISTORY SOURCE BOOK

by Steve Gilbert

THE TATTOO HISTORY SOURCE BOOK is an exhaustingly thorough, lavishly illustrated collection of historical records of tattooing throughout the world, from ancient times to the present. Collected together in one place, for the first time, are texts by explorers, journalists, physicians, psychiatrists, anthropologists, scholars, novelists, criminologists, and tattoo artists. A brief essay by Gilbert sets each chapter in an historical context.

Topics covered include the first written records of tattooing by Greek and Roman authors; the dispersal of tattoo designs and techniques throughout Polynesia; the discovery of Polynesian tattooing by European explorers; Japanese tattooing; the first 19th-century European and American tattoo artists; tattooed British royalty; the invention of the tattooing machine; and tattooing in the circus. The anthology concludes with essays by four prominent contemporary tattoo artists: Tricia Allen, Chuck Eldridge, Lyle Tuttle, and Don Ed Hardy.

The references at the end of each section will provide an introduction to the extensive literature that has been inspired by the ancient-but-neglected art of tattooing. Because of its broad historical context, THE TATTOO HISTORY SOURCE BOOK will be of interest to the general reader as well as art historians, tattoo fans, neurasthenics, hebephrenics, and cyclothemics.

Steve Gilbert is a medical illustrator and freelance writer with a lifelong interest in tattooing. His articles on the history of tattooing have appeared in *International Tattoo Art* and other tattoo magazines, and he works part-time as a tattoo artist, specializing in authentic historical designs tattooed by hand.

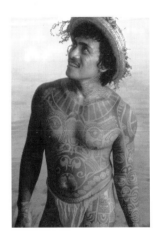

www.JunoBooks.com

New Titles!

MAGNETS FOR MISERY
TRAILER PARKS AND AMERICA'S DARK HEART OF WHITENESS
By Mark Van de Walle

Neither city nor country nor suburb, the trailer park is a mad mixture of the most decadent parts of all of the above. A fabulous nightmare about a dream of a man and a plot of land, and the freedom all that brings. The freedom to blow yourself to kingdom come while making crystal meth; the freedom to have affairs with your neighbor's underage daughter; the freedom to have sex with her in the middle of the day on the old couch that marks the place where your porch should be; and the neighbor's freedom to shoot at the two of you with the service .45 he brought back from 'Nam.

With all this freedom going on, the trailer park, of course, has style for miles: black-velvet Elvis paintings and John Wayne bourbon decanters; "Drop Kick Me Through the Goal Posts of Life, Lord Jesus"; and refrigerators that manifest the face of Christ. Which is why the trailer park is the place the UFO visits, the place where all the conspiracies come to roost, where all the gun nuts and religious kooks and drug runners and Angels, Hell's and otherwise, turn up.

In America, all our disasters happen in trailer parks. That's how you know they're disasters—because of the little bits of trailer scattered everywhere. Somewhere along the line, through a gradual process of accretion, through years of accident piled on mishap piled on dumb tragedy, trailer homes have been transformed from cheap, efficient, ready-made housing into something that is practically synonymous with every imaginable kind of disaster.

So whenever there's a flood, a hurricane, or a twister, there's a string of massacred trailers left behind to mark its passage. Where trouble goes, footage of some poor bastard standing in front of the hole where his double-wide used to be is soon to follow. In short, trailer parks have become magnets, and as such, magnets for misery, a dark reflection of the (white) American Dream, indeed, of Whiteness, period.

Mark Van de Walle is a freelance writer in New York whose work has appeared in many publications including *Artforum* and *Travel & Leisure*. He has extensive skill in first-person shooter video games.

TRAILER PARK LIVING/AMERICANA/POP CULTURE
Paperback, 7.25 x 9.5 inches, 150 pages, some photos
ISBN 1-890451-08-8 **$19.99**
 (Cnd $30.99)

Classics!

WOMEN'S STUDIES/POP CULTURE/PERFORMING ARTS
Paperback, 8.5 x 11 inches, 240 pages, illustrated
ISBN 1-890451-05-3 **$18.99**
(Cnd $29.50)

ANGRY WOMEN

by A. Juno

An enduring bestseller since its first printing in 1991, ANGRY WOMEN has been equipping a new generation of women with an expanded vision of what feminism could be, influencing Riot Grrrls, neo-feminists, lipstick lesbians, and suburban breeders alike. A classic textbook widespread in college curriculae, ANGRY WOMEN is the most influential book on women, culture, and radical ideology since THE SECOND SEX.

ANGRY WOMEN features: Diamanda Galas, Lydia Lunch, Sapphire, Karen Finley, Annie Sprinkle, Susie Bright, bell hooks, Kathy Acker, Avital Ronell, Holly Hughes, Carolee Schneeman, Valie Export, Linda Montano, and Wanda Coleman, among others.

"This is hardly the nurturing, womanist vision espoused in the 1970s. The view here is largely pro-sex, pro-porn, and pro-choice. Separatism is out, community in. Art and activism are inseparable from life and being."
—*Village Voice*

"These women—potent agents for cultural destabilization—are definitely dangerous models of subversion!" —*MONDO 2000*

ANGRY WOMEN IN ROCK

by A. Juno

"[Today], indie chicks proliferate, all tousled and tight-trousered and signed to major labels. ANGRY WOMEN IN ROCK gives us some portraits of women whose 'independence' is their substance and not just their style."

—*Seattle Weekly*

"This book—stuffed with ideas, history, wise (and wise-ass) remarks, and most importantly, hope for the future—will be thumbed through often."

—*Puncture*

"Creativity, sexuality, politics, fame, misogyny, strapping on rubber phalluses, all this is clearly dissected in question-and-answer format. —*Q*

Includes interviews with: Chrissie Hynde (The Pretenders), Joan Jett, Kathleen Hanna (Bikini Kill), 7 Year Bitch, Jarboe (Swans), Tribe 8 (the all-dyke punk band), Kendra Smith, Naomi Yang (Galaxie 500), and much, much more!

MUSIC/WOMEN'S STUDIES/CULTURAL STUDIES
Paperback, 7 x 9 inches, 224 pages, lots of photos
ISBN 0-9651042-0-6 **$19.95**
(Cnd $30.95)

www.JunoBooks.com

Classics!

BREAD & WINE
An Erotic Tale of NY
Written by Samuel R. Delany
Drawn by Mia Wolff
Introduced by Alan Moore

Award-winning science fiction author Samuel Delany and Dennis, a homeless New Yorker selling books from a blanket, discover sexual joy and explode stereotypes while exploring the possibilities for compassion and acceptance in this moving graphic novel—all the more touching because it's true.

Samuel R. Delany is the author of DHALGREN (Bantam Books, 1975), ATLANTIS: THREE TALES (Wesleyan University Press, 1995), THE MAD MEN (Rhinoceros Books, 1996), and TIMES SQUARE RED, TIMES SQUARE BLUE (NYU, 1999). Delany is a professor at SUNY, Buffalo, and lives in New York City.

Mia Wolff, author of the children's book, CATCHER (Farrar, Straus & Giroux, 1994), is a former trapeze artist and martial arts instructor, and is now a painter living in upstate New York.

Alan Moore is one of the best known and respected writers in comix today, and the author of THE WATCHMAN (Warner Books, 1987), and FROM HELL (11 volumes, Kitchen Sink, 1992-1998).

AUTOBIOGRAPHY/EROTICA/GAY LETTERS
Paperback, 8.5 x 11 inches, 80 pages, more than 50 pages of line art
ISBN 1-890451-02-9 **$14.99**
(Cnd $23.00)

ECOLOGY/CULTURAL STUDIES/ART
Paperback, 7 x 9 inches, 224 pages, over 260 line drawings and halftone photos
ISBN 0--9651042-2-2 **$24.95**
(Cnd $38.95)

CONCRETE JUNGLE
A Pop Media Investigation of Death and Survival in Urban Ecosystems
Edited by Mark Dion & Alexis Rockman

"CONCRETE JUNGLE stands as one of the finest works in urban anthropology to appear in recent years. A plentitude of provocative essays, bizarre photographs, marginal quotes, and weird diagrams are to be found in this exploration of 'the intersection of urban living and Nature.'"
—*Fringeware Review*

"This wry and often grotesque look at the food chain shows just how active nature is despite our unflagging attempts to pave it over."
—*Utne Reader*

"CONCRETE JUNGLE looks oddly like a high school science text book, but…the content is oozily compelling."
—*Artforum*

"The next time you throw a dinner party, bring this provocative, compelling, and amusing volume to the table."
—*Time Out*

www.JunoBooks.com

Classics!

FREAKS

by Daniel P. Mannix

Originally printed in a small edition and withdrawn after one month by the publisher, Pocket Books, FREAKS—out of print for nearly 20 years—was brought back to eye-popping life, with many new photos, by the renowned marginal culture press RE/Search. Now Juno Books, morphed from the now-defunct RE/Search, has brought FREAKS back into the mainstream publishing fold with panache.

In FREAKS, meet the strangest people who ever lived, and read about: the notorious love affairs of midgets • the dwarf clown's wife whose feet grew directly from her body • the famous pinhead who inspired Verdi's *Rigoletto* • the 34-inch-tall midget happily married to his 264 lbs. wife • the human torso who could sew, crochet, and type and other bizarre accounts of normal humans turned into freaks—either voluntarily or by evil design!

Daniel P. Mannix, is the author of such enduring noir classics as MEMOIRS OF A SWORD SWALLOWER; THOSE ABOUT TO DIE; THE HELL-FIRE CLUB; THE HISTORY OF TORTURE; and many others. A former sword-swallower, fire-eater, and fakir, Mannix still lives on the family farm with his falcon, miniature horses, and reptile collection.

CULTURAL STUDIES/MEDICAL CASE HISTORIES
Paperback, 8.5 x 11 inches, 124 pages, with illustrations
ISBN 0-9651042-5-7 **$15.99**
(Cnd $24.95)

GRAPHIC NOVELS/MUSIC/GAY LETTERS
Paperback, 8.5 x 11 inches, 256 illustrated pages
ISBN 0-9651042-1-4 **$24.95**
(Cnd $38.95)

HORROR HOSPITAL UNPLUGGED
A Graphic Novel

by Dennis Cooper & Keith Mayerson

"This book will definitely become a classic."
—International Drummer

"Cooper's idiosyncratic morality meets cartoonist Keith Mayerson's manga-like style in this ruthless and totally rude book." *—Gay Times*

"Trippy and brilliant." *—Attitude*

"Youthful angst is rarely portrayed as this terrifying."
—Library Journal

"Bound to reign in cult stardom status, HORROR HOSPITAL UNPLUGGED is the ultimate generation whatever's coming of age tale of Trevor Machine, the 90s answer to Holden Caulfield.... Filled with stimulating art and cynically amusing text, HORROR HOSPITAL UNPLUGGED is a rare treat offering its readers intelligent entertainment on every page." *—Cover*

The Juno Books Individual Order Form for Caring Persons Not Living by a Great Bookstore!

BILLING INFORMATION

Your name _____ Today's date _____

Your address _____

Want to get special e-mail notices on private sales offers?

Tel _____ Fax _____ E-mail _____

City _____ State _____ Zip _____

PAYMENT INFORMATION

Please charge my ☐ MC ☐ Visa ☐ Amex

Your credit card number _____ Exp date _____

Signature _____

☐ Check enclosed

SHIPPING INFORMATION ☐ CHECK IF SAME

Name _____

Address _____

City _____ State _____ Zip _____

Tel _____ Fax _____

QUANTITY	TITLE	AMOUNT

SPECIAL SHIPPING INSTRUCTIONS

	SUBTOTAL	
add 8.25% tax if you live in NY		
DOMESTIC: SHIPPING & HANDLING ($4.50 1ST BOOK, $1.50 EACH ADDITIONAL) FOREIGN: $10.00 SURFACE, $25.00 AIR MAIL 1ST BOOK; $5.00 SURFACE, $10.00 AIR FOR EACH ADDITIONAL		
Please note that books will be sent when available.	TOTAL	

HELP US THROW EVER MORE ELABORATE BOOK LAUNCH PARTIES AND PROVOCATIVE, UNUSUAL PR CAMPAIGNS! ANSWER OUR QUESTIONNAIRE AND RECEIVE A 20% DISCOUNT!

1) How did you first hear about us?

2) What do you love most about our books?

3) Which of our books are your favorites?

4) What's your sex? Your age?

5) What do you do?

6) How much do you make?

7) What kind of liquor do you drink?

8) What catalogs do you buy from on a regular basis?

9) What web sites do you buy from?

Don't worry! All this info will be kept confidential, and be used for statistical purposes only!

please now do one of these things:
1) Mail a copy of this form to: **Juno Books Sales Desk**, 180 Varick Street, Suite 1302, New York, NY 10014-4606
2) Fax a copy to: **212 366 5247**
3) e-mail a copy to: **orders@JunoBooks.com**
4) Call us toll-free at: **1-877-pH-Books**

Acknowledgments

I owe heartfelt thanks to three whip-smart artists who were attentive midwives to this book: Laura Vida, Pat Fish, and Mary Jane Haake. Chuck Eldridge of Tattoo Archive in Berkeley was endlessly generous with his vast historical knowledge and photos; artist/ historians Don Ed Hardy and Lyle Tuttle were important sources of tattoo lore; Amy Krakow, author of *The Total Tattoo Book*, guided me early on; and Chris Pfouts of *International Tattoo Art* magazine provided valuable suggestions and photos.

I'm grateful to many people who offered help and advice along the way: Matty Jankowski of New York Body Archive; photographers Dianne Mansfield and Jan Seeger; Fred Dahlinger, Director of the Robert L. Parkinson Library and Research Center at the Circus World Museum in Baraboo, W.I., Vyvyn Lazonga; Robert Bogdan; Alan Govenar; Michael McCabe; Tom Palazzolo; Jeff Crisman; Randy Johnson; Cecelia Michelon; John Wyatt; Judy Nylon; and Gini Sikes.

Several friends made important contributions to this project: Leah Singer unearthed the stunning cover photo of Betty Broadbent; Bill Mullen and Kerrie Chappelka read and critiqued early drafts; and Michael Houghton of Ben Franklin Books in Nyack, N.Y., lent me rare books delivered with amusing anecdotes.

Many thanks to my agent, Laurie Fox, of the Linda Chester Literary Agency, whose encouragement brought this idea to light; my publisher Andrea Juno, who both challenged and supported me; and the ever-efficient Simone Katz of Juno Books.

Deepest thanks go to my most trusted friend and caring critic, Mark Dery.

Copyright © 1997 by Margot Mifflin

Mifflin, Margot, 1960-
 Bodies of subversion : a secret history of women and tattoo / by Margot Mifflin.
 p. cm.
 ISBN 1-890451-10-X
 1. Tattooing. 2. Women--Physiology. 3. Women--Identity. 4. Body, Human--Symbolic aspects. 5. Body art. 6. Permanent make-up
 I. Title.
 GN419.3 .M53 2001
391.6'5'082--dc21

 00-067149
 CIP

Bookstore Distribution:
U.S. and Canada: Publishers Group West, 1700 Fourth Street, Berkeley, CA 94710
 Toll free: 1-800-788-3123, fax: 510-528-3444
U.K.: Turnaround, Unit 3, Olympia Trading Estate, Coburg Road, London N22 6TZ, United Kingdom
 phone: 0181 829 3000, fax: 0181 881 5088, email: sales@turnaround-uk.com
Italy: Logos Art srl, Via Curtatona 5/f, 41100 Modena Loc. Fossalta, Italy
 phone: 059 41 87 11, fax: 059 28 16 87, email: logos@books.it
Benelux: Nilsson & Lamm, Pampuslaan 212, Postbus 195, 1380 AD Weesp, The Netherlands
 phone: 02 94 494949, fax: 02 94 494455

For a catalog, please send 6 stamps to :
Juno Books/ powerHouse Books, 180 Varick Street, Suite 1302, New York, NY 10014
www.junobooks.com/ www.powerHouseBooks.com

For editorial inquiries, please contact:
Juno Books, 111 Third Avenue, Suite 11G, New York, NY 10003
www.junobooks.com

Printed in Hong Kong through Colorcraft Ltd

10 9 8 7 6 5 4 3

Editor-in-Chief: Andrea Juno
Book Designer: Katharine Gates
Front Cover Designer: Thomas Rothrock

Black Betty Boop tattoo flash by Jacci Gresham
(Courtesy Jacci Gresham)